COMPLETE

Calligraphy

COMPLETE
Calligraphy

Marie Lynskey

Published by SILVERDALE BOOKS
An imprint of Bookmart Ltd
Registered number 2372865
Trading as Bookmart Ltd
Blaby Road
Wigston
Leicester LE18 4SE

© 2006 D&S Books Ltd

D&S Books Ltd
Kerswell,
Parkham Ash, Bideford
Devon, England
EX39 5PR

e-mail us at:- enquiries@d-sbooks.co.uk

This edition printed 2006

ISBN 10 – 1845094379
13 – 9781845094379

DS007. Complete Calligraphy

Creative Director: Sarah King
Project Editor: Claire Bone
Photography: Paul Forrester
Designer: Debbie Fisher

Fonts: Gloucester and Gill Sans

Material from this book previously appeared in Beginner's Guide to Calligraphy
and Beginner's Guide to Illuminated Lettering

Printed in Thailand

1 3 5 7 9 10 8 6 4 2

Contents

Introduction

Mass-produced and quickly discarded things have become commonplace in our lives today, with the result that handwritten and hand-painted documents that have been created with more thought, time and attention have become increasingly precious and worthy of a place in our busy lives. Because the printed word on the page or computer screen is forever before us, it is a refreshing change and a great satisfaction to those who appreciate their value to be able to produce and view decorative lettering that has been prepared with time and care simply for the pleasure that it gives.

fig. 1. Reconstruction of cuneiform lettering on clay tablet.

The history of writing

We can trace the history of writing back to ancient times, to the cuneiform script of the Sumerians over 5,000 years ago. Clay tablets were used, the images being pressed into the damp clay, which was then baked hard. Many tablets of this sort have been discovered (fig. 1).

The word cuneiform actually means 'wedge-shaped', as the tools employed for making the information impressed the clay with small, wedge-shaped marks, tapering from a wide start to a thin, pointed end. The earliest images were attempts to describe pictorially the information that the writer was trying to convey, but a more contained selection of symbols gradually came to be adopted, which represented spoken sounds rather than things. Although this set of symbols was eventually reduced in number as the centuries went by, it was still far from reaching today's alphabet of 26 letters. The cuneiform script spread with the conquering of Sumeria by the Babylonians, who in turn were overtaken by the Assyrians. The script was adopted by conquering peoples and was dispersed by fleeing native peoples, causing it to spread throughout the Middle East.

The Egyptians were developing their writing skills at the same time as the Sumerians, but they advanced further by developing a smaller series of symbols. Their hieroglyphics (the word means 'sacred engraved writing') were essentially picture-writing systems, and the use of a reed brush or pen and papyrus made the task simpler than the Sumerians' clay tablets (fig.2). Egyptian scribes used black ink made from carbon mixed with water and gum and red ink made with a natural, red earth pigment mixed in the same way.

Papyrus is made from the pith of reeds grown in Egypt; it is kept in rolls and is only written upon on one side, the other not being suitable for lettering (fig. 3). Papyrus is constructed by removing the outer covering of the papyrus reed and cutting the inner pith into thin layers. These strips are laid side by side lengthways, with the edges overlapping slightly. A second layer of strips is placed on top, at right angles to the first row. Next the layers are beaten flat, to remove some of the moisture. The papyrus is then left to dry under pressure in order to keep it flat and smooth, and the natural adhesive in the plant binds the strips together to form a single sheet.

The Egyptians clung to their pictorial writing long after some of their neighbours had begun to devise more efficient writing systems that consisted of fewer symbols. The Phoenicians adopted a style that owed its beginnings to both cuneiform and hieroglyphics, developing an alphabet that contained a similar number of letters to those that we now use (fig. 4).

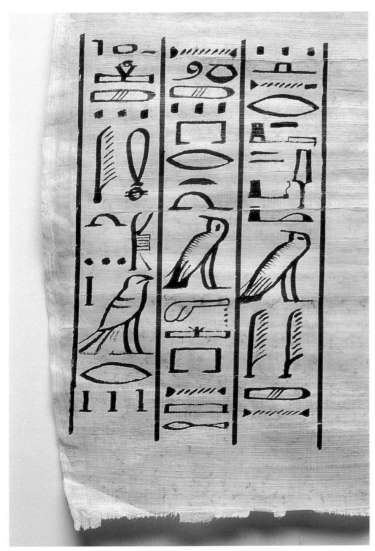

fig.2. Reconstructed hieroglyphics on papyrus.

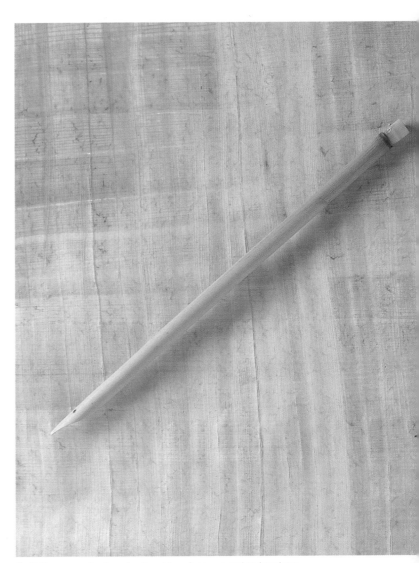

fig. 3. Papyrus, made of overlapping strips of papyrus reed and reed pen.

fig. 4. Phoenician letters.

It is from them that the Greeks may have developed their writing techniques, adapting the Phoenician letters and incorporating signs to represent their own sounds. The angular letters of some Greek lettering styles (fig.5) may have been due to the use of a wax tablet; it is easier to form straight lines when writing in wax with an iron or wooden stylus. The wax tablet was a wooden tray with a small lip round the edge and a coating of a thin layer of wax over the inner surface. Once the tablet was written upon, the letters could be easily erased by slightly melting and then smoothing out the wax again.

As papyrus became more expensive and difficult to obtain as a result of the deterioration of the Mediterranean trade routes and Rome's decline in power, vellum and parchment began to replace it. Vellum is the specially prepared skin of calves or goats, while parchment is the skin of sheep. The surface of both is very smooth and easy to write upon, and the sheets could either be white or cream, with slight, but attractive, vein markings running through the skins. Leather had been used as a writing surface by Hebrew scribes, who wrote from right to left, and it is thought that vellum was first produced in Pergamum in Asia Minor (the German word for vellum is Pergament, which seems to bear out this theory).

Roman lettering followed on from the Greek, and the Latin alphabets varied from very precisely drawn capitals, such as the quadrata, or square-capital, alphabet that was carved on stone (fig. 6), to such more free-flowing, quickly written styles as rustica (fig. 7), which was used in documents. These styles spread throughout the Roman Empire. Vellum furthermore brought about the construction of books, whereas papyrus had been rolled up.

The quill pen was also devised and became a well-used writing instrument. Quills are much more flexible than reed pens, and as a consequence the styles that were written with them evolved accordingly (see p18 for instructions on making your own quill pen).

Arabic scripts were also derived from the Phoenicians' system, culminating in the writing of the Koran, which standardised the script during the early seventh century. It spread rapidly throughout the regions that were conquered by the Arabs, but its spread towards Western Europe was halted by Arab defeats at the hands of the Franks. Some of the earliest writing on vellum is Arabic (fig. 8).

fig. 5. Greek letters.

fig. 6. Quadrata capitals.

fig. 7. Rustica capitals.

fig. 8. Arabic writing on vellum.

Chinese lettering dates from at least 1000 bc, and developed in much the same way as cuneiform, using picture forms, but in vertical columns – indeed, it still follows this method (fig. 9). We are indebted to the Chinese for their invention of paper in about ad 100 (they had previously used wood, bamboo and silk as writing surfaces, but paper came to be regarded the most practical material). Its use gradually spread, first to Japan and eventually towards the West, progressing via the Islamic countries to Spain and the rest of Europe. One of the earliest-known European manuscripts to have been written on paper is a deed of King Roger of Sicily dated 1109, whose text is written in both Arabic and Greek. Paper was being used in England from the mid-thirteenth century, but paper manufacture did not begin in this country until the end of the fifteenth century, when a small paper mill was set up in Hertfordshire by John Tate. Another two centuries would pass before its use became widespread and it supplanted vellum as the principal writing surface.

The development of lettering styles in Europe

Returning to late Roman lettering, a script known as uncial was developed and used in Roman books (fig.10), which later became the script of the Celtic monasteries as missionaries dispersed throughout Europe spreading Christianity, which had become the official religion of Rome during the fourth century. The Romans wrote on vellum with quill pens, and it was possible to achieve a much finer quality of letter with these precisely cut writing instruments.

With the break up of the Roman Empire during the fifth century, widespread communications deteriorated and it was largely the Roman Catholic Church that kept arts and learning alive throughout the Dark Ages. The uncial script was adopted by Christian scribes and became the dominant book hand in the West from the fifth to eighth centuries. Christians required texts that explained their religion to enable them to spread their message, and the Greek word biblos describes their primary book, or Bible, which was copied, re-copied and illuminated on an ever-increasing scale. The production of Christian illuminated manuscripts thrived in isolated parts of Europe, and the seventh and eighth centuries saw the creation of some of the most complex and attractive manuscripts ever produced in what became known as the insular style. Missionaries and

monks took books with them on their travels and thus encouraged the spread of different lettering styles throughout Europe. The books were lent and copied (this was the only means of acquiring a new book), and many medieval manuscripts depict monks at work, their writing materials and paints being clearly visible.

Although the uncial alphabet consisted of majuscule (capital) letters, a minuscule (small) alphabet was also beginning to emerge. The uncial hand deteriorated towards the ninth century, its spaciousness and formality being replaced by a more quickly written and economically spaced style. A mixture of the formal uncial that was used in great works and the more cursive versions that were used in informal writings gradually came to be known as the half-uncial script (fig.11).

fig. 9. Chinese lettering.

uncial

haecitaaput

fig. 10. Uncial letters.

half uncial

nobir cunae fuid

fig. 11. Half uncial letters.

carolingian
nostri inlucam

fig. 12. Carolingian letters.

merouingian
sid omne cdnfusum

fig. 13. Merovingian letters.

anglo - raxon
dchingulir bonopu
dyrputæ red alchinir

fig. 15. Anglo-saxon letters.

visigothic
nomineaheudimæ q

fig. 16. Visigothic letters.

gothic
Op lyn houet

fig. 18. Gothic letters.

textura
Nota in aduentu

fig. 19. Textura letters.

insular

iohannis furrexit

fig. 14. Insular letters.

beneventan

quia lam nonptopa

fig.17. Beneventan letters.

rotunda

oculi domini super

fig. 20. Rotunda letters.

The next major style was developed as a result of the Holy Roman Emperor Charlemagne's wish to promote learning. Charlemagne, the king of the Franks who lived from 742 to 814, gave his name to the Carolingian script (fig.12), which had long ascending and descending stokes to the letters and a free-flowing, elegant style. Charlemagne's patronage of the arts brought about the widespread adoption of minuscule alphabets, and we can trace the formation of a series of closely related styles throughout Europe.

In France, there was the Merovingian style (fig.13), which was named after the dynasty which preceded Charlemagne's. An insular style of lettering (fig.14) continued to develop in northern Britain and was not superseded by the Carolingian until the mid-tenth century. Anglo-Saxon lettering (fig.15), which was influenced by Roman missionaries, was introduced by monks from England to continental Europe.

The Spanish Visigothic (fig.16) was a style that survived into the twelfth century, while the Beneventan script(fig.17) evolved in Monte Cassino in southern Italy during the ninth century and survived into the thirteenth century. All of these lettering styles thrived in Europe, and were used in the manuscripts that were produced in various centres of learning throughout the early Middle Ages.

The thirteenth century saw the emergence of the Gothic scripts (fig.18), whereby the rounded letter shapes that had been used during the previous centuries became gradually more angular, culminating in the textura script (fig.19) of the fourteenth century, with its dense, black covering of vertical lines connected by thin, hairline strokes. Richly decorated Gothic manuscripts, illuminated with gold leaf and reflecting the extravagant fashions, courtly life and romantic ideals that were popular at the time, were produced for great patrons of the arts. In Italy, the rotunda style (fig.20), which represented a return to a more rounded version of the Gothic hand, found favour, particularly in music books. The Gothic styles took up much less space than the Carolingian hands, which enabled more text to be fitted into a page. Gothic was the first lettering style to appear in the printed books that were first produced during the fifteenth century. As a result, slowly produced, handwritten books began to decline in numbers, while increasingly widely available printed books carried the written word to classes of people who had never before had the chance to possess it.

An attractive style known as bastarda (fig.21) bridged the gap to the next major changes in lettering styles that were brought about by the Renaissance. Bastarda was a cursive amalgamation and adaptation of the Gothic and Carolingian styles that appeared in Europe during the fifteenth century. The letters are quite curved, but with angular points at the top and bottom. Although it was adapted as an informal writing style, some beautiful formal examples can be found in the form of official documents and poetry, although not religious documents.

Italy spearheaded the introduction of the Renaissance lettering styles, which represented attempts by scholars to return to the simpler styles that had preceded the Gothic scripts. Such styles as the Carolingian were used as models, but the new styles had a gradual tendency to slope to the right and to become increasingly cursive, no doubt in the interests of speed. This italic hand, as it became known, soon became very popular and widespread. Cancelleresca, which had a neat, formal appearance, was one form of italic script that emerged (fig.22), while another, the humanistic hand (fig.23), had a neat, clear-cut precision to its letters and evolved as a result of the study of antiquarian Roman styles.

With the widespread production of printed books, we finally arrive at the copperplate style (fig.24), which was first formed by the action of the engraver's burin – an engraving tool with a sharp point – on printing plates. Interestingly, the terms 'lower case', which is often applied to minuscule letters, and 'upper case', which describes majuscule or capital letters, are derived from the cases, or drawers, in which printers kept their different sets of type. Copperplate came to be used to form fantastically flourished lettering, sometimes embellished almost to the point of illegibility. When written with a fine-pointed pen and ink, the letters could be very beautiful, and it was the copperplate script that filled the copybooks that many writing masters used to teach handwriting. From the beginning of the nineteenth century, steel pens began to be produced and manufactured in quantity; these had the advantage over quill pens of ease of acquisition and greater durability and consequently became widely used.

fig. 21. Bastarda letters.

fig.22. Cancelleresca letters.

fig. 23. Humanistic letters.

fig. 24. Copperplate letters.

Materials and equipment 1

Materials and equipment for the scribe

Calligraphy, or the study and reproduction of historical lettering styles, as well as the creation of new lettering styles, is today a very popular recreational activity. The array of materials and equipment that is now available to the scribe and illuminator is both very wide and varied in quality. The equipment and materials that you will need at the outset are discussed below.

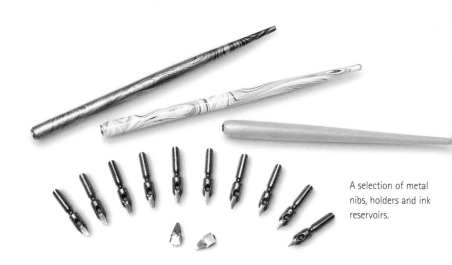

A selection of metal nibs, holders and ink reservoirs.

Pens and nibs

Although metal nibs have been in use since Roman times, early examples were not very satisfactory. Now produced by many different manufacturers, good metal nibs can produce excellent results. It is important that you use proper calligraphy pens and nibs if you want to create really good lettering. Fountain pens may be easy to use, but their nibs are never sharp enough to produce distinctly contrasting thin-and-thick strokes, and it is these that give most calligraphic hands their style and beauty. Nibs come in a wide variety of styles and sizes. For consistency, William Mitchell nibs have been used throughout this book. They are one of the best brands to use. If you buy other brands you may find that sizes vary. A size 70 for one brand may be another brand's size 0.

A calligraphic pen consists of a nib-holder, a nib and a small reservoir to hold the ink. The nib is first fitted into the holder (fig.1), and the reservoir fitted last (fig.2).

After gaining some initial experience with metal nibs, it is well worth trying quills and reed pens in order to widen your understanding of calligraphy and your ability. If you cannot make your own quill pen, you may be able to buy a ready-made one; because demand is small, however, they may be difficult to find. If this is the case, try contacting a local or national lettering society to ask if they know of a supplier or can put you in touch with a scribe who will make pens for you.

A homemade quill pen

Curing a quill

A quill pen is made from the feather of a large bird, such as a goose or swan. One of the first five flight feathers is used, as these are the largest and strongest (fig.3).

A quill needs to be cured before it can be cut. In order to do this, you must first remove the end of the barrel and soak the feather in water for about 12 hours so that the cells expand.

Remove the membrane inside the barrel with a suitable object, such as a small crochet hook or a length of wire, taking care not to scratch the barrel.

When it is free of obstructions, harden the barrel by plunging it into hot sand. Heat the sand (which should be as fine as possible, like the silver sand that is used by potters) in a flat pan and push the quill into the sand so that the barrel is filled. Use a spoon to scoop the sand into the quill if necessary, and leave it in the sand for only a few seconds before removing it to examine it. The opaque, white colour of the barrel should have become transparent, and provided that there is no distortion or blistering to the quill from overheating you can continue to the next stage. If the quill has not been left in the sand for long enough it will be too pliable when it cools, so it will probably be necessary for you to learn by trial and error when the quill has become hard enough to write with, but not so hard as to be brittle when it is cut.

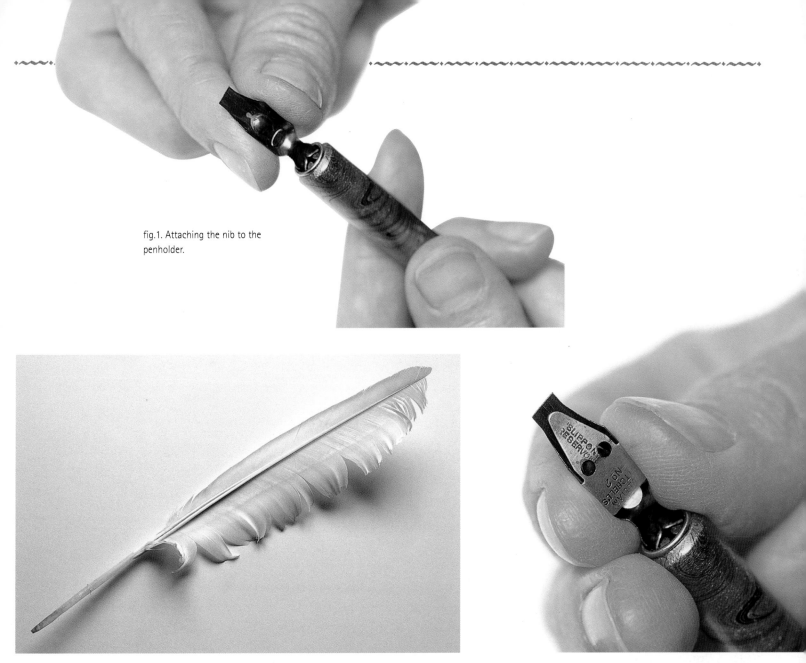

fig.1. Attaching the nib to the penholder.

fig.2. Fitting the ink reservoir to the nib.

fig.3. An untreated quill.

Shake out the sand. While the quill is still hot and slightly pliable, scrape off the membrane from the outside of the barrel with a blunt knife in order to avoid scratching it. Then dip it into cold water and dry it in order to prepare it for cutting (fig.4).

Shorten the feather to a length of no more than about 20 to 25cm (8 to 10") and remove the plume from both sides of the quill. Alternatively, if you prefer to keep a little plume for appearance's sake, you can leave some on the side which will not rest against your hand, although you will find it less cumbersome if you trim this down to about 1cm ($\frac{1}{2}$") in width. All of the barb (the plumage around the top end of the quill) must be removed, as it would otherwise interfere with your hand when writing.

fig.4. A cured quill.

PROJECT *Making your quill pen*

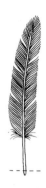

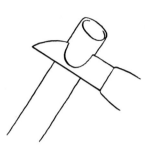

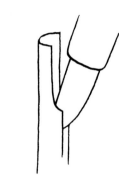

1 First remove the end of the barrel, then cure as detailed previously.

2 Using a very sharp knife, remove the end of the barrel, cutting along a long, slanting angle.

3 Make a short slit down the length of the quill. Work carefully, and lever the blade gently, until the quill cracks to form the slit.

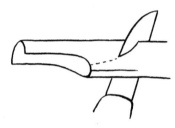

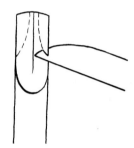

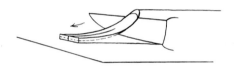

4 The next cut is a large scoop taken out of the opposite side to the slit, so that the slit is more or less centred in the remaining portion. This cut is quite difficult, as quills are very tough, and you will probably have to experiment on several quills before you produce a good pen.

5 Make a cut on each side of the slit to form the writing edge. Make sure that you match each side so that the slit is central and the pen is of the required width.

6 To make the writing edge clean and sharp, rest the end of the quill on a smooth, hard surface and thin the tip slightly with a forward stroke.

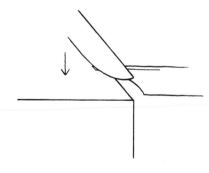

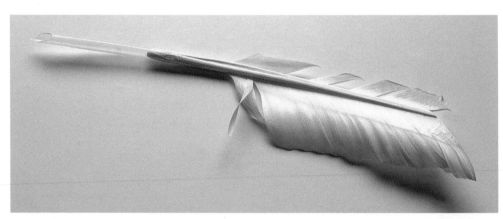

fig.5. The completed quill pen.

7 Finally, remove a tiny portion from the tip with a downward cut to create a completely straight edge.

The pen should now be ready (fig.5), but dip it in ink and try writing a few strokes to see if it is smooth and well cut. The end of the nib can be re-cut if it is not correct or after it has become blunt through use.

Ink

The type of ink that you use is very important, as it is difficult to produce good letters with a poor-quality ink. There are many bottled inks on the market, ranging from thin, transparent liquids, which often flow very blotchily from the pen and are likely to fade when exposed to daylight for long periods, to quite acceptable, strong blacks that have the correct consistency. It is worth experimenting with various types of ink so that you get an idea of what is available and which ink is the most suitable for you.

Chinese ink

The best ink is Chinese ink, which will not fade when exposed to strong sunlight. Although it can be bought in liquid form in bottles, solid sticks of ink which are ground in an ink slate (fig.6) produce the highest-quality ink. The sharpness of letter that can be achieved with Chinese ink sticks is infinitely superior to that produced by bottled inks.

Fill the deep end of the slate with enough water to make the quantity of liquid ink that you think you will need. The ink

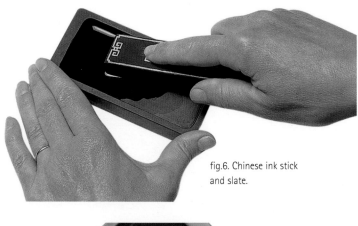

fig.6. Chinese ink stick and slate.

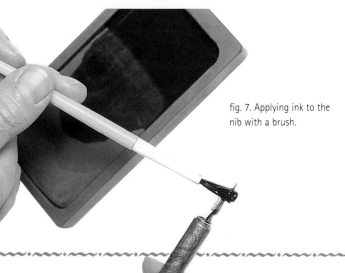

fig. 7. Applying ink to the nib with a brush.

must be freshly ground on the day that you intend to use it because it thickens and goes off if it is kept for too long. It is therefore usually only necessary to grind up a small amount at a time.

Grind the ink stick back and forth along the full length of the slate, taking the water with it until a very strong, black ink is produced. You will need to apply heavy pressure and will probably have to grind the stick for at least 15 minutes.

During the grinding process, keep testing the strength of the ink by painting a little on a sheet of paper to see if it is dark enough when it dries. When you are happy with the appearance of the ink, apply it to the pen with a small brush (fig.7).

Papers for calligraphy.

Paper

Good-quality cartridge paper is ideal when you start to practise calligraphy. It is worth buying a pad of A2-sized (596 x 422mm) paper from an art shop, because the practice lettering that you will begin with will be quite large, and you will therefore need to work on large sheets of paper if you are to fit a reasonable number of lines of lettering onto the page.

Avoid paper which is on the thin side, however, as it will crinkle up when the ink makes it wet. Some papers are also too shiny to take ink very well, and you will either find that your letters are not sharp enough or that the ink sits on the surface of the paper and takes too long to dry. Try to find cartridge paper of about 120gsm (grammes per square metre), which should have the right weight and surface quality for your lettering. (See Chapter 9 for different types of paper and a little more on their manufacture.)

Drawing boards

It is vital that you write on a sloping surface so that the pen meets the paper at the most advantageous angle. When you first take up calligraphy, you can make do with a board – perhaps a piece of fibreboard measuring about 60 by 90cm (2 by 3') from a DIY store – resting against a table and on your lap (fig.8). As you progress, however, you will find it more convenient to acquire a small drawing board, which you can set up at a fixed angle (fig.9). You can buy good drawing boards from well-equipped art shops, and some have a parallel rule attached that can save you a lot of time when ruling up sheets of paper (fig.10).

Fixing a few sheets of blotting paper to the surface of the drawing board is an important modification that will enable you to write on a slightly springy surface rather than a hard, flat one. Try to find large sheets of blotting paper that will cover a reasonably large area and fix two sheets to the board with masking tape (fig.11).

A guard sheet is the next requirement, and this should be as long as your board will allow, as you will need to move the paper underneath it from side to side as you work along each line of text. The positioning of the guard sheet is important: you should find the most comfortable position for writing at your board while also ensuring that your eye level is as shown in fig.12. Attach the guard sheet in such a way that the line of lettering that you will be working on appears at the correct level.

As you write, make sure that your hands always rest on the guard sheet and not on the paper that you are writing on. This is very important advice, as no matter how clean you believe your hands to be, they will always deposit small amounts of grease on the paper that they touch. This can have dire consequences for your work, because greasy paper will not absorb ink well and you will produce poor-quality letters if you write over any greasy patches.

fig.8. Drawing board resting on lap and table.

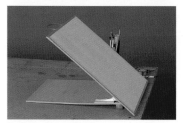

fig.9. Small portable drawing board.

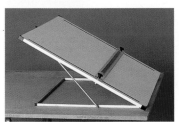

fig.10. Large drawing board with parallel rule.

fig.11. Add blotting paper to the board.

fig.12. Add guard sheet at correct level for writing height.

The calligraphic styles in this book

Having gathered all of the equipment and materials that you will need, you are ready to proceed. The lettering styles illustrated in this beginner's manual are adaptations of some of the historical examples detailed above that have been modified in the interests of clarity, consistency and ease of production. Together they constitute an interesting range of hands that are suitable for a wide variety of uses and occasions.

Foundation hand lettering 2

Foundation-hand lettering

When you write formal lettering, one of the first things that you have to consider is the

size of your nib in relation to the writing lines that you are going to use.

It is always best to start writing between top and bottom guidelines to enable

you to make straight, even lines of lettering. Some people like to dispense with

the guidelines after a short time, but using them is far more reliable, and it doesn't take

much time to draw up sets of pencilled guidelines that can be rubbed out later.

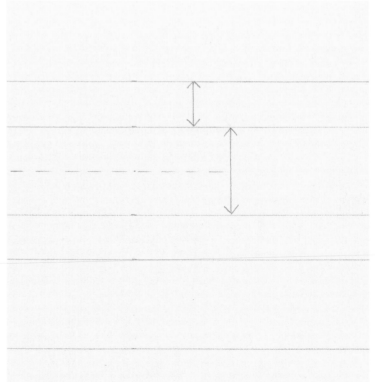

Ruling writing lines

Writing lines that are five times the width of the nib are appropriate for most lettering styles, and when you begin you should use a fairly large nib, such as the size 1½ William Mitchell nib, which is about 2.5mm (³⁄₃₂″) in width. You can determine the width of your writing lines by making a series of five small strokes, side by side, with your pen (fig.1), which will give you the correct width. You should then rule up a sheet of paper with sets of writing lines. Allow twice the width of the writing lines between each pair of lines to give enough space for the ascending and descending strokes (fig.2).

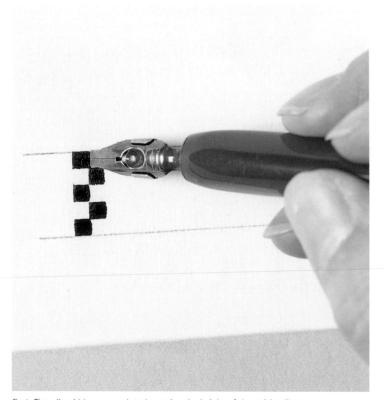

fig.1. Five nib widths are used to determine the height of the writing lines.

fig.2. Ruling up a page of writing lines.

Regulating the ink flow

Before tackling the foundation-hand alphabet shown in fig. 3, begin by gaining some experience in using your pen by drawing the various strokes that you can make with it. Dipping the whole nib into the ink tends to be rather messy and leaves a lot of surplus ink outside the space between the nib and reservoir, which is the part of the pen that actually delivers the ink to the edge of nib and thus transfers it to the page. Instead, fill the nib with ink by applying the ink with a small brush and drawing it across the opening between the reservoir and the nib so that the ink fills most of the gap. (see fig.7, page 19).

Start by making some diagonal lines following the direction of the pen (fig.4), so that the stroke is as broad as the width of the nib. Try to make the ink flow freely and evenly from the whole width of the nib, without leaving any gaps or making any scratches. If you have trouble getting the ink to flow from the pen, you may have positioned the reservoir against the nib too tightly, thereby preventing the ink from flowing through. Reservoirs vary slightly in their manufacture, and some can be a little tight. If you think that this could be the problem, bend back the tip of the reservoir slightly. The side wings can also be adjusted either outwards or inwards if the reservoir is too tight or too loose.

Another reason why the ink may not be coming out is that the reservoir tip is too far away from the end of the nib. Finally, you may have applied too little ink to the nib so that it is not reaching the writing edge. If you have the reverse problem – too much ink flowing from the pen – then you should either adjust the reservoir so that there is less of a gap between the reservoir and nib or else move the point of the reservoir a little further from the writing edge.

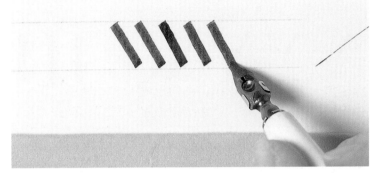

fig.4. Diagonal practice strokes.

fig.3. The foundation-hand alphabet.

abcdefghi

jklmnopqr

stuvwxyz

Experimenting with strokes

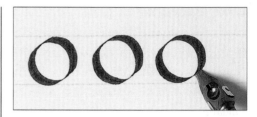

1 The angle at which you hold the pen should be about 30° to the paper.

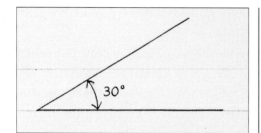

2 When the ink is running smoothly from the pen and your diagonal lines are even, with no jagged edges, try making a zigzag pattern. You are now making the thickest and thinnest lines that the pen can produce, and the nib should be moving from side to side for the thin strokes and in a straight line for the broad strokes. Note that if the correct, 30° angle is maintained, the thin stroke will always be longer than the broad stroke.

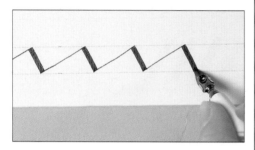

3 Next try some backward-sloping diagonals, which are slightly more difficult to produce. Try to reproduce the same angle and thickness of the strokes shown, as these are written with the pen held at the correct angle.

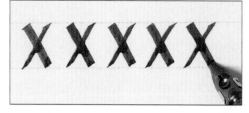

4 Keeping the pen at 30°, carefully make these strokes and then practise crosses, keeping both parts of the cross well-balanced.

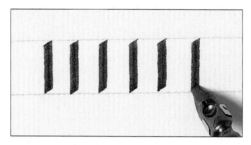

5 Now try some vertical lines taking care to keep the strokes as upright as possible. If one edge is jagged and the other smooth, you are probably applying too much pressure to one side. Adjust your grip and apply a little less pressure to the smooth edge and a little more to the jagged side, which should solve the problem.

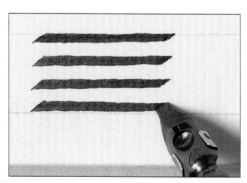

6 Practise some horizontals next. These are a little more difficult than vertical lines, as any error made along the length of the stroke tends to be more noticeable. As you gain experience in the use of your pen, however, any initial unevenness should soon disappear.

7 Curved strokes can give the novice calligrapher a lot of trouble. First, form a series of circles composed of two strokes as shown, trying to keep them as smooth and rounded as possible.

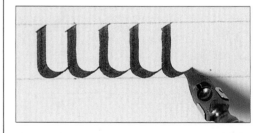

8 To start with, you could draw pencil guidelines and trace the pen around them so that you get used to the feel of the strokes when you are making them correctly. Make sure that the nib does not stray outside the pencil line.

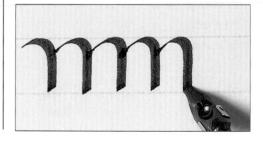

9 Next try strokes that are made up of a combination of round and straight lines.

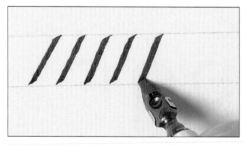

Foundation-hand lettering

1 When you are ready, move on to the alphabet, here shown with directional strokes added. This is a simple style called the foundation, or round, hand, because the letters are the foundation of most other styles and are all based on a round, 'o' shape. The 'o' determines the measurement that governs the width of the other letters.

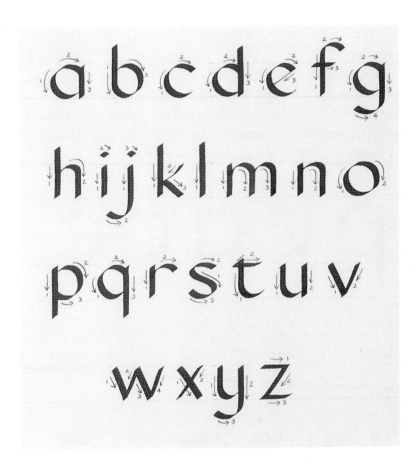

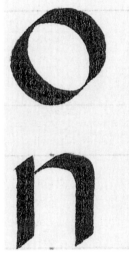

2 An 'n' is exactly the same width as the 'o', as are all of the other letters except for the 'i' and the 'l' (which are narrower because they are composed of only one stroke) and the 'm' and 'w' (which are in effect double versions of 'n' and 'v' respectively and are therefore twice the width).

3 The 'z' is the only letter for which your pen will have to make one of the strokes at a different angle. When making the central stroke of the 'z', turn the pen so that it is horizontal to the page. This produces a thicker stroke, which makes the letter look better than if it were written with the pen held at the normal angle throughout. Work through the letters, making the strokes in the directions shown, and then practise those that haven't worked out very well.

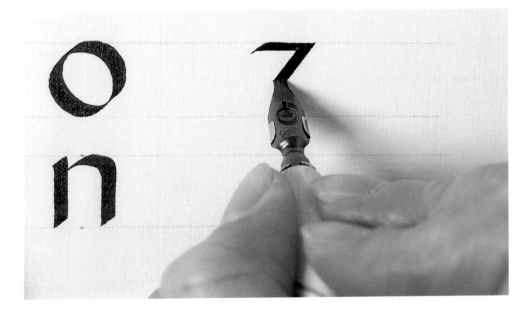

Correct spacing

Once you begin to write words, you will need to think about the spacing of the letters within them. Spacing takes time to master, but after a while you will automatically find yourself judging it correctly.

The basic requirement is that the letters look in balance with each other and that none are squashed-up, or too far apart. In fig.5 the letters are unevenly spaced and too far apart; the space between the letters is gradually widening and the letters do not look as though they all belong to the same word. In fig.6 the letters are much too close together, giving a cramped appearance which makes the text difficult to read. In Fig.7 the letters are correctly spaced, with as equal an amount of space as possible between each letter.

It is helpful to look on the letters as groups of three and to make sure that the central one of the three always looks as though it is exactly in the centre, and not nearer to either its left- or right-hand neighbour. In fig.8 the first two groups of three letters are not evenly spaced. The bottom example is correct.

fig.5. The spacing of the letters of this word is too far apart.

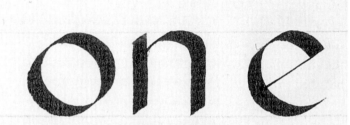

fig.6. The letters are this time too close together.

fig.7. The word correctly spaced.

fig.8. The first two groups of three letters are not evenly spaced, the bottom example is correct.

Words that are a combination of similar types, for example, those that consist of rounded letters only, such as those in the word 'code' (fig.9) or of straight letters only, such as in the word 'lilt' (fig.10) are much easier to space than those that contain a mixture. Words that combine both rounded and narrow letters such as 'millipede' (fig.11) are harder to balance. Here the letters are widely spaced at the beginning and closely spaced at the end.

Try to get into the habit of thinking about the space that you are leaving between each letter and always make it roughly equal. Two straight letters written side by side leave much less space between them than two rounded letters (fig.12) so they are moved further apart to give the appearance of an equal amount of space. With the less regular letters, such as 's', 'f', 'v' and 't', in which at least one side is neither completely straight nor curved, you will have to try to judge the amount of space needed to give the same effect that would be achieved with more regularly shaped letters.

The spacing between words should be about one letter's width (fig.13). If you leave too much space between words your page of lettering will appear to have too many gaps, or what are called 'rivers' of space, running down the page, in other words, the gaps between words will coincide with each other from one line to the next, forming large, blank areas on the page. By contrast, if too little space is left between words, some may look as though they are joined together.

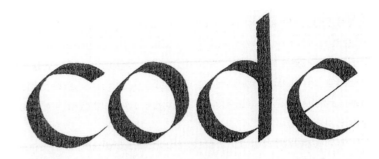

fig.9. A word composed mainly of rounded strokes will have the letters almost touching.

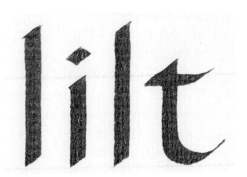

fig.10. A straight stroked word will have letters spaced well apart.

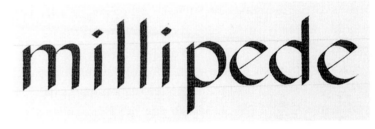

fig.11. A combination of straight and rounded strokes needs proper spacing to look correct.

fig.12. Rounded strokes are always much closer together than straight strokes.

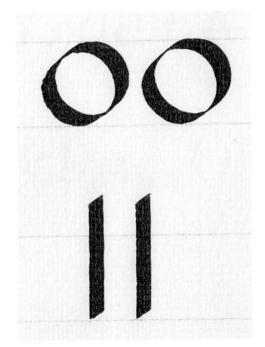

Golden slumbers kiss your eyes, Smiles awake you when you rise: sleep, pretty wantons, do not cry, and I will sing a lullaby. Rock them, rock them, lullaby.

fig.13. A gap the width of one letter is left between each word.

Practise all sorts of pieces of lettering, paying special attention to any letters that give you particular trouble or to the strokes that you find most difficult to produce. It is wise to spend a lot of time mastering the early learning stages rather than rushing into the more complex styles before you are ready.

Fig.14 shows the foundation-hand capital, or majuscule, letters. These are written with a letter height that is seven times the width of the nib (fig.15), so rule up a page of guidelines for these letters. After writing them in alphabetical order, practise writing groups of similarly shaped letters, such as the rounded letters 'C', 'D', 'G', 'O' and 'Q', moving on to letters that comprise vertical and horizontal strokes only, like 'E', 'F', 'H' and 'L', and then to those with diagonal strokes, such as 'T', 'K', 'V', 'W', 'X' and 'Y'. Varying the letter order like this will help you to become more familiar with the relationship of each letter to others in the alphabet.

Now write majuscule and minuscule letters together (fig.16). Although you can work on this practice piece using guidelines for the five- and seven-nib-width measurements to ensure that you make the capitals the correct height, you would normally only use the height required for the minuscule letters, and would judge the capitals by eye.

In order to write a piece of lettering containing the correct grammar, you will need to insert punctuation marks (fig.17), and numerals (fig.18). Although the brackets, exclamation mark and question mark are all drawn at capital-letter height, the colon and semi-colon look best when they are written with their top marks just below the top minuscule writing line. An ampersand is shown in fig.19.

fig.14. The foundation-hand capital letters with directional strokes.

fig.15. The capital letter height is seven times the width of the nib.

fig.16. Practise the majuscules and minuscules side by side.

fig.18. Numerals.

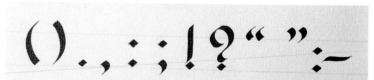

fig. 17. Punctuation marks.

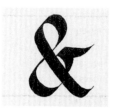

fig. 19. An ampersand.

Adding serifs

The plain letters of the foundation hand are improved and linked with small strokes known as serifs. The various types of serif are constructed as shown in fig.20. The full serifed alphabet is shown in fig.21, and the serifed capital letters are shown in fig.22.

The serif at the top of ascending strokes and at the beginning of most of the capital letters starts with a thin stroke drawn from right to left and then traces an arching curve back to the right again. Now make the upright stroke so that it falls in line with the curving stroke. Do not make the first two strokes too long, or you will leave a small gap in the centre of the three strokes and the serif will be too large. These two strokes really only need to be the equivalent of one nib width to produce the correct-sized serif.

The serifs at the foot of the 'f', 'p' and 'q', as well as many of the feet of the capital letters, are made by taking the pen to the left, just short of the point at which the letter will finish, and then making a horizontal stroke that cuts across the upright without leaving a gap. The other serifs are less complicated, being just a slight curve at the beginning or end of a stroke.

fig.21. The foundation-hand alphabet with serifs.

fig.20. Types of serif: the first three examples are simple curves completing some of the upright strokes; the following two are composed of two strokes, as shown underneath – a narrow stroke to the left and then the broad stroke completing the serif; the remaining example is a diagonal stroke which finishes with a smooth curve.

fig.22. Serifed foundation-hand capitals.

The 'm' is a good example of a letter that needs a mixture of slightly different serifs in order to make it look well balanced. The first serif at the beginning of the first vertical is a smaller curve than those that will make up the next two strokes. At the feet of the first and second verticals are small serifs that turn slightly towards the right. The final serif can be a little more pronounced. If this larger serif were used for the first two strokes, it would fill too much of the gap between the vertical strokes and would mar the legibility of the letter.

The cross strokes of the 'f', 't' and 'z' can just be given a slight turn at either end to add a smooth flow to the letter and to take away the hard, plain look of the unserifed stroke.

It is not necessary – and, indeed, is sometimes even a mistake – to try to join up the letters with too many serifs. Serifs should be simple adornments that give a more pleasing appearance to the text and do not detract from its clarity and legibility. Overdone serifs can really spoil the look of the lettering (fig.23) and can also make it difficult to read. The 'r' is the letter that is mistreated more than any other in this way (fig.24), and when forming it try not to give the foot of the downstroke more than a slight turn, or it will end up looking more like a badly formed 'c'.

When changing to different lettering sizes, remember to make your writing lines five times the width of the nib. Avoid sizes below the William Mitchell No 3 nib, which is about 1.25mm (³⁄₃₂") in width, at this stage, because smaller lettering is more difficult. Although it can hide errors, it is better to learn to form the letters correctly from the outset. Fig.25 illustrates writing lines for lettering drawn with a size 3 and a size 2 Mitchell nib.

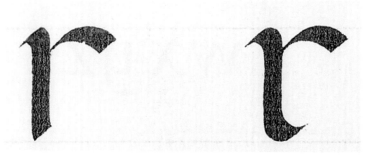

fig.23. The foot of the 'r' is frequently given too large a curve. The correct 'r' is on the left.

fig.24. Here the correctly written word is shown above.

fig.25. Writing lines for nib sizes 2 and 3.

Pen patterns

Pen patterns are not only good fun to produce, but can also be extremely useful for embellishing small calligraphy projects.

There is no end to the attractive patterns that you can make, and fig.26 shows a selection. Practise reproducing them.

fig. 26.
Pen patterns.

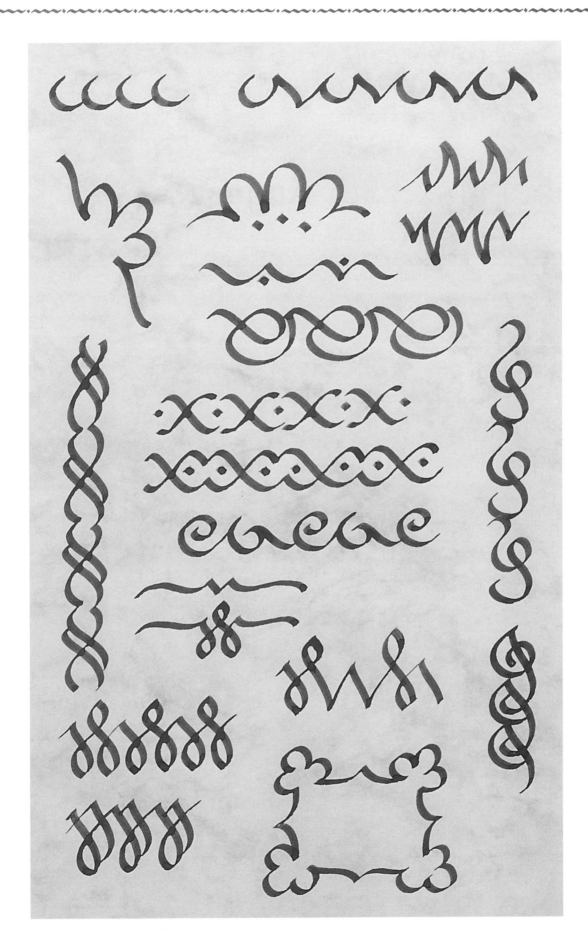

PROJECT *Making simple labels*

In order to practise and make use of what you have learned so far, you could use the foundation hand to make a few labels for home produce.

Raspberry

1 On your chosen paper, write the main words that will be contained on the label in a large lettering size. Leave plenty of space around the words so that you can trim the label to size.

25th August

2 Write the secondary information in a smaller size on a separate practice sheet. Measure the amount of space that the text takes up and mark this length on the label under the first line.

Raspberry Jam

3 Rule the writing lines for the smaller lettering and mark the width so that it will be centralised beneath the main lettering.

Raspberry Jam

25th August 2000

4 Write the secondary information within the marked space, making sure it is centred below the first line.

5 Draw a pen pattern around the edge as a little embellishment.

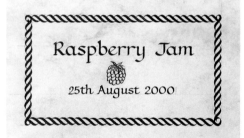

6 You could also add a small line drawing to decorate the label further.

7 Calligraphic line drawings are easy to do: first make a pencil sketch of your subject and then work out the direction of the strokes that will be needed to form a nicely shaped picture. When you have found the best way in which to create the picture, repeat the process on the label.

8 Any fruit shape can be pen drawn with a little care.

As an alternative to the horizontally laid out label above, you can follow the same basic steps to create a vertical, or portrait style label, as shown here.

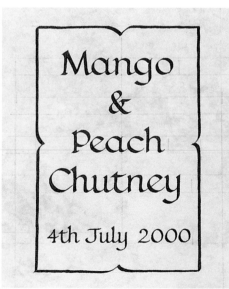

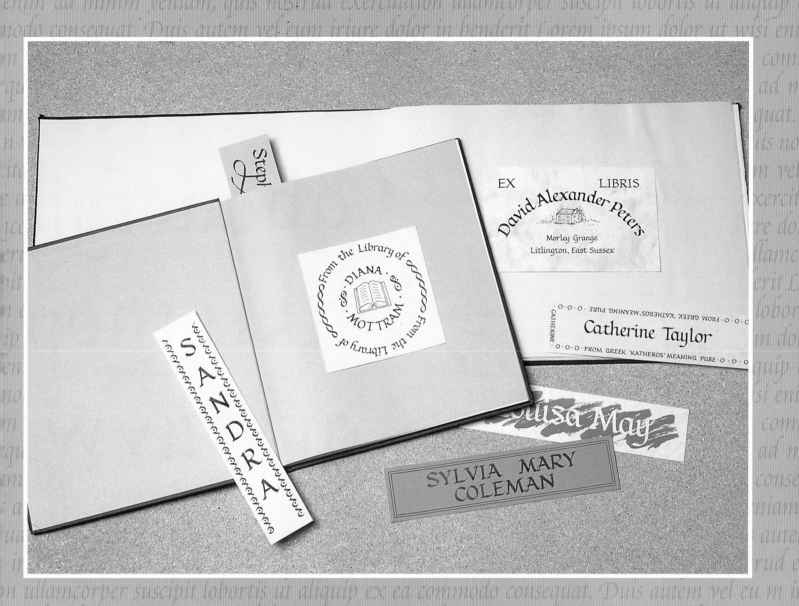

Compressed
foundation 3
hand

Compressed foundation hand

The foundation-hand alphabet takes up a great deal of space because all of the letters are quite wide. A more practical width of lettering is achieved by compressing the whole alphabet by the same amount, so that each letter is based on an oval rather than a circle.

In the compressed foundation-hand alphabet (fig.1), the strokes forming each letter are produced in exactly the same way as those for the ordinary foundation hand, and the pen angle remains the same, but the width of the letters are reduced so that they all conform to the oval 'O' (fig.2). The 'e' is the only exception, whose second stroke becomes rounded.

A few of the letters have alternative versions, (fig.3), which can add more character. The 'a' and 'g' are based on letters that were used in the alphabets of the early Middle Ages. They can be useful to vary the similarity of some combinations of letters, to add interest to the writing and also to make it easier to read. Take, for example the word 'glade'. In fig.4, it has been written in compressed foundation hand based on the original letters used for the uncompressed foundation hand. The same word is shown in fig.5 using some of the alternative letters, which gives it a little more variety.

abcdefgh
ijklmnop
qrstuvw
xyz

fig.1. Compressed foundation-hand minuscules.

o o

fig.2. Oval 'O' and round 'o' to demonstrate compression.

a g y
v w
x ʒ

fig.3. Alternate versions of some minuscule letters.

glade

fig.4. A word written in normal foundation-hand letters.

glade

fig.5. The word again using some of the alternate letter forms.

The curved versions of the 'v' and 'w' are also useful variants. The alternative version of the 'z' may be a rather unusually shaped letter, but it removes the necessity for a letter formed with a pen angle that is different to that used for all of the other letters. Some people prefer the diagonally stroked 'y' to the other version. The curved 'x' is more suited to some work than the diagonally constructed version. Ultimately, however, it is you who has the choice as to which letters you use in particular places. It is worth learning all of the different versions because they will come in useful from time to time.

fig.6. Where two cross strokes meet the letters can be joined together.

Compressed foundation-hand serifs

The serifs on these letters are the same as for the foundation-hand alphabet, but, because the amount of space between each letter is smaller, remember that it is even more important that they are not overdone. Letters with a curving, final stroke can be linked together easily. If two cross-strokes come side by side, they can be joined as shown in fig.6.

There are two types of serif that may embellish compressed foundation-hand capital letters. The first set of letters (fig.7) is written with the wedge-shaped serifs that we used for the normal, non-compressed version of the foundation hand (see Chapter 2). The second set of letters (fig.8) is written with straight, or flag, serifs. These give a stronger and neater impression to the letters and are useful for headings where a bold, clear effect is required, whereas a heading written with letters using the wedge-shaped serifs (fig.9) has a little more style.

ABCDEF
GHIJKL
MNOPQ
RSTUVW
XYZ

fig.7. Compressed foundation-hand capitals with wedge serifs.

ABCDEF
GHIJKL
MNOPQ
RSTUV
WXYZ

fig.8. Straight serifs are added to this alphabet of compressed foundation-hand capitals.

Working with different lettering sizes

We will now concentrate on the use of different lettering sizes, because it is important to combine them with care. As was described in Chapter 2, foundation-hand lettering should be five times the width of the nib. The chart (fig.10) illustrates the nib widths for most of the William Mitchell nib sizes. As you reduce the size of the nib, a greater degree of precision is needed when drawing your writing lines. Although a small inaccuracy will not be very noticeable when the writing lines are 13mm (½") apart, lines for a size 6 nib that are only 2.5mm (⅛") apart need to be drawn as accurately as possible. A tiny discrepancy of even a quarter of a millimetre will make quite a difference to the lettering and could make the text look very uneven over three or four lines (fig.11). Some of the smaller nibs are not very accurately made, and there is also so little difference between a size 5, 5½ and 6 nib that you will often find, for example, that a nib stamped as a 6 will be wider than a 5. In order to avoid any mistakes, it is always best to make a few sample strokes and to write a few words with the nib that you intend to use and then to check the width for the distance apart of the writing lines before you start.

fig.9. A heading written first with wedge serifs then with straight serifs to show the different character each style gives to the text.

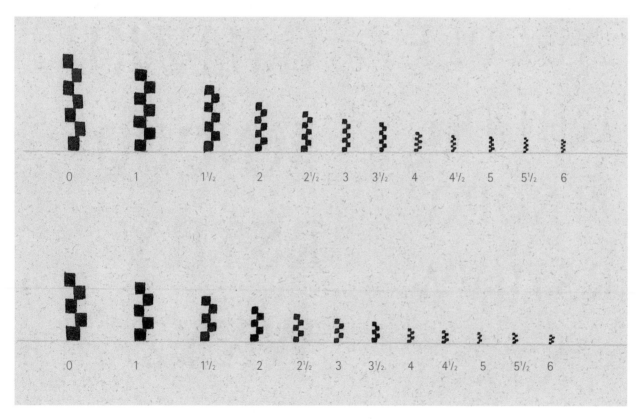

fig.11. Above: Writing lines for the small nib sizes must be drawn very accurately as tiny measurement discrepancies, as shown here, can make quite a difference to the lettering size.

fig.10. A chart showing sets of nib widths of all the William Mitchell nib sizes from 0 to 6.

PROJECT *Making a bookplate*

When designing a bookplate, remember that the text will look more attractive if it is written in several different sizes.

Choose a combination of nibs, with at least one nib size between them, such as sizes 1½ and 3 (Step 1). Alternatively, try sizes 3 and 4 (Step 2). If you use sizes that are next to each other in the numbering sequence, the difference will not always be great enough to be really noticeable (Step 3) and sometimes, particularly when using the smaller sizes, the text will just look like inaccurately written lettering. For our bookplate project the name will be written with a size 2 nib (Step 4), 'This book belongs to' will be written with a size 3 and we will use a size 5 nib for the address.

Now work out the arrangement of the words that will give the best shape to the whole piece of lettering (Step 5). The easiest way in which to do this is to write out all of the words in their respective lettering sizes and then to cut them out and to paste them on a sheet of layout paper in their intended positions. All of the lettering will be centred on this bookplate, so first draw a vertical line down the centre of the layout sheet. Then measure and position the cut-out letters centrally down this line.

Step 3. Sizes that are too close together will not show enough difference.

Step 1. Experimenting with nib sizes 1¹/₂ and 3.

Step 2. Experimenting with sizes 3 and 4.

Step 4. Choosing the final sizes.

Making a bookplate (continued)

By looking at this draft version (Step 5), you will see whether the combination of lettering sizes that you have chosen looks right. If you are not sure that it does, try writing some of the words in a different size to see if the balance of the words and the spacing between the lines looks better. Try different combinations of lettering sizes and distances between the lines of text until you find a set of sizes that looks just right. It is well worth taking the trouble to try several sizes, as it is surprising how often you think that the original sizes work quite well together, only to find that altering them slightly produces a much better effect.

For projects such as this, it is not necessary to stick to the writing-line-height formula of twice the letter height between each line of text, which is only necessary for straightforward blocks of lettering that do not involve many small sets of words in different sizes. The size of the bookplate can either be determined by the lettering sizes that you have chosen or you can otherwise work to a specific size and make the lettering fit

into it. The bookplate that we will be working on measures 16 x 12cm (6.3 x 4.7"), so the centred arrangement and the sizes of lettering illustrated in step 6 will fit this nicely.

The bookplate can be decorated with a few ornamental flourishes, which you should design in rough and then add to the draft version to make sure that they will all fit properly. The final cut-and-pasted draft is shown in Step 7.

Choose a suitable paper for the bookplate and carefully rule up the guidelines for the writing as accurately as possible. A very sharp HB or F pencil is best for this, as the lines can be rubbed off easily after the text has been written. Do not press too heavily, or you will leave scored impressions of the lines on the paper, even after they have been rubbed out.

Measure and mark the width of each word on the paper so that you can see exactly where you need to start and finish writing each line of lettering. Put in markers, too, to help you to place the pen patterns around the outside correctly.

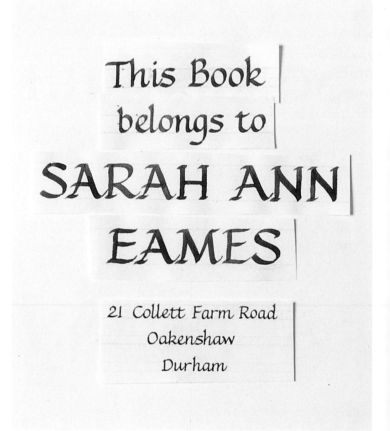

Step 5. Arranging the words to give the best shape to the bookplate.

Step 6. The complete text in position in the chosen lettering sizes.

Write the text from the top to the bottom of the paper, so that your hand is never working over wet lettering (Step 8). Alternatively, if you are writing a larger piece where the lettering on several different areas of the page is of the same size, it can save time to write all the words of the same size at the same time, but, if you do this, make sure that the ink is completely dry before working on text above words that you have already written. It is easy to be careless when you are ready to start writing the next lettering size and to forget that there may still be wet patches of ink. Serifs and areas of letters where several strokes meet can build up a large amount of ink, which can take quite a while longer to dry than the rest of the lettering.

When you are writing between markers, remember that your lettering will be slightly different from day to day and that a sentence which takes up 10cm (4") when written on one day may take up much less, or more, space on another, when you may be writing with either more tension or more freedom, depending on your mood. You will also usually find that the first few lines of lettering that you write when you start working will be much more cramped than those written as you are gradually loosening up and writing with more ease and freedom. It is therefore a good idea to warm up with a few practice sentences before working on any text where the spacing is critical.

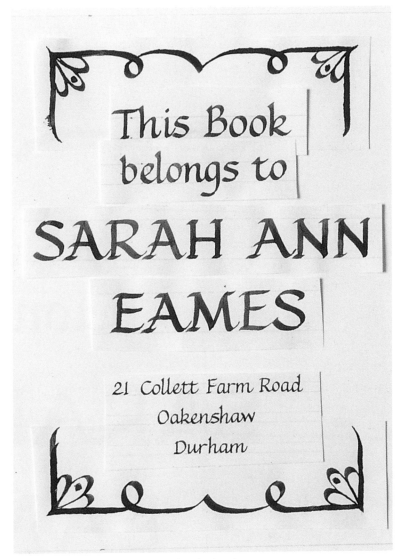

Step 7. A border design is added to complete the draught.

By looking at your draft, you will see exactly where each line of lettering should start and finish, and, with a little care, you will be able to make sure that the words fall correctly into place. It may be tempting to pencil in all of the words lightly and then to write over the top of them, but this is not a good idea, as you could find yourself trying to make the letters fit the pencil marks and forget about forming them as well as possible. Pencilling in words can sometimes be helpful in certain places – especially for the title when you are working on an important document – in order to make sure that you are fitting the words in correctly, but if you get into the habit of doing this your writing style will become too rigid and unspontaneous. If you have trouble fitting words into measured spaces, it is more

Step 8. Write the text from top to bottom.

helpful to remove the text of the draft line by line as you write and to place it above the area that you are about to write on. If you have used masking tape to keep the draft lettering in place, it should not mark the paper and can be pulled off easily. Write the words while checking that you are keeping more or less to the spacing on the draft.

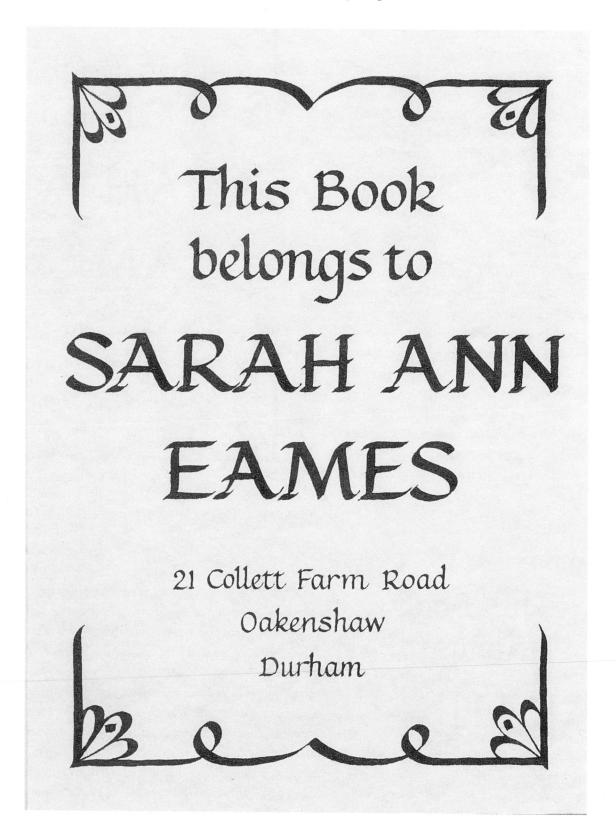

PROJECT *Bookplates with curved lettering*

The first bookplate design that we worked on had a very simple, centred layout. When you want to create something a little different, however, try working on a set of alternative layouts to see if you can find a more interesting arrangement.

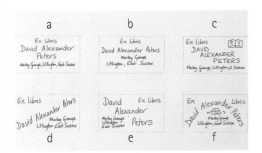

1 Here are a series of sketched layout ideas for another bookplate, this time one that is landscape in format rather than portrait (the width is greater than the height). The design will incorporate a small line-drawing illustration of a house, which you could trace from a photograph if necessary. The chosen layout (f) has curved lettering, which is quite easy to write.

2 Use compasses to rule the writing lines. Provided that the curve is not too tight, writing around it presents few problems when using a simple lettering style like this one.

3 Practise writing curved lettering. If the curve is quite tight, you will have to make the letters slightly wider on their outer edges and slightly more compressed on the inner edges. For a project such as this, however, the curve of the letters should be fairly shallow, causing very little distortion to the letters.

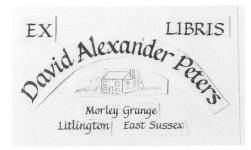

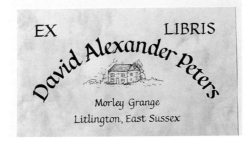

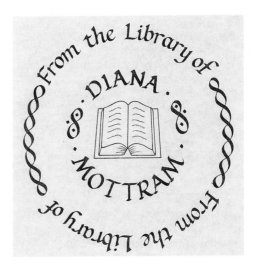

4 You will probably need to extend the central measuring line on your draft below the area of the bookplate in order to centralise the curve at the correct point below the paper to give the degree of curve needed for the lettering. When you come to write the actual text, if your paper is not large enough for the compass point to be positioned on it, stick it to a larger sheet and carry down the guideline on to it. The compass point can then be positioned on this

extra sheet to make your guidelines accurately, with the added advantage that no pinhole will be left on the bookplate.
A full-circle design is also illustrated, with filler patterns drawn on either side of the words to fill the spaces. The central writing line on this piece curves quite tightly, so that the capital letters have had to be carefully written to fit between the writing lines correctly. The overall effect is satisfactory, however, and the design works well.

PROJECT *Making bookmarks*

Bookmarks are another simple way of using calligraphy. They are fairly straightforward to produce. The writing lines need to be carefully positioned for the various lettering sizes.

Simple horizontal bookmark

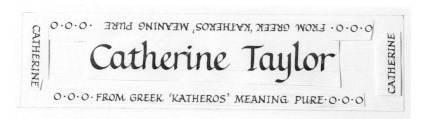

1 The small lettering around the outside of the design is quite close to the edge of the card. Because it can be difficult to write to the edges of small pieces of card – they tend to move easily and will not always lie completely flat – write this piece of lettering on a larger sheet of card on which the outside edges of the bookplate have been marked and then cut the card to size when the text is finished.

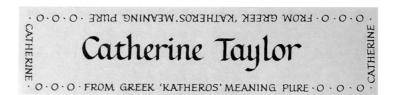

2 This shows the completed bookmark.

Right: This shows a simple vertical bookmark with pen pattern borders.

Bookmark with curved lettering between parallel lines

2 Then measure out the line height at small intervals along its length. Next, join these intervals to give as smooth a curve as possible at the correct distance to the first.

1 Here curved lettering is written between writing lines that have been carefully measured. Make the first line in any shape.

3 Add flourishes to the ascender and descender strokes to fill the remaining space.

Bookmark with non-parallel lines

1 Right: This bookmark uses writing lines that are not parallel to each other, which gives a different effect. You will need to spend time working on the draft in order to achieve writing lines that run smoothly and make attractively spaced words.

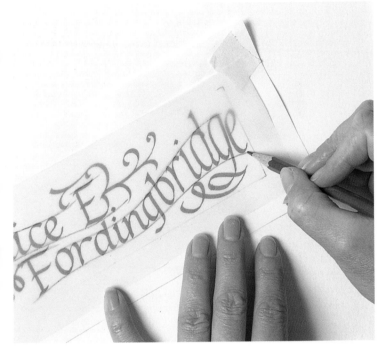

2 Trace the writing lines and transfer them to the card.

3 Right: Work through the lettering then add the flourishes at the end.

Using a ruling pen

Ruling pens and compasses are useful for all sorts of purposes in calligraphy, and can be used to create some outer decoration.

Ruling pens and compasses are used in many ways.

Using a paintbrush, apply ink or paint to the gap between the two ends of the pen. Experiment on a scrap piece of paper until you have become accustomed to putting the correct amount of ink into the pen.

Draw the pen along the edge of a bevelled rule (fig.12), making sure that the ink does not come into contact with the rule itself. If it does, it will smudge when you remove the rule. Remember, too, that if you overload the pen with ink, the ink will gush out and make a large blob, while too little ink will result either in patchy lines or in no ink reaching the points.

The pen can be adjusted to draw a thick or thin line, but take care not to make the line too thick, or you will increase the risk of producing a blob of ink on the page. Ruling compasses, which work in exactly the same way, enable you to draw perfect circles with ease.

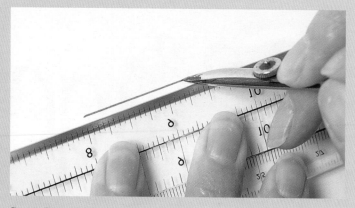

fig.12. The ruling pen is drawn along the bevelled edge of a rule to prevent the paint touching the rule.

Bookmark using masking fluid

1 Layout for a bookmark using masking fluid. Use it in a pen, just like ordinary ink – it flows quite well and can make good letters. Small nib sizes are best avoided, however, as the letters will not be very accurate.

2 Write the letters with masking fluid using a large nib, paint over any areas which are too thin with a small brush to give a thick covering.

Bookmark with ruled border

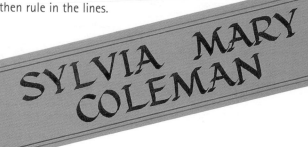

1 Layout for a bookmark with a ruled border.

2 Right Opposite: Write the lettering then rule in the lines.

3 Paint a colour wash of gouache over the letters with a large
brush.

4 When you are sure the paint is completely dry, remove the
masking fluid with a rubber.

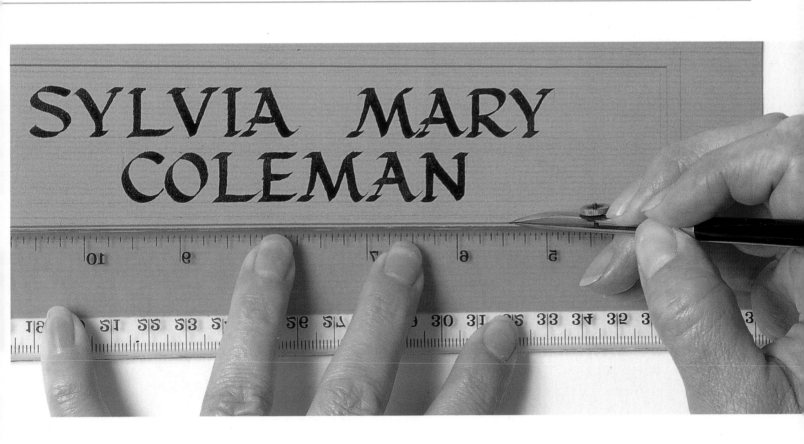

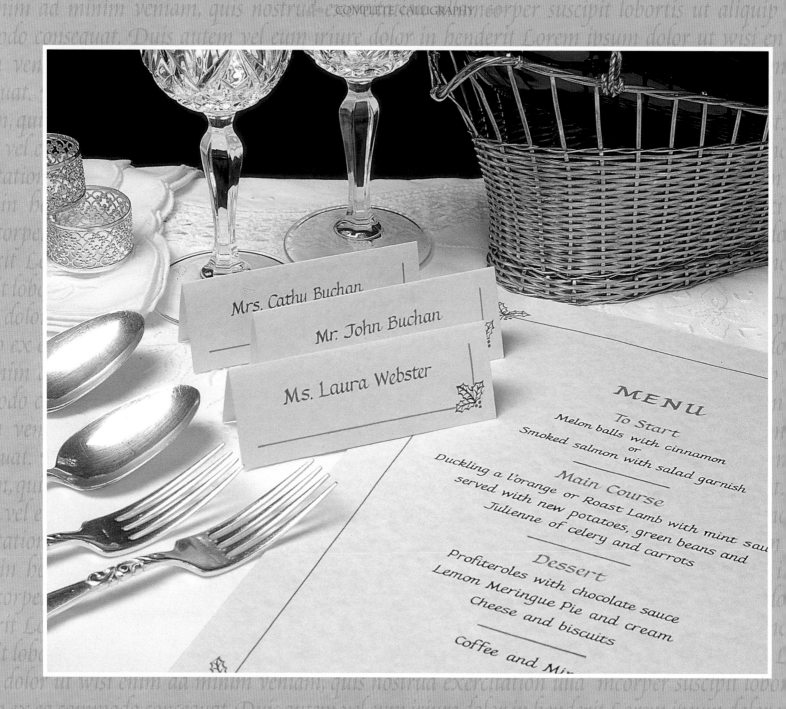

Italic lettering 4

Italic lettering

We will now move on to italic lettering, which is basically the same as the compressed foundation hand, but with a slope to the letters of about 10° from the vertical as illustrated in fig.1.

When writing in the italic hand, the most important thing is to keep a constant degree of slope throughout the piece of lettering, as words written at different angles look very untidy. As with the previous two alphabets that we worked on, keep the pen at an angle of 30° to the writing lines. If you have difficulty keeping the letters at the same forward angle of slope throughout your lettering, draw in a few diagonal guidelines at intervals across the page to help you, until you have become used to the correct angle. The letters are formed as shown in fig.2.

This alphabet is a formal italic, which is more regular and rounded than the sharper, and more angular, cursive italic (which will be the subject of the next chapter). The rounded 'a', 'e', 'g' and 'y' are shown here, but the alternative versions used with the compressed foundation hand can also be used with italic.

Working with colour

You may need a selection of different colours when you are planning and writing a piece of lettering, such as a menu. Writing with coloured inks can be different from using black ink because the colours are usually of varying consistencies. There are a great many bottled coloured inks on the market, and many are sold as calligraphy ink. As with black ink, the quality varies enormously, but most are generally rather thin and transparent and flow too quickly from the nib for fine letters to be produced satisfactorily. It is nevertheless worth experimenting with types of coloured ink, and if you are satisfied that you can produce similar results to black lettering, the ink should be of good quality.

It is also easy to write with paint. Gouache is a water-based paint that works very well when used in a pen. It comes in small tubes in a vast range of colours and should be mixed with water in a small palette or suitable container (fig.3).

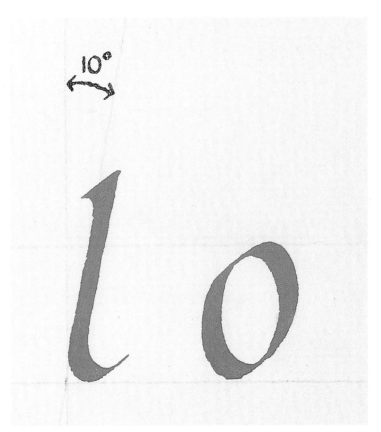

fig.1. Italic letters are written with a slope about 10° from vertical.

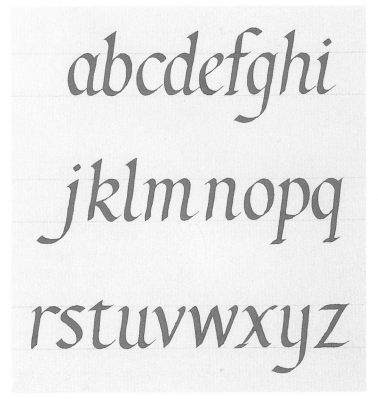

fig.2. Formal italic alphabet.

fig.3. Gouache paints, mixing palette and mixing brush.

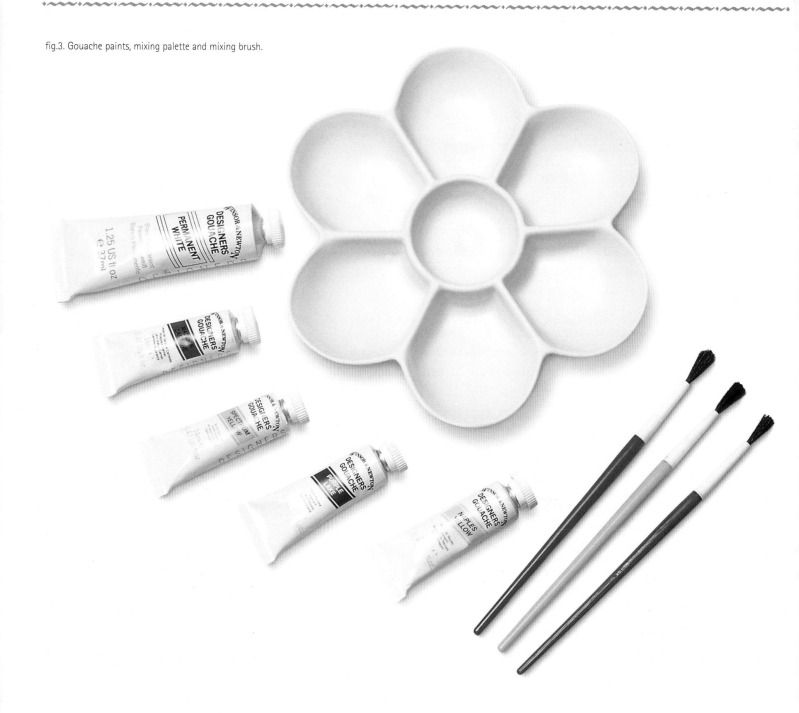

The consistency required for calligraphy is like very thin cream. The paint should be a good, opaque colour, but not too thick to clog the pen. When writing in several different colours, you will find that they vary slightly in consistency. Some colours are quite grainy – the browns tend to be like this – while greens can be difficult to make opaque without the use of a slightly thicker consistency than is required for most other colours. Always practise a few words in any newly mixed colour before working on your final piece of lettering to make sure that the consistency is correct. When working with paint, it is a good idea occasionally to rinse and wipe the nib to make sure that the paint hasn't dried under the reservoir or on the outside edge.

The range of gouache colours is large, because when different gouache colours are mixed together they lose some of their brilliance. You should therefore avoid mixing two or more colours together and instead choose a single colour from the range. All colours have their advantages and disadvantages, so your choice will usually be a compromise when selecting the best one for your work. Some of the most useful colours are listed.

Gouache paint

Scarlet lake is the best red by far: it is a lovely, strong, bright colour, and when it is mixed with water its opacity and consistency are very good. Because it tends to smudge when you are rubbing out any writing lines across which it has been written, when mixing it with water it is a good idea to add a drop or two of gum arabic to make sure that the paint remains firmly attached to the page.

Ultramarine is a strong, bright blue. Although its colour is extremely vibrant when it is used straight from the tube, it tends to be a little transparent when mixed to the correct consistency. If this happens, add a little permanent white to give it greater opacity.

Spectrum yellow is a bright, deep yellow, whose strength should be sufficient if you are writing on a pale-coloured surface. If necessary, you could add white to it to make it more opaque, but if you do so try to use as little as possible, because white has a heavier consistency than most other colours and the paint will not flow smoothly from your pen if you use too much. (Writing with white paint is not recommended.)

Permanent green middle is a good, medium-coloured green (there are also dark and light versions of this colour). Although greens are inclined to fade when they are exposed to sunlight, this colour lasts better than most of the others. It tends to be transparent when it is mixed to the correct consistency, in which case you could add a little white to it, but remember to be sparing with the white, because the paler the shade of green the more prone to fading it becomes.

Burnt Umber is a soft, donkey-brown colour. It is quite dark when used straight from the tube and therefore usually needs a little white added to it. Because this is another colour that tends to fade quickly, however, keep the shade as deep as possible when mixing.

Purple lake is an attractive colour to choose when you need a purple colour – Parma Violet is another good choice. Of the two, purple lake – a reddish-purple colour – does not fade in the light as quickly, whereas Parma violet, which is on the blue side of the colour spectrum, is more opaque.

Rose Tyrien is a shocking-pink colour that you may find useful on occasions.

fig.4. Coloured Chinese ink sticks.

Chinese ink sticks are also available in various colours (fig.4), although these are not as widely available as bottled inks and gouache paints. Grind coloured ink sticks with water in an ink slate (fig.5) in the same way as black ink sticks until you have obtained the correct consistency and depth of colour.

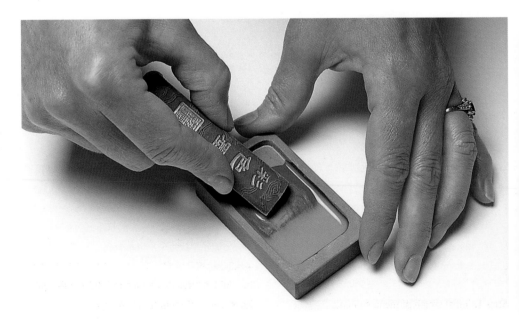

fig.5. Coloured ink sticks are ground on an ink slate in the same way as a black ink stick.

PROJECT Making a menu and place cards

The menu should be no larger than A4 (298 x 211mm) size, which is a standard paper size from which printed copies can easily be made. You will need three different sizes of nib: one for the title, one for the name of each course and one for the details of the food.

When designing the menu, begin by roughly drawing out the wording in the order and general shape in which you intend it to appear (Step 1). This will give you an idea of the spacing required for the quantity of lettering to be included.

Work out if your chosen sizes will fit the overall dimensions that you have decided upon for the menu. If you are using a size 4 nib for the body of the text, the line height will be 4mm ($^5/_{32}$"), with 8mm ($^{11}/_{32}$") between each set of writing lines. Determine if this will enable you to fit all of your text into the size of paper that you intend to use by measuring out the writing lines down the length of the draft sheet. You will find that a size 4 nib will produce lettering that takes up too much space to fit the required menu size comfortably. You should therefore try a size 5 nib for the small-sized lettering.

Enough of a margin needs to be left around the edges to make a reasonable border, as well as for the holly-leaf decoration in the corners (Step 2). Using the line-height guide (which was explained in the previous chapter), try to guess the nib sizes that may be suitable for the other two sizes of lettering that you will be using.

Start by working on the smallest lettering and write out one of the sections in rough to see how it will look (Step 3).

Now work out which size will be best for the course headings (Step 4). The first lettering is too large, so use the smaller size (Step 5). Make a draft of all of the lettering for the courses to check that everything will fit on your paper.

Work out the lettering size for the title (Step 6). It is worth writing the title in several sizes and then cutting them out and trying each in turn. Now add a border (Step 7).

Once you have decided on and drafted all of the lettering to size, rule up your paper or card with the writing lines. Some very attractive papers are available in large sheets or pads of different colours, and a selection is shown in Step

Step 1. Initial sketch of menu contents.

Step 2. To ascertain whether your chosen nib sizes will fit the page mark off the writing lines down the length of a sheet. The column of marks to the left allow for a size 4 nib for the small text but this leaves too little room for the border. The column to the right is measured for a size 5 nib and this will leave plenty of room for the border.

Step 3. Write out and position the small text roughly into place on the layout sheet.

Main Course

Main Course

Step 4. Two sizes of course heading are experimented with.

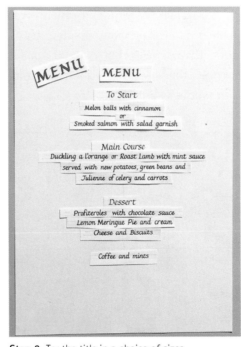

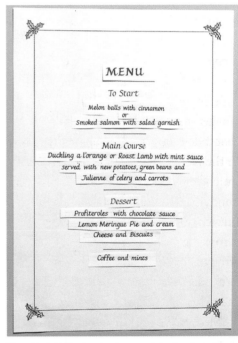

Step 5. The chosen size positioned on the draught.

Step 6. Try the title in a choice of sizes.

Step 7. Add the border to complete the draught.

Step 8. A selection of papers and cards: Constellation Pearl card in satin and shantung patterns; Conqueror laid card in green, pink and blue; Parchmarque paper in white and four colours; Canford card, three colours from an extensive range: Ingres pastel paper in a pad of three colours.

Making a menu and place cards (continued)

8. If you want a really special paper, you could go to a specialist paper shop that has sample books for you to look through and choose from the hundreds of colours, textures and weights of paper available. (For more on paper and card, see Chapter 9).

An attractive, fairly thick, but lightly textured, paper has been chosen for the menu (Step 9). In the close-up photograph (Step 10) you can see the grain of the paper, which is quite pronounced. If you choose a paper with a characteristic like this, make sure that you buy some extra sheets for experimenting on. When using a smaller-sized nib in particular, take care that it does not catch on any raised fibres in the paper. Most papers do not present much of a problem, but it is very annoying if you catch your nib on an uneven area and send a spattering of ink across the paper. Although errors can be removed from most good-quality papers (see page 86–89), prevention is better than cure.

Measure and rule your guidelines and marking points onto your chosen paper. Now you are ready to write your menu card (Step 11).

Write the title in scarlet lake gouache, a lovely, bright red that will really enliven your work.

Permanent green middle gouache will be used for the course headings, so make sure that you have mixed it to the correct consistency so that the writing will not be transparent. Using a guard sheet, write in all of the course headings, taking care that you don't touch the writing surface with your hands.

Add the smaller details in black ink.

Step 9. The chosen paper is cream coloured Parchmarque card, the surface is quite textured but smooth enough for lettering.

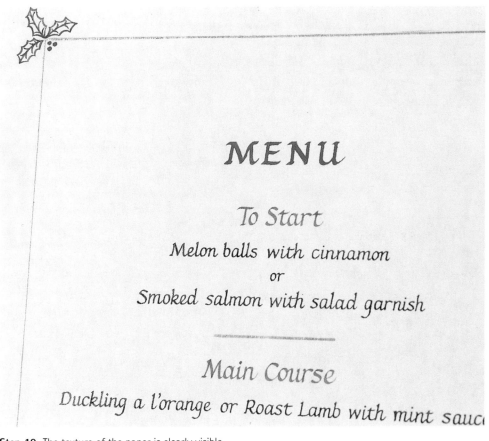

MENU

To Start
Melon balls with cinnamon
or
Smoked salmon with salad garnish

Main Course
Duckling a l'orange or Roast Lamb with mint sauc

Step 10. The texture of the paper is clearly visible.

Gold paint gives a very good effect for details, and a little has been used in the corner decoration and lines between the courses. Winsor and Newton manufacture a gold-coloured gouache, with a rich gold colour similar to real gold. It needs to have quite a thick consistency when it is applied in order to cover the paper well without looking patchy. There are other good gold-substitute paints available, too, such as that produced by Pelikan, but these can be quite difficult to find.

When you have finished, carefully rub out the writing lines, taking extra care around the red lettering if you have used gouache. Use a very soft rubber so that it does not mark the paper.

A matching place card can also be designed. These are very simple to produce. First, write a draft set of the guests' names to help you to measure and correctly center each name on its card. Then add a small holly-leaf decoration. Finally, draw in a border with a ruling pen to echo the menu's design.

Step 11. Writing your menu.

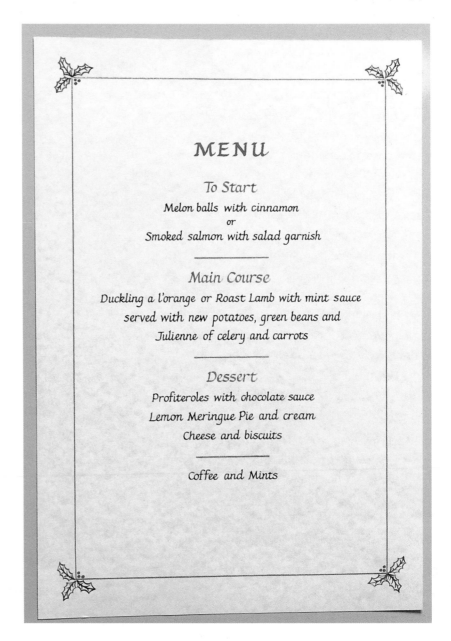

PROJECT *Designing a certificate*

1 Cut-and-paste draft lettering to determine the arrangement of the landscape layout.

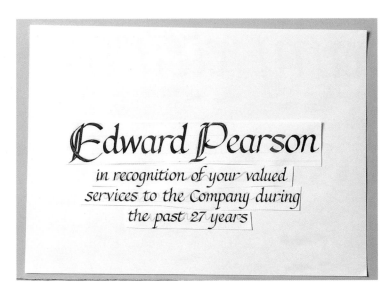

2 Begin the draught with the main title then centralise the smaller text below.

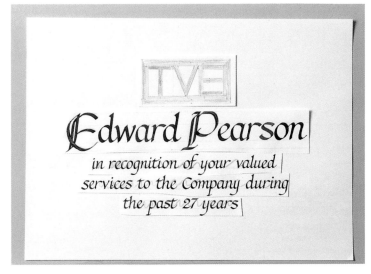

3 Adjustments can be made to the lettering sizes to determine the best combination. Next, the logo, dates and 'To' are arranged in positions that give the best overall balance.

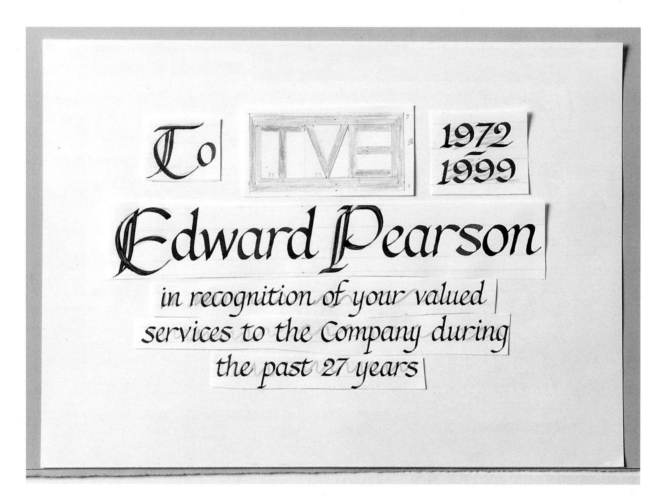

4 This shows the completed draft.

5 The paper chosen for this certificate has a mottled, marble effect and is called Marlmarque. The writing lines are lightly ruled to avoid making indentations in the paper. Add marking points for the start and finish of each line of text. Now you are ready to write your certificate.

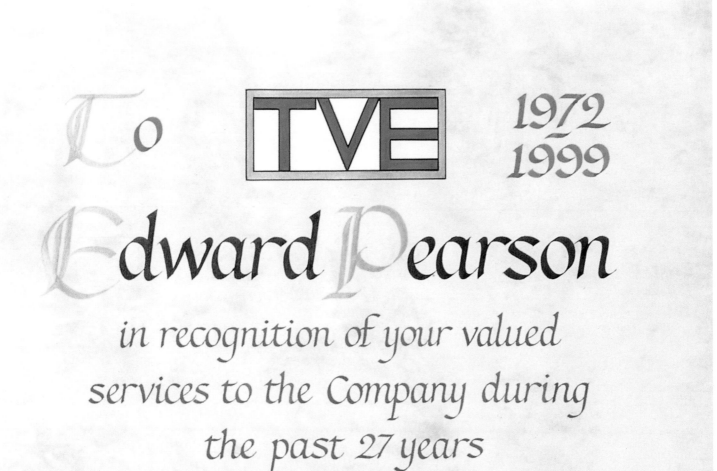

To **TVE** 1972 – 1999

Edward Pearson

in recognition of your valued

services to the Company during

the past 27 years

A size 1 nib is used for writing the main name and a size 2½ for the three lines of text below. The other words are written with a size 1½ nib. The large initial letters in the main name and 'To' are large italic letters written with double pen strokes for the downstroke of each letter. The same size 1 nib is used, even though the letter height exceeds the usual seven nib widths for capital letters; this is because double strokes make the letters larger and extend them below the bottom writing line. They

have each been adapted from other lettering styles to add a little more interest to the design, which, for an A4-sized certificate, contains quite a small amount of text. (Double-stroke letters are covered in more detail in the next chapter.)

The positions of the two large, gold letters can be ascertained by using the draft as a guide. These are written first.

The black text is written next, so that it falls correctly into place after the gold initials.

'To' and the dates are now written, and then finally the lines of text at the bottom. After the text has been completed, the logo is sketched or traced into position. The background colours are now painted. The green and gold lettering and logo are painted in gouache colours.

The outline of the logo is drawn, using a ruling pen for precision.

Finally, the writing lines are removed, care being taken not to smudge the lettering.

Change of Address:~

From 26 October 2000

Sarah and Christopher Eames

will be living at

Telephone
01716 214188

24 High Bank Cottage,
Milton Lane, Westcott,
Buckinghamshire

Cursive italic 5

Cursive italic

Cursive italic, in which there is more of a contrast between the thick and thin strokes, is a more stylish version of the italic hand than formal italic. Cursive italic can be adapted to form a handwriting style that is quick enough to be practical yet still retains characteristics of the more formal calligraphy styles.

fig 1. Connecting strokes for cursive italic letters.

Before attempting the whole alphabet, practise the strokes illustrated in fig.1. These are the two connecting strokes that make this style markedly different from formal italic (compare the two types in fig.2). Cursive-italic lettering can also be written with more continuous stokes than formal italic.

The whole alphabet is illustrated in fig.3. Notice that the tops of some of the rounded letters have been flattened out slightly (fig.4). The serifs, especially the tops of the ascending strokes, are much sparer than those used with formal-italic letters. Most are just a subtle rounding-off of the stroke at its beginning and end (fig.5), which both aids the speed of writing and makes the style simpler and clearer. The 'f' is usually given a long tail with a bottom stroke to match the 'g', 'j' and 'y'. When a more decorative style is required, this is a lettering style that really lends itself to extravagant flourishes and elongated serifs. (These will be dealt with later in the chapter.)

A set of simple, unadorned capitals that match cursive-italic minuscules are illustrated in fig.6. Like the minuscules, they have been constructed with minimal serifs and fewer lifts of the pen. They are quite plain, modern-looking letters, which have a very distinctive feeling of flow and movement. These have been used in the piece pictured in fig.7, which is the text of a passage from Shakespeare's Romeo and Juliet, giving the speeches of each in turn in two alternating colours. (The text is written on blue Conqueror card, which has a laid surface. This card is smooth enough for calligraphy that is written with a fairly small nib, and it also takes ink very well.) Fig.8 shows a few alternate versions of the cursive italic capitals.

fig.2. Letters 'a' and 'n' in cursive italic and formal italic. Cursive is on the left.

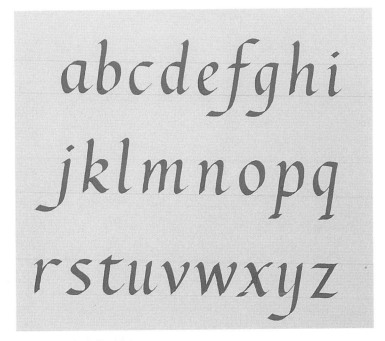

fig. 3. The cursive italic alphabet.

fig. 4. Rounded letters are written with flattened out top strokes.

fig. 5. Minimal serifs are used for cursive italic letters.

ABCDEFGH
IJKLMNOP
QRSTUVWX
YZ

fig. 6. Simple cursive italic capitals.

If I profane with my unworthiest hand
This holy shrine, the gentle sin is this;
My lips, two blushing pilgrims, ready stand
To smooth that rough touch with a tender kiss.

Good pilgrim, you do wrong your hand too much,
Which mannerly devotion shows in this;
For saints have hands that pilgrims' hands do touch,
And palm to palm is holy palmers' kiss.

Have not saints lips, and holy palmers too?

Ay, pilgrim, lips that they must use in prayer.

O! then, dear saint, let lips do what hands do;
They pray, grant thou, lest faith turn to despair.

Saints do not move, though grant for prayers' sake.

Then move not, while my prayers' effect I take.
Thus from my lips, by thine, my sin is purg'd.

Then have my lips the sin that they have took.

Sin from my lips? O trespass sweetly urg'd!
Give me my sin again.

From Romeo and Juliet by W. Shakespeare

fig. 7. An excerpt from Romeo and Juliet, in cursive italic lettering.

fig. 8. Some alternate cursive Italic capitals

PROJECT | *Writing change-of-address cards*

When you are designing a piece of text, you will not always want to centre all of the lettering, and when you are planning a piece whose lettering is off-centre it is important to achieve a good balance of lettering and spacing across the whole page. This is illustrated by the following simple project – a change-of-address card – whose text is shown in draft form in Step 1. The nib sizes used for this piece were a size 3 for the main name, a size 4 for the top line of lettering and a size 5 for the remaining words.

Step 1. Text required for a change of address card.

Step 2. Left: set of alternate sketched layouts for the change of address text.

Sketch out a few alternative layouts to see which looks the most attractive (Step 2). The first example, the straightforward, centralised layout, is neat, but rather uninteresting. The second example shows a gradual shifting of the lines of text across the page, from top left to bottom right, with the telephone number fitted into the empty bottom left-hand corner. Vertical layouts are not very practical for this type of card, as the names of people and places need to be split between too many lines to allow ease of reading. The best choice for this piece of lettering is example (b), which has a landscape layout with the text gradually stepping down from left to right.

Make a draft of all of the lettering (Step 3), using the appropriate nib sizes. Cut out the words and arrange them on a layout sheet, making alterations as necessary until you are satisfied with your complete draft.

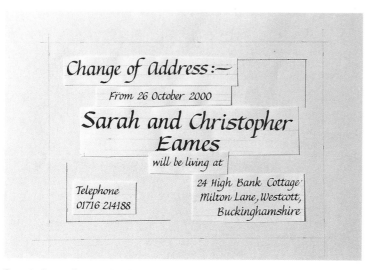

Step 3. Cut and paste the text into the chosen layout.

Step 4. Lettering your change of address card.

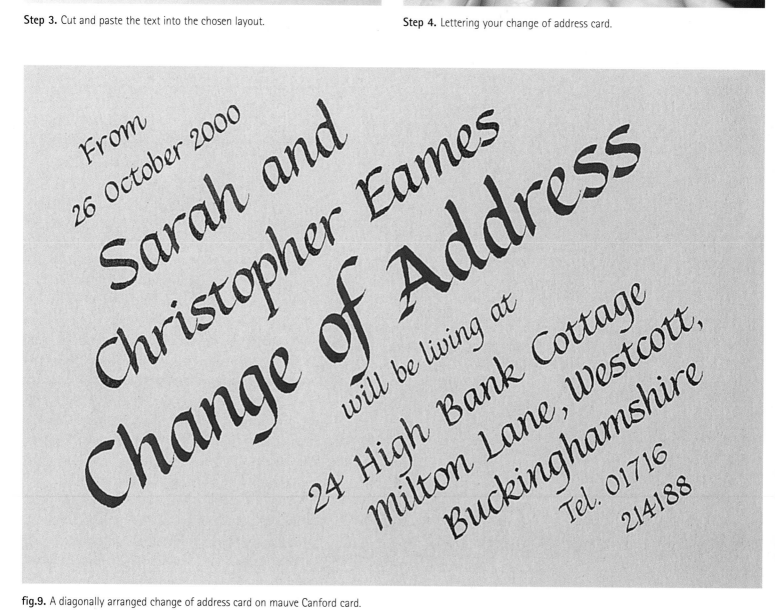

fig.9. A diagonally arranged change of address card on mauve Canford card.

Measure and rule your guidelines and marking points onto your chosen card. You are now ready to write your change of address card (Step 4).

Using a ruling pen, add linear fillers to the two empty corners to balance up the design. The finished card, which was written on peach-coloured Parchmarque card, has a matching envelope.

Fig.9 shows an alternative design for a change-of-address card. The text has been written diagonally, in black ink and mauve gouache, across lilac-coloured Canford card (Canford is sold in a huge range of colours and is available from many art shops).

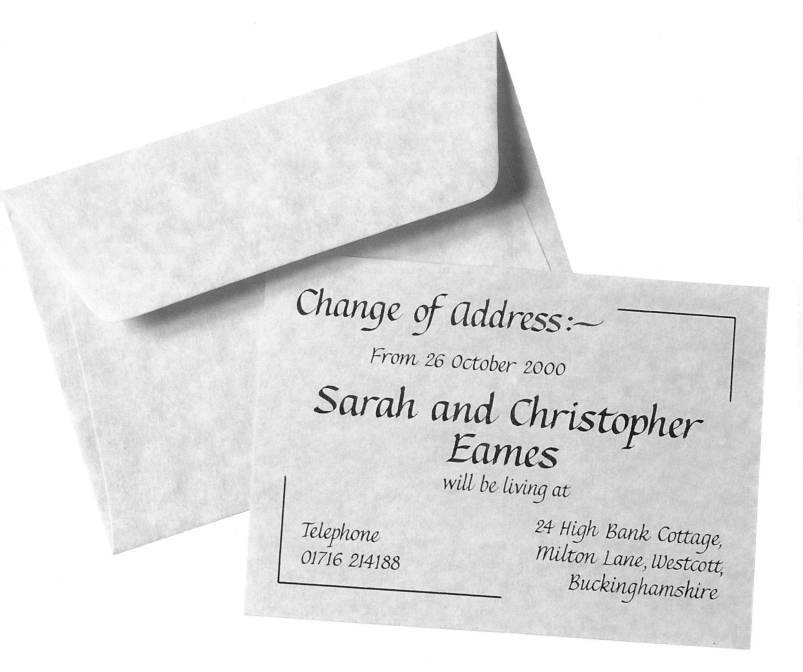

Change of Address:~
From 26 October 2000
Sarah and Christopher
Eames
will be living at

Telephone
01716 214188

24 High Bank Cottage,
Milton Lane, Westcott,
Buckinghamshire

Flags and flourishes

Cursive italic can be sharpened to an even greater extent than the examples shown so far, and fig.10 shows letters which have very acute curves to the beginning and end of their strokes, as well as thin, hairline strokes connecting the main changes of pen direction. Note that the tails of the letter 'p' have been given a backward serif to indicate an increased sense of movement (fig.11).

As was previously mentioned, cursive letters lend themselves to exaggerated serifs and flourishes. Fig.12 shows some of the minuscule letters to which it is particularly easy to give this treatment. They are all letters with an ascending or descending stroke that can be given a 'flag' serif to accentuate the forward-flowing movement of the lettering style. Combinations of letters can also be linked to good effect (fig.13).

Capital letters written in this style are even more adaptable to flourishes, and the alphabet shown in fig.14 illustrates the letters with several variations of flourished strokes.

Hairline serifs are sometimes added to the extremities of cursive italic letters to give an added touch of finesse. You need to be fairly adept with your pen to create a good effect with these, however. A very slight flick of the pen is all that is needed (Fig.15), so that only the left corner of the nib remains briefly in contact with the paper. Note that this type of stroke should be a casual embellishment and not a studied addition (Fig.16) to the letters, as this destroys their charm and spontaneity.

fig. 10. Cursive italic letters sharpened further to give greater contrast between strokes.

fig.11. The serif on the leter P flows into the down stroke from behind.

fig.12. Flag serifs on ascenders and descenders.

fig.13. Combinations of letters can be linked together.

fig.14. Below: lourished italic capitals.

Monograms

You can design a monogram by building up a capital letter with a series of flourishes. The best way in which to go about designing it is first to work it out in pencil. Remember that it takes a while to achieve a good design that has smooth, flowing curves and an interesting shape.

Step 1. An 'A' monogram.

Step 2. A dividing line is used on the pencil draught to help balance the design.

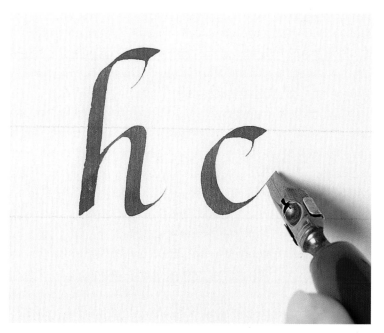

Fig.15. Hairline serifs.

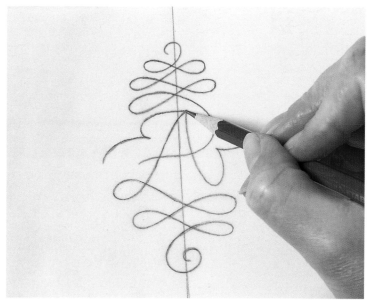

Step 3. The letter is traced onto the card giving pencil guidelines to follow when making the flourishes.

Try to keep most of the flourishes on the outside of the letter, which will make it easier to see the letter itself – the design's raison d'être, after all. The 'A' in Step 1 has a simple series of loops at its top and bottom, which curve around and back over themselves several times before ending in a final curl.

Make sure that the design is balanced by ruling a dividing line vertically through the centre of the letter and keeping a balance of pattern on both sides (Step 2). Now trace your design onto your card (Step 3).

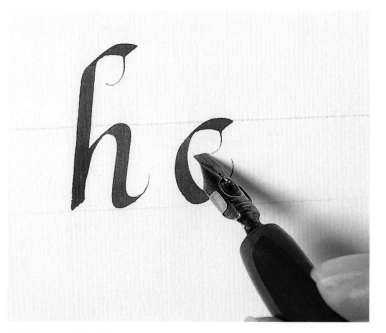

Fig.16. Over-worked serifs.

Once you are happy with your pencil outline, work out the best way of making the pen strokes to achieve the best effect. Keep the pen angle the same as when writing ordinary letters, so that you produce the same contrasting thick-and-thin strokes. If you find that some of the strokes are a little difficult to form, such as the long, thin, diagonal strokes from right to left (Step 4), adjust the design to limit these as much as possible.

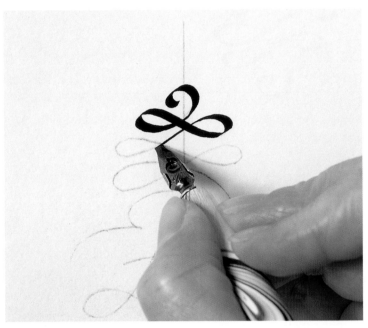

Step 4. Take care with the thin diagonal strokes which are the most difficult to produce.

You cannot make the whole flourish with a single pen stroke, because a metal nib does not work properly when it is dragged backwards for the thin strokes. Each part of the flourish should therefore be a separate stroke (Step 5) which join up perfectly around the curves (Step 6).

The letter can either be made double-stroked to give an interesting effect or consist of a combination of single and double strokes, which makes a letter look larger and bolder as its limbs appear wider, being composed as they are of two strokes and the space in between. The 'N' shown in fig.17 has double strokes for each of the three strokes forming the actual letter and curving terminations at each corner. Fig.18 shows a double stroked 'H' monogram.

With more complex designs, you may find that when you draw in some of the thicker pen strokes the design can look a little congested in the areas where several strokes cross over each other (Fig.19). Such strokes can also close up some of the gaps, thereby completely spoiling the design. These areas therefore need to be adjusted so that the strokes are more evenly spaced on the final design (Fig.20).

Two letters give even more scope for creating scrollwork with which to link the letters (Fig.21 and Fig.22). Use a smooth piece of paper or card for this work to be sure that you will be able to make the strokes in a flowing, graceful manner. After you have worked out the design, either go straight ahead and try writing it freehand or use a pencil outline as a guide.

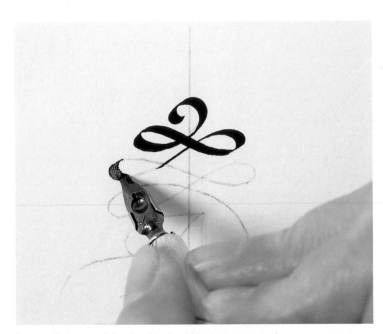

Step 5. Each part of the flourish should be a separate stroke.

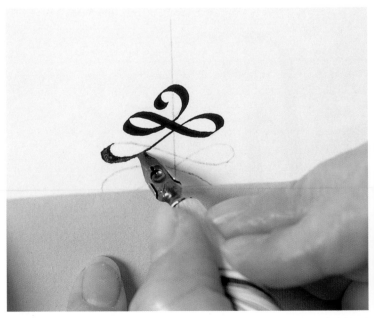

Step 6. The separate strokes should join up perfectly.

Fig.17. An 'N' monogram composed of double strokes.

Fig.18. A double stroke 'H' monogram.

Fig.19. This 'Q' monogram has areas where the cross strokes are too congested.

Fig.20. The redesigned 'Q' monogram now has better spaced crossing strokes.

Fig.21. 'LC' monogram.

Fig.22. 'PG' monogram with double stroke letters.

fig. 23. An alphabet of upright double-stroke capitals.

fig. 24. Double-stroke italic capitals.

Double-stroke letters

Double-stroke letters can be useful for titles or the initial letters of verses, and an alphabet consisting of double-stroke capitals is shown in fig.23. An alphabet of double-stroke italic capitals is shown in fig.24. Although these letters were written with a size 3 nib to a height of 32mm (1¼"), you have a lot of latitude when constructing letters in this manner. For example, the same-sized nib also made the letters illustrated in fig.25, showing that it is possible to work to a given size and space in order to fill it to best advantage.

A few of the letters have been broken down in fig.26, and the order in which the strokes were made has been given to help you to master their construction. You will need to practise some of the letters a great deal before you write them, in order to get used to the correct order of stroke construction that is needed to form the best shape. As you can see, double-stroke letters work equally well when they are either upright or have a cursive, forward slant.

When constructing the letters, ensure that where combinations of strokes meet you work them into each other carefully so that you do not end up with an unattractive jumble of lines that meet incorrectly. The letter 'A' is one of the more difficult to construct as a double-stroke letter, because the lines cross in several places.

For letters with curved strokes, such as 'B', 'C', 'D' and so on, the outer curve should be written first, so that the shape is correctly established before the inner curve is added. Where the horizontal strokes running across the bottom of a letter meet the curved strokes, the outer curved stroke should join the top horizontal stroke and the inner curved stroke the bottom horizontal stroke (fig.27).

fig. 25. The same sized nib wrote these three different sized double-stroke letters.

Many of the letters, such as 'V' and 'W', look better if one or more of the strokes are left as a single stroke. Others, such as 'L' and 'Y', benefit from the addition of a balancing stroke to maintain an even distribution of weight across the letter.

Fig.28 is a piece of lettering in which double-stroke initials begin each of the verses, as well as the title. The title letters have been given a more decorative treatment by means of a few additional flourishes. The letter 'H', in particular, lends itself to this sort of treatment.

With regard to the layout of this piece, note that the verses have been offset to the left and right down the page, thereby giving greater width to the whole design. A piece such as this,

which has five verses with quite short lines, makes rather a long, narrow column running down the page if the verses are written directly beneath each other. This design spaces the larger initials within the block of text better. The sets of four lines of each verse have given the same treatment by means of stepping alternate lines in and out of each other at the same interval.

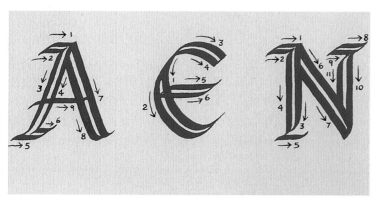

fig. 26. The order in which the strokes are made needs to be worked out and followed carefully.

fig. 27. Take care to join up inner and outer strokes correctly.

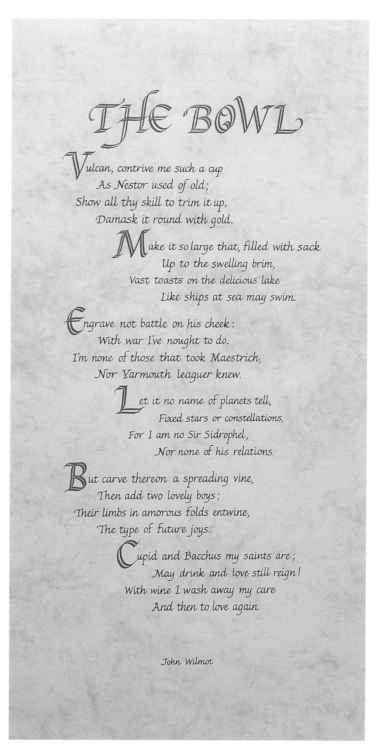

THE BOWL

Vulcan, contrive me such a cup
As Nestor used of old;
Show all thy skill to trim it up,
Damask it round with gold.

Make it so large that, filled with sack
Up to the swelling brim,
Vast toasts on the delicious lake
Like ships at sea may swim.

Engrave not battle on his cheek:
With war I've nought to do.
I'm none of those that took Maestrich,
Nor Yarmouth leaguer knew.

Let it no name of planets tell,
Fixed stars or constellations,
For I am no Sir Sidrophel,
Nor none of his relations.

But carve thereon a spreading vine,
Then add two lovely boys;
Their limbs in amorous folds entwine,
The type of future joys.

Cupid and Bacchus my saints are;
May drink and love still reign!
With wine I wash away my care
And then to love again.

John Wilmot

fig. 28. Text with double stroke capitals.

Double-stroke letters are also useful for large-sized lettering, because the double-width stroke forms a letter that is a lot larger than the single-stroke capital when written with a nib. Making double-stroke letters can also enable you to avoid working with very wide nibs, which are sometimes a little awkward to use or may produce inaccurate lettering if the nib is not sharp enough or if it contains too much ink. If you do not want your double-stroke letters to be too large in comparison to the rest of the single-stroked lettering, however, you will need to use a smaller-sized nib.

You can buy pens with points of varying distances and thicknesses (fig.29) that make a double stroke for you. The points are usually quite fine, with the result that the letters that they produce are lightweight, with a transparent appearance (fig.30). The example shown was written with a nib-size 50 Mitchell 'Scroll Writer'. A music pen is also available (fig.31), which has five points for drawing musical staves; of the five strokes produced, the top and bottom strokes are slightly broader than the central three. Such pens are fun to experiment with, and you can also achieve some interesting effects with them.

fig. 29. A double-stroke nib.

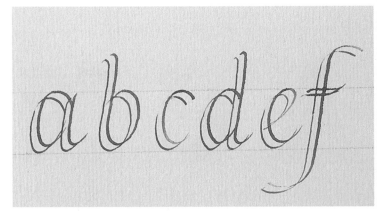

fig. 30. Letters produced by a double-stroke nib.

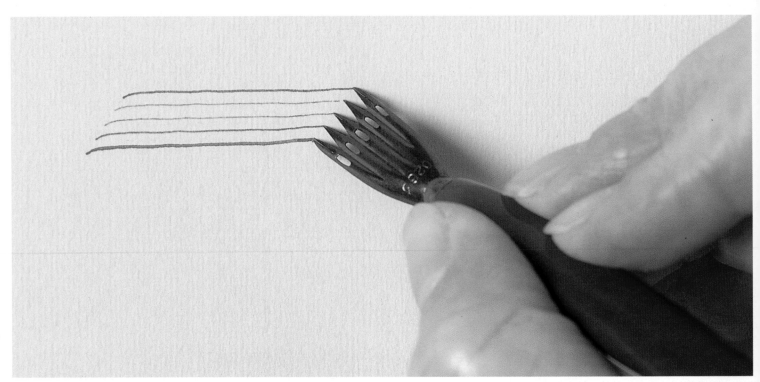

fig. 31. A five-line music stave nib.

Elswood Horticultural Society

SPRING

FETE

and Plant Sale

Saturday 15th May 2000

ELSWOOD VILLAGE HALL

from 1pm – 5pm

Admission £1

Gardening Advice

Books

Cake Stall

Tombolla

Refreshments

Craftwork

Paintings

Animal Welfare

Using capitals 6

Using capitals

Calligraphy is often needed when writing posters, and we will deal with some poster projects in this chapter. We will tackle layout further and also look more closely at large capital letters, in particular Roman capitals, which were originally quite complex in construction, but can today be adapted to form a simpler, modern style.

fig.1. Roman capital letters

Roman capitals

Fig.1 displays the alphabet of Roman capital letters, while in fig.2 they are grouped into their different widths. From these examples we can see that the 'O' is completely circular, the 'C', 'D', 'G' and 'Q' are also based on a circle, while the 'H', 'M', 'N' and 'W' are the full width of the 'O'.

Fig.3 shows the narrow letters, which are just over half the width of the 'O'. Note the economical use of fairly small, straight serifs. The remaining letters are shown in fig.4. In the Roman-capital-letter alphabet, many of the letters that began with a serif in the alphabets that we previously learned instead begin with a continuous, straight, vertical stroke downwards (fig.5), which is followed by a top stroke that forms the serifed portion. The letters 'B', 'D', 'E', 'F', 'P' and 'R' have received this treatment, which is similar to the straight–serifed alphabet (fig.8, page 35), but has slightly different proportions to the letters. The difference between Roman and foundation-hand capitals is that the foundation-hand letters are all of fairly equal proportions, allowing for their different shapes, whereas the Roman letters are either distinctly wide or narrow, depending on their letter shape.

The Romans were very precise and mathematical in the lettering techniques that they used for forming inscriptions on monuments, and they constructed their letter shapes so that they balanced well. Although the same degree of precision cannot be attained with pen-written lettering, the general proportions can be adapted to good effect for work in which clarity and impact are important, such as posters.

fig.2. Wide letters.

fig.3. Narrow letters.

fig.4. The remaining letters which fall between the two widths.

fig.5. Strokes forming the top part of many of the Roman capitals.

Posters

We will incorporate text advertising a spring fête (Step 1) into a poster. The main points of the text that should be emphasised are the name of the event and its date, time and place; the remaining details are less important.

Because the paper sizes used by printers are usually the 'A' sizes, if you are planning to have the poster reproduced it is best to plan your design according to whichever of these 'A' sizes suits your requirements best. The full series of sizes that you are likely to use is: A0 (1,192 x 844mm), A1 (844 x 596mm), A2 (596 x 422mm), A3 (422 x 298mm), A4 (298 x 211mm) and A5 (211 x 149mm), each ascending size being double the previous one. A4 is the size that is commonly used for office stationery, while A3 is typically the size of the posters that you frequently see fixed to trees and village noticeboards, and our poster will be A3 size.

When creating your artwork, you can either make it the size that you want it to be printed or scale it up slightly and then ask the printers to reduce it to the correct size for the poster. The advantage of having your original artwork reduced in size for printing is that it will sharpen up the lettering and minimise any minor inaccuracies. One disadvantage, however, is that because lettering for posters often needs to be quite large, making it even larger can give you the problem of finding large enough nibs with which to write the work. Never make your original artwork smaller than you intend the printed version to be, however, because when it is enlarged any minor inaccuracies will be magnified, while lines that appeared quite even in the original version will look as though they have uneven edges.

In order to scale your work up or down in size, simply mark the dimensions that you require the finished item to be on a sheet of layout paper (Step 2) and then draw a diagonal line from corner to corner, extending the line outside the required dimensions for an enlargement. Work in the opposite way when reducing. Draw a vertical line upward from any point along the bottom line – for example, if you want an enlargement of 50%, draw the line from a distance half as far again from the original width. Where the vertical line meets the diagonal line, draw a horizontal line to the left-hand edge. The proportions of the new rectangle will now be precisely correct for an enlargement of 50%.

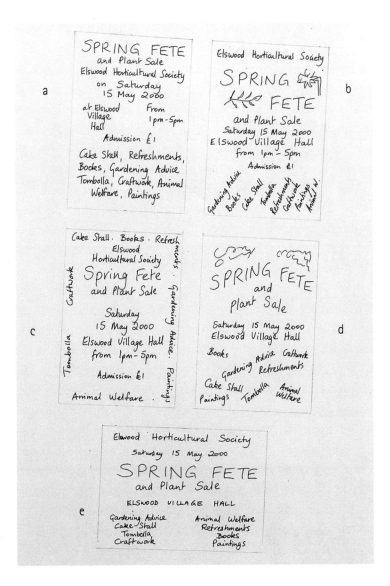

Step 1. Above: Five sketches for a poster for a Spring fête.

Step 2. Scaling paper size up or down.

Working on poster layouts and designs

Of the five preliminary sketches for the layout of the spring-fête poster, layout b) has been chosen as having the best balance and clarity. It has a bold title and a little floral decoration in the spaces to the right and left of the words, and although the diagonally written words in the bottom portion are easy to read, they do not detract from the more important lettering.

Taking the alternative layouts in turn, the layout of option a) is a fairly straightforward arrangement, with nothing particularly eye-catching about the design. In addition, the main title, which runs across the top of the page, has less impact than the same words in the other four arrangements. Running on the list of words in the bottom portion in a continuous row, separated only by commas, makes the text a little more difficult to read quickly and is also a rather static design. Choice c) is made quite interesting by writing the smaller details around the edge of the poster, but this reduces the space available in the centre for the more important text, which would have greater impact if it was larger. Although layout d) is an attractive design, its different lettering angles make it a little too fussy. As is demonstrated by example e), a landscape arrangement is not very practical for posters, because the majority of the places in which they will be displayed, such as in shop windows or on trees and noticeboards, suit a portrait-shaped poster better.

Step 3 shows the cut-and-pasted draft of the text for the preferred layout. The capital letters that make up the words 'SPRING FETE' can be given special treatment, and we will use Roman capitals written with a size 3 Automatic pen (see page 76). The remainder of the description of the event, along with its date, place and time, will be written in compressed foundation hand. The title across the top of the poster will also be in compressed foundation hand, and you should make sure that the lettering is of a size that will enable you to fit all of the words on one line. The venue will be given prominence by means of widely spaced Roman capitals, while the remaining details at the bottom of the poster will be written in italic to introduce a little variety. This means that three different lettering styles will be used for the text, and because any more would create a discordant appearance, this is about the maximum number of styles that you should include on one page.

When ruling the writing lines for the diagonal words at the bottom of the poster, make sure that you keep them parallel by turning the page and marking the measurements accurately. If you do not have a parallel ruler, draw the first diagonal at the correct angle and mark off the other lines from this, using three sets of points per line (Step 4) to ensure that they are accurate.

Measure and rule your guidelines and marking points onto your chosen paper and write your poster, following the draft (Step 5).

Step 3. The cut-and-pasted poster draught.

Step 4. Using three measured points to draw diagonal writing lines.

Step 5. Writing the poster.

Step 6. The finished poster.

Alternative poster

Another set of information for a poster advertising a craft fair has been cut and pasted into position in Step 1. The main title is in italic letters written with an automatic pen (Step 2). Roman letters spell out the venue details and the contents list at the base of the page, while two further sizes of italic have been used for the rest of the text. Remember that small calligraphic fillers are useful for breaking up areas of text, and two very simple, linear motifs have been added to this layout to separate some of the central details. The finished poster pictured (Step 3) has text written in black ink on a bright-lemon-yellow card.

Printers usually offer a good range of colours for posters, but if you want a specific type of paper – perhaps with a mottled effect or a laid texture – you can buy your own from a specialist paper shop and ask the printers to use that. However, remember that this is only worth doing if you can hang some of the posters where they will be closely scrutinised. Because most posters will usually only be seen from a distance, using a subtly textured or coloured type of paper may be a wasted effort.

Step 2. Lettering the poster.

Step 3. The finished poster.

Step 1. A cut-and-pasted draught for a poster advertising a Craft fair.

Poster and automatic nibs

For posters, your lettering sizes will probably have to be larger than usual. The William Mitchell nibs that we have been using up to this point go up to a size 0, which makes a stroke that is just over 3mm (about ⅛") in width, giving a capital-letter height of about 22mm (about ⅞"). If you need to produce letters that are larger than this, you could buy a set of poster nibs (fig.7), to each of which a large reservoir is attached that holds the increased amount of ink required. You will have to take care not to overfill the nib, otherwise you will produce blotchy letters and lose the fine lines that are integral to good calligraphic letters. Hiro Leonardt also makes large-sized nibs (fig.8), whose reservoirs are positioned above, rather than below, the nib.

Automatic pens (fig.9) are excellent for poster-writing, as they are not only sold in very large sizes, but are also easy to use. Their construction includes two angled pieces of metal with touching edges and a series of small slits along one edge that allows the ink to flow better. When working, make sure that the slitted edge is facing away from the page as you write. Although these pens can be dipped into a container of ink, some of their nibs are so large that they have to be filled with a large, well-loaded brush in order to transfer the ink to the whole of the inside edge. (Be extremely careful when you are moving a fully loaded pen from the inkpot to the paper, although once you are holding the pen at the correct angle to the paper and are ready to write the danger of spilling the ink is past.)

For the craft-fair poster, a number 3 automatic pen was used to write the title. The width of the stroke is nearly 5mm (about ¼"), giving a letter height of 25mm (about 1"). The pen decoration was also written with this pen size.

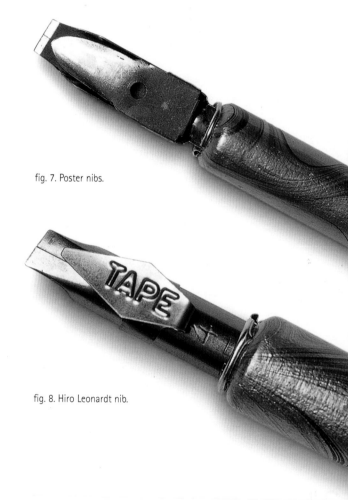

fig. 7. Poster nibs.

fig. 8. Hiro Leonardt nib.

fig. 9. Automatic pens.

Writing signs

If you need to work on a very large scale – if you are making a sign, for example – you have two options regarding pens. Firstly you could make your own pen, or use automatic pens.

PROJECT *Making your own poster pens*

1 Here we are using a piece of absorbent material cut with a thin edge. The example shown is a piece of cardboard with a small piece of cotton fabric wrapped around the end that is held in place with staples. It is rigid enough to provide a good edge for the lettering and the cloth absorbs enough ink or paint to make the letters.

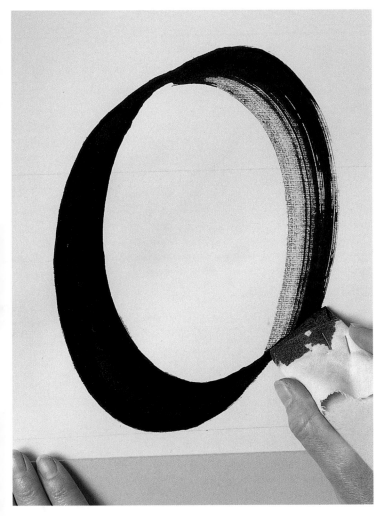

2 Mix plenty of ink, because when you are making large letters with a very absorbent nib you will get through it very quickly. Refill the nib frequently in order to avoid a dry brush effect.

3 The sign illustrated was written with this type of writing instrument on an interesting, Japanese paper flecked with tiny, metallic squares. The width of the stroke made is 40mm (just over 1½") so letters of 200mm (just under 8") could be written if necessary. This lettering has a height of 175mm (nearly 7").

PROJECT *Making a cork nib*

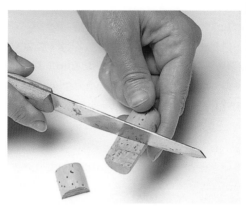

1 Cork is another good nib-forming material, and a cork from a wine bottle should be long enough for your purposes. You will need a very sharp knife to cut it into shape and remember to take care when cutting, because the cork is quite rubbery and can be difficult to cut. The completed cork nib is quite robust, however. Start by making a straight cut downwards into the cork.

2 Then cut across it to remove a portion.

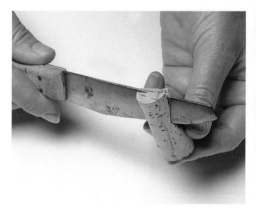

3 Now scallop off the back edge to leave a thin edge of cork.

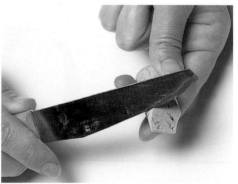

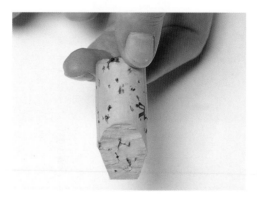

4 The shape so far should look as shown here.

5 Scallop off side portions to make the end of the nib the required width then shave it down until it is about 1mm (less than ¹⁄₁₆″) thick, so that it will give accuracy to your letters.

6 If the writing edge is not straight, make a downward cut along its length. Your nib can also be reshaped if it becomes blunt. (This is more or less the same method that was used to make reed pens centuries ago.)

The 'RAFFLE' sign (fig. 10) shown was written with a cork nib 19mm (about ¾") wide, and the letters were written between guidelines 90mm (about 3½") high. You will need a small tray of ink, so that when you are dipping the cork pen into it the ink is transferred along the whole of the writing edge. Although you will have to dip the pen into the tray many times – and should be careful to avoid ink drips – the letters can be formed fairly easily, with a good degree of accuracy.

Your second option is to make compound letters, which are letters whose individual strokes are composed with more than one thickness of nib. Compound letters are often drawn first and then written and painted. Being very clear and well-defined, Roman characters – which are often constructed as compound letters – are eminently suitable for signs. The lettering for the sign pictured in fig.11 was first drawn and then outlined with a size 3 automatic pen before finally being filled in with a paintbrush. This procedure gives a nice calligraphic quality to the letters, as well as retaining the accuracy that can be lost when using large, home-made nibs.

Waterproof signs

If a waterproof sign is required, use acrylic paint, which is mixed with water but becomes waterproof when it is dry. Although the paint is quite thick, which means that the letters will not have the accuracy of gouache-painted characters, a little crudeness is not very noticeable in large-scale letters. Indeed, the overall effect can be very good (fig.12). If the sign needs to be freestanding, use mount board, which is sold in large sheets and in a wide range of colours by most art shops and picture-framers.

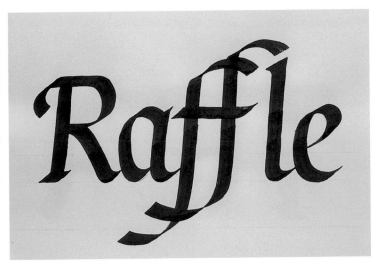

fig. 10. RAFFLE sign written with a cork nib.

fig.11. CAKES sign in Roman letters.

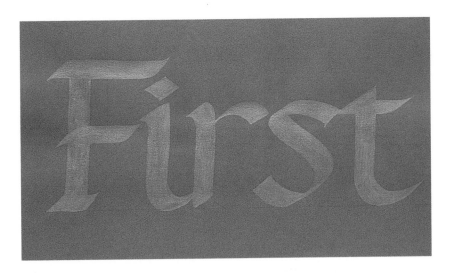

fig. 12. Sign using waterproof acrylic paint.

Automatic pens

The 'TEA ROOMS' sign pictured in fig.13 was written with a size 6 automatic pen. Even a pen of this size can produce lines that are very accurate. Unfortunately, the amount of ink that is required for each stroke often necessitates refilling the nib halfway down a stroke, so take care that you rejoin the line very accurately.

When you are using slightly transparent inks or paints, a dark-and-light effect can be produced where a stroke has been stopped and restarted, as can be seen on the letters in fig.14. In order to reduce the chance of this happening, it is therefore best to stick to either black or very dark colours.

The size 6 automatic pen makes a stroke 19mm (about ¾") wide, so capital letters written at the usual seven nib widths would be 133mm (about 5¼") high. Remember that letters on posters tend to look better when they are a little squatter than normal-sized lettering. Six nib widths have therefore been used for this sign, resulting in better-proportioned letters.

The 'EXIT' sign in fig.15 was written with a size 6a automatic pen, whose nib is about 25mm (about 1") wide. The lettering is 150mm (nearly 6") high, which makes for quite a large sign – this one measures 210 x 750mm (8¼ x 29½"). Although the quality of the letter edges starts to diminish with this size of nib, it is not enough to mar the lettering when viewed from the intended distance.

fig.14. Transparent letters produced with ink that is too thin.

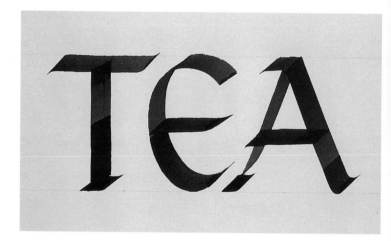

fig.13. TEA ROOMS sign using a size 6 Automatic pen.

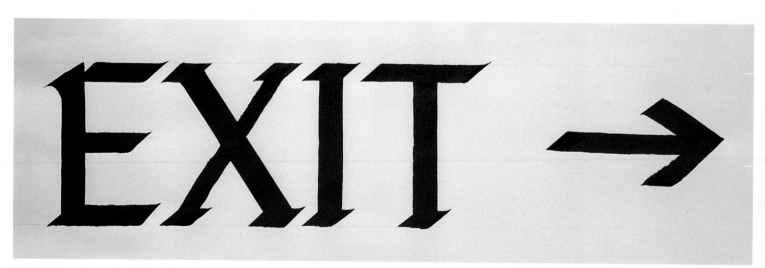

fig.15. EXIT sign using a size 6a Automatic pen.

St. Stephens, Barwich

Monies contributed and collected out of the parish of St. Stephens in Barwich, towards the releife of our afflicted bretherin in Ireland:-

Mr. Samuel Dickson	ten shillings	
Mr. Thos Cobb	seven shillings	six pence
Mrs. Newman	ten shillings	
Daniel Hopper	five shillings	
Goodwife Hargreave	one shillinge	
Edward Morris	three shillings	
Richard Morris	sixe shillings	
John Williamson	eight shillings	
Joseph Austin	three shillings	
Nic: Eckleston	foure shillings	
Will: Potterton	one shillinge	
James Shaw	two shillings	sixe pence
Goodwife Shaw	one shillinge	
Edm. Carter	one shillinge	
John Carter	one shillinge	
Sarah Carter		six pence
Hen: Cunningham	one shillinge	
John Walker		eight pence
Margaret Thomson		sixe pence
William Smith		six pence
Walter Palmer		six pence
Edw: Salter		six pence
Jeremiah Whitlock		six pence

Sharpened Gothic Lettering

7

Sharpened Gothic lettering

We will now move on to a more decorative style: sharpened Gothic lettering. The Gothic styles are angular, and the well-known blackletter hand – which is the most angular of all – will be covered in the next chapter.

The sharpened Gothic style represents a halfway stage between the lettering styles that we have covered so far and the blackletter hand. The alphabet – which is very attractive – is based on the pointed 'o' (fig.1), which has sharp points where the top and bottom strokes meet. The two halves of the letter should appear to be reversed images of each other, so that the curve of the stroke is exactly the same on both sides.

The full alphabet is shown in fig.2. The same angle of curve that is used for the 'o' is required to form all of the rounded letters, so practise writing 'a', 'b', 'd', 'e' and 'o' together so that you learn the correct formation of these strokes. Although the 'q' contains a rounded stroke next to an upright, the small stroke that joins the first curved stroke to the upright begins as though it were another fully curved stroke. The 'p' contains an arching crossbar that links the upright to the curved stroke. The same type of stroke is used to form the letter 's' (fig.3), in which the middle diagonal stroke is the same as in an ordinary 's', but then the top and bottom arching strokes are added. The 'c' and 'r' use this arching stroke for their top strokes, too, and it also appears at the bottom of the 'j'.

Pay particular attention to the tails of the 'g' and 'y' (fig.4), in which a very narrow, diagonal stroke connects the body of the letter to the final downstroke and the tail. Because it has a diagonally ascending stroke, you will also have to concentrate on the 'd' (fig.5) – it takes some practice to make the top curve correctly so that it joins up with the bottom part of the letter in the correct place. A strategy that should help you to form the first part of the letter correctly is to imagine you are just going to write an 'o' and then to add the extra top portion as an afterthought.

Most of the letters that are normally written with more than one vertical stroke – the 'h', 'm', 'n', 'v' and 'w' – have a curved stroke following the first vertical. Practise these letters together to get used to the stroke formation.

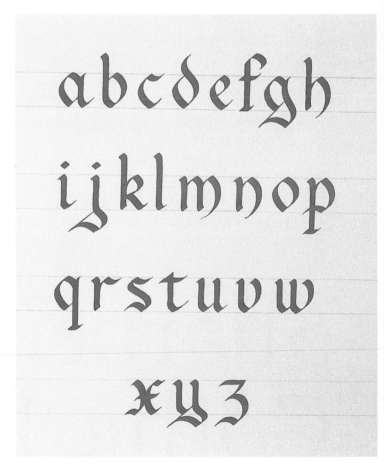

fig.1. The pointed 'o' on which sharpened gothic is based.

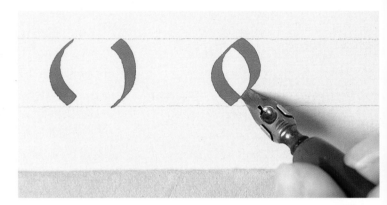

fig.2. Sharpened Gothic alphabet.

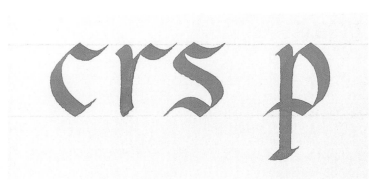

fig.3. Construction of letters with arching crossbars.

The serifs of this alphabet are not very pronounced, those on all of the vertical strokes being no more than a slight curve to the right at the start of the letter. The feet of the 'p' and 'q' also have small, horizontal serifs.

The capitals for this hand are illustrated in fig.6. The letters that differ the most from those that we have already used are the 'E' and 'T', which are formed with a curved stroke for the main body of the letter. Although the top stroke of the 'E' is arched, the 'T' has a straight, horizontal stroke. Note that the 'N' has a curving second stroke.

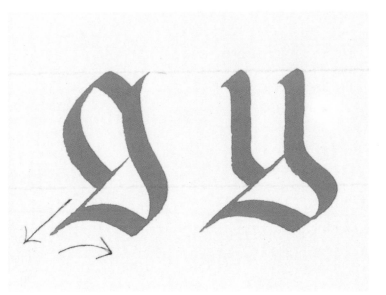

fig.4 Construction of 'g' and 'y'.

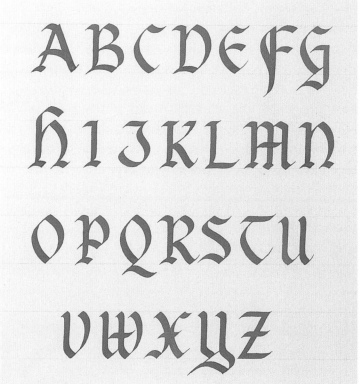

fig. 6. Sharpened Gothic capitals.

fig.5. Construction of a 'd'.

PROJECT *Historical documents*

Its historical appearance makes this style appropriate for any document that you want to look old, and the transcription of the historical document illustrated in Step 1 is written in this hand. With the more elaborate lettering styles, it is especially important to think carefully when combining different styles and sizes, because some do not go together very well.

An attractive, vellum-effect paper called Elephanthide, which comes in two thicknesses and two colours, was chosen for this work. A sheet of paper that has a relatively heavy weight is generally better for calligraphic work than a lighter alternative, because it is less inclined to buckle when wet and you will also be able to remove any mistakes more successfully.

The document lists the contributors to a special collection for a church that was made in 1641. Red, sharpened Gothic letters have been used for the title, which should be the most prominent piece of text. In common with most Gothic styles, because the capital letters of this hand are quite difficult to read when grouped together, a large lettering size in a combination of upper and lower case letters is preferable to a title that consists solely of capitals. This lettering was written with a size 1 Mitchell nib.

The description of the collection was written in sharpened Gothic with a size 3 Mitchell nib. The smaller details that appear in two columns running down the page use compressed foundation hand. (Any very small lettering on a document is always best written in one of the more legible styles, like this one.) The nib size that was used was a 4.

Measure and rule guidelines and marking points onto your chosen paper and write out the document (Step 2).

St. Stephens, Barwich

Monies contributed and collected out of the parish of St. Stephens in Barwich, towards the releife of our afflicted bretherin in Ireland:–

Mr. Samuel Dickson	ten shillings	
Mr. Thos Cobb	seven shillings	six pence
Mrs. Newman	ten shillings	
Daniel Hopper	five shillings	
Goodwife Hargreave	one shillinge	
Edward Morris	three shillings	
Richard Morris	sixe shillings	
John Williamson	eight shillings	
Joseph Austin	three shillings	
Nic: Eckleston	foure shillings	
Will: Potterton	one shillinge	
James Shaw	two shillings	sixe pence
Goodwife Shaw	one shillinge	
Edm. Carter	one shillinge	
John Carter	one shillinge	
Sarah Carter		six pence
Hen: Cunningham	one shillinge	
John Walker		eight pence
Margaret Thomson		sixe pence
William Smith		six pence
Walter Palmer		six pence
Edw: Salter		six pence
Jeremiah Whitlock		six pence

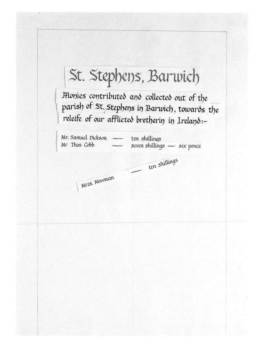

Step 1. The required text, three lettering sizes are needed.

Step 2. Write out the text then remove the writing lines.

PROJECT Completing the document

The document was finished with a simple tying ribbon, which you can attach as follows. First, fold over the bottom edge of the paper so that its thickness has doubled or tripled. Next, make two slits through all of the layers of paper, using a sharp knife and a ruler (Step 1). The slits should be parallel to each other, about 2cm (¾") apart and a fraction wider than the width of your chosen ribbon. Remember not to position the slits either too close together or too near the bottom of the page, or else the paper may tear when the ribbon is tied.

Thread the ribbon through the slits (Step 2). If the paper is reasonably stout and the slits are wide enough, you should be able to pull the ribbon gently through the slits without damaging the paper, leaving the ribbon firmly attached. Now trim the ends of the ribbon to make a neat finish (Step 3).

The document can now be rolled up from the top and the ends of the ribbon tied around the center (Step 4).

Step 1. Cut two slits, the width of the ribbon, through each layer.

Step 2. Thread the ribbon through the slits.

Step 3. Neaten the frayed ribbon ends if necessary.

Step 4. The scroll can be rolled and tied for presentation.

Removing mistakes

Because it is so easy to be distracted and then to write an incorrect letter, you will often make mistakes when you are writing large amounts of lettering. If you are using a good-quality paper, you should be able to remove the error and then rewrite the correct version on the same spot, leaving little or no evidence of a correction having been made.

Several tools are useful for removing errors (fig.7). We will cover this subject in some detail, because the more advanced your calligraphic skills become, the more complex the pieces that you are working on will also become. If you don't remove any errors that you make, you will have to abandon, and then rewrite, an intricate piece of work on which you have already spent a lot of time.

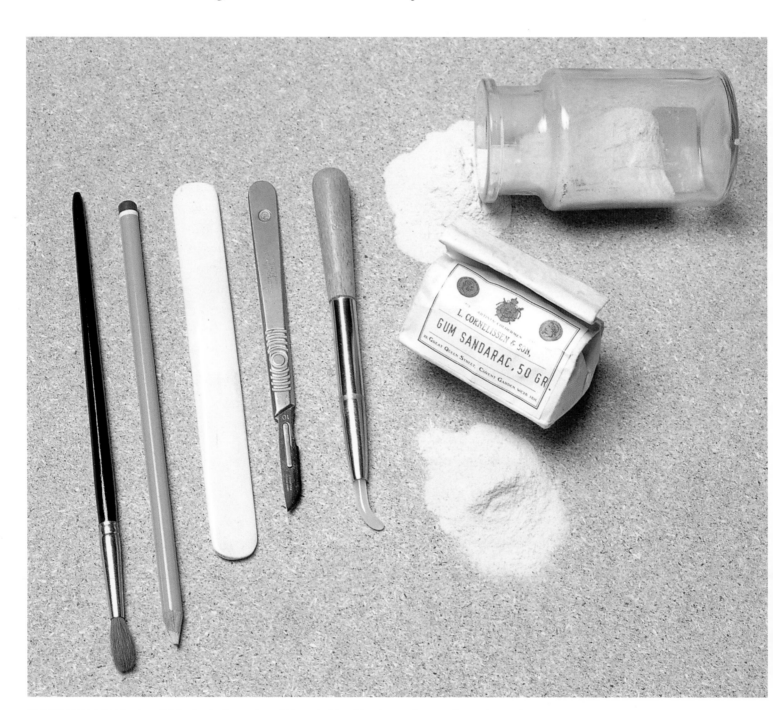

fig.7. Error removing tools - l – r. soft brush, pencil eraser, bone folder, scalpel, burnisher, gum sandarac powder, pumice powder.

PROJECT *Removing errors with an eraser*

A pencil eraser, or rubber, with a hard, white, rubber core is the most useful tool for removing errors, because you can rub away at a very small surface area without greatly disturbing the surrounding letters or paper. The rubber will usually be quite hard, so it is advisable to practise using it on a spare piece of paper to see how hard you need to rub in order to remove the incorrect area. Note that although it is easy to scuff the paper – especially a soft paper, like cartridge paper – you should be able to rub quite hard at thicker, better-quality papers without causing any irreparable damage. When you have removed all of the incorrect area (Step 1), carefully brush away any rubber particles and paper dust that may be lying on the paper.

You will now need to smooth the surface of the paper with a bone folder (a burnisher can also be used). This is a small, flat piece of bone, with either two rounded ends or one pointed and one rounded end, which is mainly used in bookbinding to flatten and sharply crease folded pages. Because there will be a variety of occasions on which you may need a bone folder, you will find it a cheap and useful tool, and you can buy one from a specialist art or paper shop. If your bone folder has a round and a pointed end, use the round end gently to rub and press the loosened paper surface down (Step 2). By experimenting on a scrap of paper, you will be able to ascertain how much pressure you can apply before the fibres become too crushed and an unwanted indentation is made on the surface.

Try writing over the repaired area to see whether the new letters can be written successfully or whether you are going to have problems with either a surface that has become too roughened or with spreading ink. If the surface is still too rough, burnish it a little more. If the ink spreads too much, try carefully rubbing a little pumice powder and gum sandarac into the surface, which should hold the ink in place (Step 3). Pumice powder and gum sandarac, as well as a mixture of the two, called 'pounce', are available to buy. Although these powders are principally made for preparing the surface of vellum skins for writing, they also can be used on paper. Lightly dust the prepared area with a little of the powder and then gently rub it in with a clean cloth, using a light, circular action so that you do not give any marked direction to the fibres. Finally, dust away any excess powder so that it does not clog your pen. Now carefully write in the correct letters (Step 4).

You should not be able to see any marks on the paper – the word should look as if no mistake was ever made (Step 5).

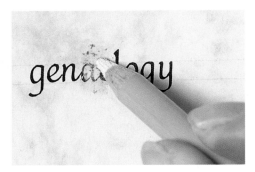

Step 1. Remove the incorrect letters with a pencil eraser.

Step 2. Use a burnisher or bone folder to smooth the roughened surface flat again.

Step 3. If necessary rub in a little 'pounce' to improve the surface.

Step 4. Write the correct letters in carefully.

Step 5. Remove the writing lines.

PROJECT *Removing errors with a knife*

Another method of removing errors is to scrape away the incorrect areas with a very sharp scalpel or craft knife. (These are available from most art shops and you can buy spare blades cheaply.) Remember that a very light touch is needed when doing this, in order to avoid damaging the writing surface (Step 1). Because some vellum is very thick and quite a lot of the surface skin can therefore be removed before any damage is caused, this method is particularly useful when you are working on vellum. When you have removed all of the erroneous area, burnish the vellum flat so that it can be successfully written over again (Step 2). Now write in the correct letters (Step 3).

If your paper is quite thin and you can see that the ink has worked its way through the whole thickness of the paper when you turn it over and examine the reverse side, there is no point in trying to remove the letter. If you do, you will be left with a hole. In this case you have no choice but to start again. Although you could try to paint out the incorrect areas with a similarly coloured paint to the paper, this is invariably a very unsightly way of making corrections, because they are likely to be obvious afterwards, especially since any new letters written over painted areas are usually of poor quality (this is

because ink will spread on most painted surfaces). The best way in which to avoid the problem is to use a good-quality paper, which will have been manufactured with this sort of treatment in mind.

The colourings or patterns of some of the more decorative papers are sometimes only on the surface, so that when you remove the top layer you will be left with a different colour – usually white – underneath. When this happens, you will have to try to restore the lost pigment.

First, gently rub a little pigment that matches the colour of the paper onto the discoloured area before dusting away the residue. Although powdered pigments are available, it is much easier to use a good-quality, coloured pencil of the correct shade (Step 4), such as one of the Derwent pencils. Derwent pencils, which are sold by many art shops, are available in a very wide range of colours, including quite a large selection of the light beiges and browns that are useful for pale-cream-coloured papers. They are soft pencils, and if you use one very lightly and then rub the coloured-in area with a soft cloth (Step 5) to disperse the pigment further, you should be able to disguise the alteration to the extent that it can only be seen on close examination.

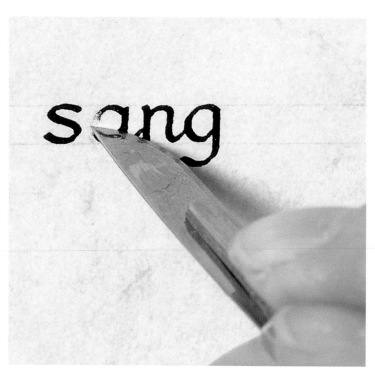

Step 1. Use a sharp scalpal or craft knife to remove the incorrect letters.

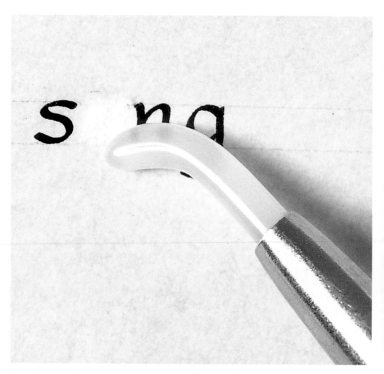

Step 2. Smooth the surface flat again with a burnisher.

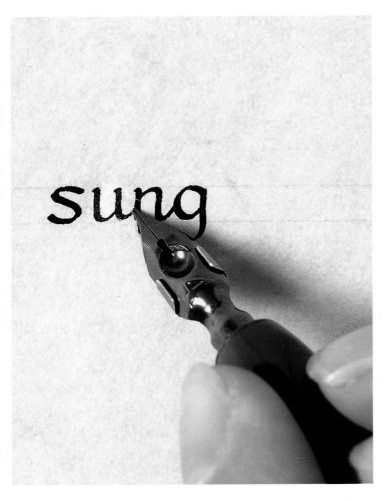

Step 3. Write the correct letters.

Step 4. If, as in the example, the paper pigment has been removed, after rubbing out the writing lines use a coloured pencil of the correct shade to replace the pigment, use a tissue to work the pigment into the paper.

Step 5. The corrected word.

PROJECT *Designing a family tree*

A handwritten family tree can make a very attractive document to hang on the wall. If you have researched your family history, you could make a chart that contains the names of as many current family members and ancestors as you like. You could also include some interesting pictures, maybe of places that have a family connection or of the professions of some of the people named.

Step 1 shows the text of a simple, four-generation family tree, which should be within the scope of most people whose grandparents can provide the necessary information.

Begin by sketching your information in the form of a rough, drop-line chart (Step 2), which will enable you to see what form the general shape and layout will take. Drop-line charts are created by placing the names of a married couple side by side, with an equal (=) sign between them denoting their marriage. The husband's name is usually placed on the left and the wife's on the right, but you do not have to adhere rigidly to this convention if the other way round suits your layout better. The marriage's date and place are written underneath, usually in a smaller lettering size.

Draw a vertical line descending from the equal sign. Next, arrange the names of the children of the marriage horizontally, in order of age, from the eldest on the left to the youngest on the right (Step 3).

Because there is no equal sign if the children belong to a single-parent family, the line proceeds downward

Family Tree of Andrew and Sarah Grey

Andrew Grey, born 15.2 1936, married 24.9. 1965 Catherine Parker, born 12.1.1938, parents of:
1) Michael Grey, born 4.4.1967, married 5.8.1995 Sarah Cornish, born 15.9.1970
2) Steven Grey, born 3.11.1969
3) Cara Elizabeth Grey, born 27.2.1971

John Michael Grey, born 1.12.1909, married 7.5.1931, Elizabeth Walters, born 17.9.1910, parents of:
1) William Grey, born 9.6.1932, married 6.9.1959 Jane Daniels, born 2.11.1936, they have one child - Ann Lisa Grey, born 4.12.1963
2) Roger Grey, born 7.4.1934
3) Andrew Grey

Henry Grey, born 17.9.1883, married 5.8. 1905 Mary Carter, born 6.7.1884, parents of:
1) Sidney Grey, born 27.8.1907
2) John Michael Grey

James Parker, born 2.7.1913, married 16.9.1937 Mary Latham, born 24.5.1913, parents of:
1) Catherine Parker
2) Edith Parker, born 2.11.1939, married 14.5.1963 John Williams, born 1.4.1938
3) John Parker, born 5.3.1942

James Parker, born 29.5.1880, married 2.7.1906 Louisa Bellman, born 6.9.1883, parents of:
1) James Parker
2) Doreen Parker, born 18.2.1915
3) Edward Parker, born 6.8.1918

Step 1. The text of a four-generation genealogy.

from the centre of the information given about the parent (Step 4). The names of unmarried partners can be written with a plus (+) sign between the pair of names to differentiate them from married couples, and then a line descending from the plus sign can be drawn (Step 5). With the ever-growing complexity of family relationships and the possibility of various combinations

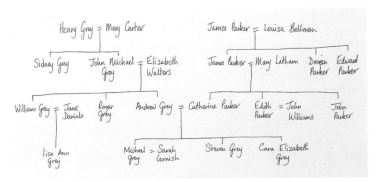

Step 2. Sketch a rough draught of the genealogy in a drop-line format.

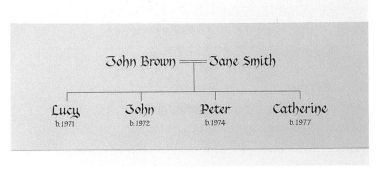

Step 3. The formation of a drop-line genealogy.

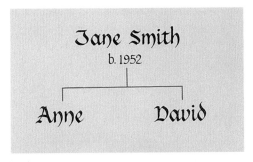

Step 4. For a single parent take the line down centrally below the name of the parent.

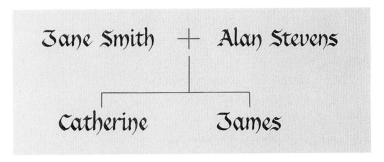

Step 5. A plus sign can be used to indicate unmarried partners.

Andrew Grey
b. 15. 2. 1936
m. 24. 9. 1965

Catherine Parker
b. 12. 1. 1938

Step 6. Write out each name on layout paper and add the biographical details underneath, trying to centralise the information.

Step 7. Rule the required number of generation lines on a layout sheet.

of biological, step- and adoptive parents, family trees will inevitably become increasingly difficult to organise clearly. However, the main thing to remember is that your principal objective is to create an attractive and informative chart, and you should therefore use whichever means suits you best for conveying the information. Provided that you make sure that it is clearly legible and unambiguous, any layout is acceptable.

Write out the name of each person in a large lettering size (a size 4 nib has been used in the example), and then inscribe their biographical details underneath with a smaller nib, such as the size 5 used here (Step 6). Because they are only needed as a guide for the final piece, it does not matter if the smaller details are not perfectly centred beneath the name.

Rule up a large sheet of layout paper with the correct number of lines for the generations that will appear on your chart (Step 7).

Now cut out and paste the names onto the sheet and arrange them to form the best layout (Step 8) by placing each

name in its correct order on the page just beneath the relevant generation line. Leaving a gap of about 1cm (about ½") below the generation lines will be sufficient and will enable them to be used to construct the connecting lines.

When the names are all in their correct positions, link the names of husbands and wives with equal signs. Then draw a pencil line downward from each set of parents to the generation line beneath (Step 9). If the children's names are not immediately below their parents', the line should stop just short – about 5mm (¼") – of the line below, so that a connecting line can be drawn to the left or right to meet up with the line associated with the correct set of children.

Using the horizontal generation lines, link the names of each group of siblings with a heavier pencil line by drawing a line above each group of children, from the first to the last name, and then pencilling in a small – about 5mm (4/16") – line from the horizontal line to the name of each child (Step 10). If the line descending from the parents has not yet been connected to the horizontal line, draw in the relevant section. Do this throughout the chart until the whole network of family groups has been correctly linked.

Add a title in a suitable lettering size, which you can centre at the top of the sheet. The completed draft is shown in Step 11. Write out the text (Step 12), working through the larger lettering first. Rule the writing lines carefully and use your draft lettering to determine the spacing of each name by measuring and marking the length of each set of words on the page.

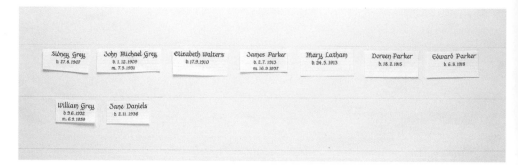

Step 8. Add the drafted names to the layout sheet in the correct sequence.

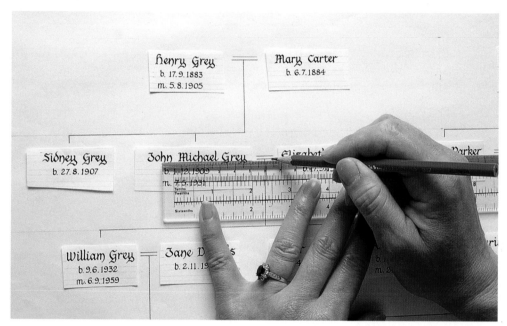

Step 9. Link up husbands and wives and connect them to their children.

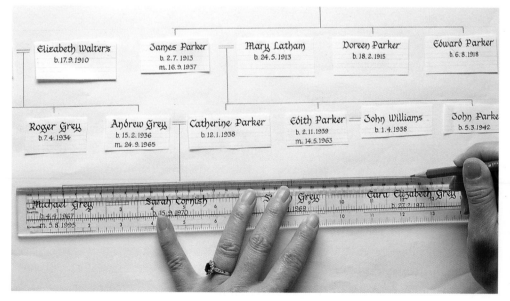

Step 10. Rule in the lines connecting the groups of siblings.

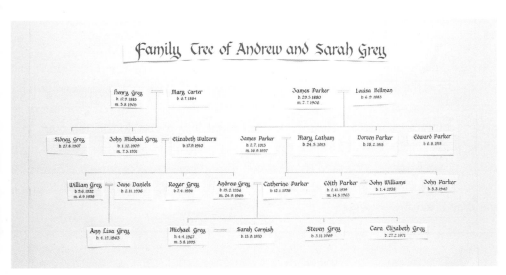

Work through the smaller lettering in the same way. You may not need to mark the length required for all of the smaller details, as the name above can often be used as a guide by noting at which point the smaller details start and finish in relation to the letters above them. Now add the title. Rule in the lines that make up the connecting framework, drawing them in with a ruling pen and a contrasting colour of gouache paint. Remove the writing lines.

Step 11. Completed draft.

Step 12. Proceed with your lettering.

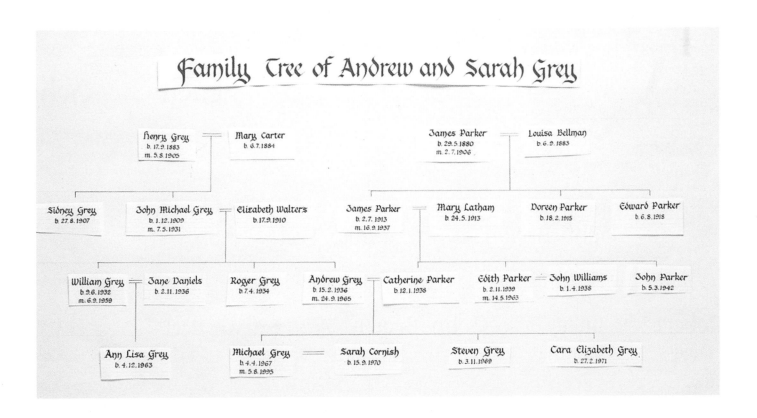

Large family trees

A larger, illustrated, genealogical chart is shown in fig.8. Although the steps used to build up the chart were exactly the same as those given above, remember that some very wide generations may be inherent in larger charts and that these will need to be compressed as much as possible in order to keep the whole piece within reasonable proportions. To assist the compression process, the names of couples can be arranged in a vertical block, with the line leading downward to the next generation being drawn directly below both partners' names (fig.9).

Try to keep each generation on a separate line, which will make the chart much easier to read. It may occasionally make better sense to fit a small family group between generations in order to simplify the layout, but if you do this too often you will lose the clear flow of generation following generation. If you need to make connecting lines cross over each other, use a small bridge (fig.10), so that it is obvious which line is going where.

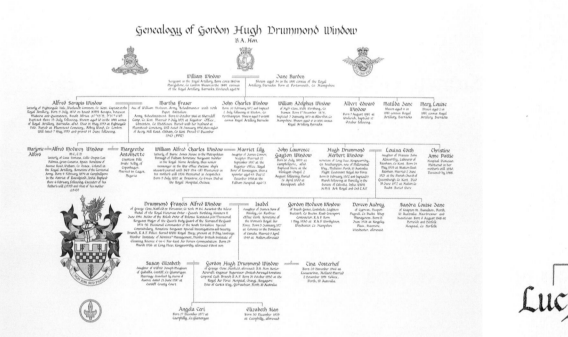

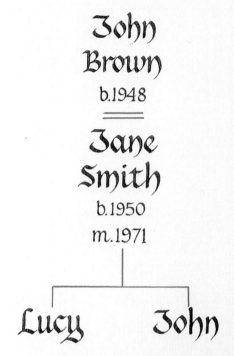

fig.8. A large illustrated genealogy.

fig.9. Detail of vertical block of text.

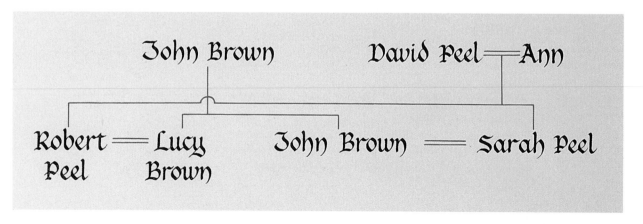

fig.10. Bridges can be used where lines cross to avoid confusion.

Rock Buns

. Cream
.. Add
il light
our in very
; mixture
20 minutes.
. sugar

4oz self-raising flour
2oz butter
2oz sugar
1 egg
2oz dried fruit

Rub fat into flour then
add sugar and half of
the egg then the dried
fruit. Mix all together
and place in spoonfuls
on a greased baking
tray. Cook for 15 minute:
in oven at Reg. 4.

Blackletter 8

Blackletter

Blackletter – another Gothic lettering style dating from the Middle Ages – derives its name from the density of its upright strokes, the closer spacing of its letters and the closer placing of its writing lines, all of which give it a much blacker appearance on the page than the more open styles that preceded it. This type of lettering accompanied many of the beautifully decorated and illuminated books of the medieval period. Although it was also used in some of the earliest printed books, it quickly lost ground to styles that were both easier to read and more practical for the printer to use.

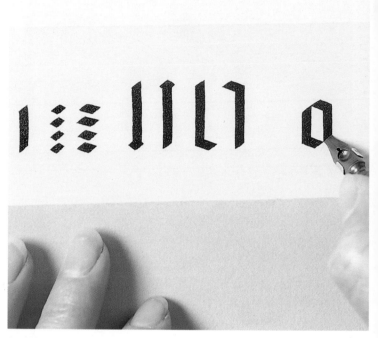

fig.1. Blackletter practise strokes.

Begin learning this lettering style by practising the strokes shown in fig.1. Because there are not many curved strokes in the blackletter hand, it suits calligraphers who have difficulty making uniformly rounded strokes, although care must be taken to get the spacing right so that the lettering does not look ugly.

The minuscule letters are illustrated in fig.2. Closely examine the construction of these letters and note that there are several terminations to the upright strokes and that each has a diagonal stroke attached to the beginning and end that is one of three different lengths (fig.3). As with the other alphabets, the 'm' (fig.4) is a good example because it uses all three of these strokes in one letter. The first and last strokes are the short diagonal running straight into, or out of, the upright (fig.3). The bottom stroke of each of the first two uprights must be the small, centrally placed stroke illustrated in fig.3b; if you do not use this stroke you will close up the gaps between the uprights and make the letter difficult to read. The top two strokes connecting the three uprights are the slightly longer diagonal line that flows out of, or into, the upright (fig.3c). If you take care when forming these connecting strokes, the style will look even and well balanced.

The letter 'a' starts with a long cross-stroke at a slight angle at the top, which leads into the downstroke and the final serif at the bottom. A thin, diagonal stroke is needed for the middle part of the letter to follow into the downstroke and the bottom stroke that connects with the bottom serif. To finish the letter, make a hairline connection between the top and the centre of the letter, as illustrated in fig.5. Use the corner of the pen to make this stroke, which should be a natural curve leading round from one part of the letter to the other.

The top of the 'd' should be carefully judged so that it finishes in the correct place to allow the second downward stroke to be the right distance from the first. The 'e' is another letter that includes a thin, diagonal, connecting line, this time between the top stroke and the first upright stroke. A short, horizontal line can sometimes be taken from this stroke to the right, as is shown in fig.6, or else the stroke can be a diagonal line following the direction of the top stroke.

The 'g', 'j' and 'y' are all similarly formed letters, whose tails are connected to the rest of the letter by means of a thin stroke. The stroke leading from the downstroke of the 'j' begins where the vertical starts to bend to the right on a level with the bottom writing line.

abcdefghij

klmnopqr

stuvwxyz

fig.2. Blackletter minuscule alphabet.

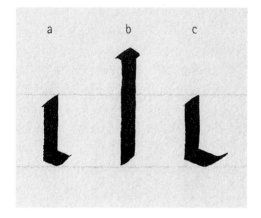

fig.3. Terminations to upright strokes.

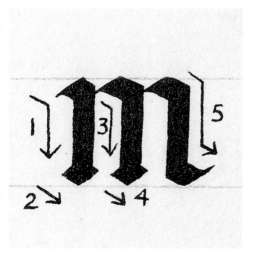

fig.4. The blackletter 'm' contains the three different

terminations to the upright strokes.

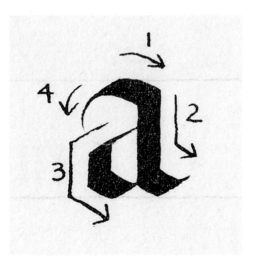

fig.5. Formation of letter 'a'.

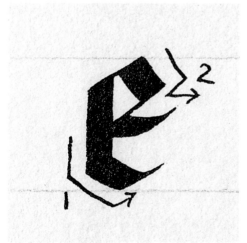

fig.6. Letter 'e'.

The 's' is quite a difficult letter to write because it is formed by changing the pen direction many times (fig.7). The main strokes are then bisected by a thin, diagonal line running through the centre, which should leave two tiny gaps on either side of the two middle strokes. You will have to adjust your pen very slightly when filling these. The 'x', which is formed as shown in fig.8, has two central strokes that overlap each other.

Because the letters are written quite close together, and because so many of the strokes are the same, this style can be quite difficult to read. Some of the letters have variants (a few are shown in fig.9), however, whose use can make the hand both easier to read and more decorative. The final strokes of such letters as 'h', 'n' and 'm' can be given an elongated, curving finish, for example, which breaks up a long row of uprights very well (fig.10). Similar curves, albeit at the top of the letters, can be added to the 'v' and 'w'. You can find examples of all of these strokes in medieval manuscripts. A crosspiece can also be given to the central strokes of the 'w' and 'm' to make the letters a little clearer.

The capital letters of the blackletter alphabet are among the most decorative of any calligraphic hand (fig.11). As well as being quite complex, there are several versions of some letters – indeed, you can even embellish them further with extra strokes to suit your purposes. Nearly all of them have a thin, vertical stroke placed alongside an upright, and in order to make the thinnest possible stroke you will have to turn your pen completely sideways (fig.12). A small, extra stroke is often placed within the more open letters (fig.13). Because these letters are so decorative, however, words that consist solely of capitals are very difficult to read and tend to look overly fussy. If you are using the blackletter hand for titles, it is therefore much better to combine the upper and lower cases instead, and to make the letters' increased size the dominant feature (fig.14).

The ascenders and descenders of the blackletter style can be given a very attractive finish by means of the fishtail, or Fraktur, serif shown in fig.15. The serif requires the same sort of hairline stroke that was used in the formation of cursive italic letters, which is made by using the corner of the pen to flick out the extra stroke (fig.16).

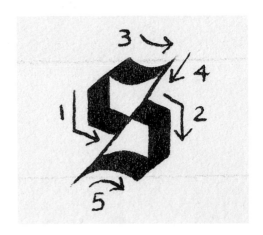

fig.7. Letter 's'.

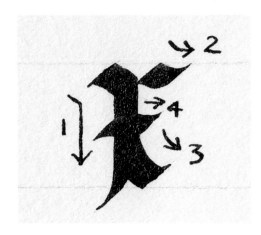

fig.8. Letter 'x'.

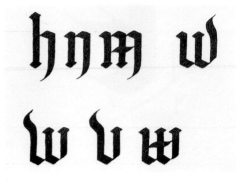

fig.9. Alternate letters

fig.10. Using the more embellished letters to improve the legibility of a long row of vertical strokes.

ABCDEF
GHJJKLM
NOPQRST
UVWXYZ

fig.11. Blackletter capitals

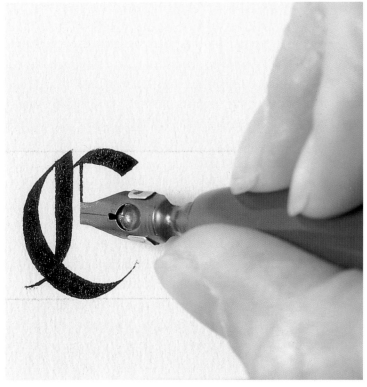

fig.12. The pen is held vertically for the thin strokes of the capital letters

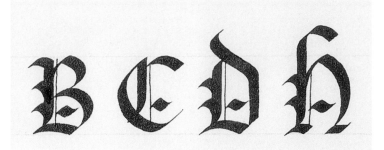

fig.13. A small additional stroke is often placed within the curved area for decoration.

fig.15. Fraktur serifs.

fig.16. The serif needs a deft manipulation of the corner of the nib.

Ye Olde Tea Shoppe
YE OLDE TEA SHOPPE

fig.14. A title in a mixture of blackletter minuscules and capitals is much easier to read than one composed of capitals only.

PROJECT *Making a calendar*

Numbers can be written to match the straight-sided, blackletter style, and these are shown in Step 1. Because they are not very easy to read, however, it is generally better to accompany most lettering styles with the simpler numerals of one of the plainer styles, for example, when you are writing an address, for which legibility is very important.

A simple, calligraphic calendar can be made using a heavy weight of paper or thin card. Write out the names of the seven days of the week in fairly large lettering (the examples shown in Step 2 were written with a nib size of 1). Write the months of the year in the same size, too, but in a different colour. Leave plenty of space between each word because the cards will all be cut to the same size. Cut the cards so that each word is central (Step 3).

Write the numbers 1 to 31 with a larger nib (for the numbers illustrated in Step 4 a size 3 automatic pen was used, making figures 30mm (about 1") high).

Cut out all of the pieces of card to a height of 60mm (2 6/16"). The cards containing the weekday and month names should be cut to a width of 120mm (4 3/4") and the numerals cards to a width of 60mm (2 6/16").

You can display the day's date in various ways. Firstly, you could make a central hole at the top of each card and then hang the cards on a row of hooks fixed to a small board. You can buy suitable hooks from a hardware shop. Secondly, you could make a simple stand out of thick folded card, fashioning a lip at the bottom to hold the cards (Step 5)

A third alternative is to fix the cards into place on a board with strips of Velcro. Velcro (usually black or white), which is available from haberdashery shops, is composed of two strips of fabric that adhere to each other, but that can be pulled apart time and time again. Buy the 'stick-and-stick' version, which is adhesive on the back of both strips, so that one piece can be applied to the back of a card and the other to the board (Step 6). If you look at the Velcro closely, you will see that one side is composed of tiny hooks and the other of a mesh of loops, to which the hooks catch. Use pieces of the hooked side of the strip for the cards and of the looped side for the display board. The board can then be hung up (Step 7).

Manufacturers of commercial display boards often cover them with a fabric that is designed for Velcro attachments, and you may be able to find such display boards and boxes of small, circular, Velcro fasteners in office-supply shops.

Step 1. Blackletter numbers.

Step 2. Write the weekdays and months in a large lettering size.

Step 3. The weekdays and months are centralised on the cut cards.

Step 4. The numbers 1 to 31 are written in foundation hand for clarity.

Step 5. A simple stand for the calendar cards is made from thick folded card.

Step 6. 'Stick and stick' Velcro.

Step 7. A cord can be attached to the board for hanging.

PROJECT *A Shakespeare sonnet*

Because the blackletter hand is very dense, a piece of text written in a block in this style looks very effective. The Shakespeare sonnet shown in Step 1 consists of lines of roughly the same length and therefore lends itself to this treatment.

Cutting and pasting text can be avoided with a layout like this because the lines are so similar in length that writing them out, line after line, as a straightforward practice piece will provide you with enough guidance for the final work and will also give you a good impression of how the finished piece will look in terms of its density of text, line spacing and so on.

When you have written the draft text, measure the length of the lines (Step 2) to help you to make small adjustments to the starting point of each line to ensure that all of the lines are centred when you are writing the final piece. Any lines of text that are a little shorter than the majority can be indented slightly, making the difference in length less noticeable, while those that are slightly longer can be started slightly further forward to give a square block of text. Now write out the text (Step 3). Because blackletter is written with only one letter height between each

line of text, take care that you do not make the ascenders and descenders too long (Step 4).

The final piece was written on pale-blue Parchmarque paper in pairs of lines that were coloured terre verte (a sage-green colour), yellow ochre and deep red. A size 3 Mitchell nib was used, and the writing lines, as well as the spacing between the lines, measured 6mm (1/4"). A dense piece of work like this needs a wide border, so allow for large margins around the text when you trim the paper to size.

Step 1. The text is written in draught and coloured pencils indicate the chosen colour scheme.

Step 2. Rule up the writing lines then, using a central vertical line for measuring, mark the start and finish points of each line of text.

Step 3. Proceed with the lettering.

Step 4. Blackletter needs only one letter height between each pair of writing lines.

Making borders

It is important to give some thought to the borders that will surround your work. Some examples are shown in fig.17. If you leave too little space for a border, the text will look as though it has been crammed on to the page. By contrast, if the borders are too large, the text may look a little lost. Good border proportions are usually achieved by allowing about a quarter of the width of the block of text for the side and top borders. The bottom border is generally made a little wider to give a balanced appearance.

Another Shakespeare sonnet is illustrated in fig.18. The initial letter has been enlarged for decorative purposes. If you allow a large initial letter to extend beyond the rest of the block of text, you could add a simple, coloured, floral-patterned border down the left-hand edge (fig.19). By allowing the initial letter to protrude beyond the top line of the text you also can work the border along the top edge of the design, as well as down the left-hand side. By slightly shifting the block of text in relation to the page you can furthermore either extend the border around three sides or make it completely surround the text.

You can also introduce small motifs and decorations to pieces that consist of several verses by placing these between the verses (fig.20 and fig.21). Alternatively, you could write the text within any suitable shape (fig.22). A framed piece is illustrated in fig.23.

fig.17. Different border widths. a) too narrow b) too wide c) correct.

fig.18. Sonnet.

fig.19. Border construction.

Desiderium

My spirit longeth for Thee,
Within my troubled breast;
Although I be unworthy
Of so divine a Guest.

Of so divine a Guest,
Unworthy though I be;
Yet has my heart no rest,
Unless it come from Thee.

Unless it come from Thee,
In vain I look around;
In all that I can see,
No rest is to be found.

No rest is to be found,
But in Thy blessed love;
O! let my wish be crowned,
And send it from above!

John Byrom

fig.20. Decoration between each verse embellishes this text.

Against Idleness and Mischief

How doth the little busy Bee
Improve each shining Hour,
And gather Honey all the Day
From ev'ry op'ning Flow'r!

How skilfully she builds her Cell!
How neat she spreads the Wax!
And labours hard to store it well
With the sweet Food she makes.

In Works of Labour or of Skill
I would be busy too:
For Satan finds some Mischief still
For idle Hands to do.

In Books, or Work, or healthful Play,
Let my first Years be past,
That I may give for every Day
Some good Account at last.

Isaac Watts

fig.21. The verses can be arranged around a central decoration.

SOUND,
sound the clarion,
fill the fife! To all the
sensual world proclaim,
One crowded hour of
glorious life Is worth
an age without
a name.

fig.22. The text of this piece has been fitted into a circle.

"I'll lend you for a little while a child
of mine," he said,
"For you to love the while he lives,
and mourn for when he's dead.
It may be six or seven years, or
twenty-two or three,
But will you, till I call him back,
take care of him for me?
He'll bring his charms to gladden you,
and should his stay be brief,
You'll have his lovely memory,
as solace for your grief.
I cannot promise he will stay,
since all from earth return,
But there are lessons taught down
there I want this child to learn.
I've looked the wide world over in
my search for teachers true

And from the throngs that crowd
life's lanes, I have selected you.
Now will you give him all your love,
nor think the labour vain,
Nor hate me when I come to call
to take him back again."
I fancied that I heard them say,
"Dear Lord, thy will be done.
For all the joy, thy child shall bring,
the risk of grief we'll run.
We'll shelter him with tenderness,
we'll love him for the while we may.
And for the happiness we've known
forever grateful stay.
But should the angels call for him,
much sooner than we've planned,
We'll brave the bitter grief that
comes and try to understand."

fig.23. Two columns of text are separated by a central illustration.

PROJECT · *Constructing a recipe book*

The final project in this chapter is a recipe book, some of whose recipes have been written in draft. The title and list of ingredients for each recipe have been written in blackletter, while the cooking method is in italic.

If you want to create greater visual interest by varying the layout of the recipes from page to page, you could position blocks of text in ways that suit the quantity of text contained in each recipe. Step 1, for example, starts with a straightforward, centred title and then lists the ingredients in a block to the left, with the method being written on the right.

In Step 2 the ingredients have been split into two columns below the centred title, with the method occupying the entire width of both columns beneath them.

Because the list of ingredients illustrated in Step 3 is short, it has been placed under the title on the left-hand side of the page, with the method written in a block on the right to balance it.

Rock Buns

4 oz self-raising flour
2 oz butter
2 oz sugar
1 egg
2 oz dried fruit

Rub fat into flour then add sugar and half of the egg then the dried fruit. Mix all together and place in spoonfuls on a greased baking tray. Cook for 15 minutes in oven Reg.4

Step 1. Here the title is centred, with ingredients to the left and method to the right.

Macaroons

2 egg whites
5 oz castor sugar
5 oz ground almonds

few drops almond essence
almonds or cherries
rice paper

Whisk egg white until very stiff. Add almond essence, then sugar and ground almonds. Roll the mixture into rounds and place – well spaced out – on rice paper. Put a cherry or almond on top of each biscuit Bake for 20 minutes at Reg.4 When nearly cold, remove from tin and tear around the rice paper.

Step 2. Here the ingredients are split into two columns, with a centred title and the method the width of both columns.

Shortbread

1 oz castor sugar
2 oz butter
3 oz plain flour

Preheat oven to Reg.4. Cream butter until very soft. Add sugar and cream until light and fluffy. Stir in flour in very small amounts. Press mixture into a tin. Cook for 20 minutes. Dredge with castor sugar while still hot.

Step 3. The title and ingredients are on the left, with the method on the right.

Step 4 shows a long list of ingredients centred down the page, with the method split into two columns to the left and right of them. The book can contain even more variants – to arrive at a good layout, regard the lettering as blocks of text that can be moved about the page and split into further blocks if necessary. This method of designing a page of text is useful for many types of work.

When you have decided on your layout, measure and rule the guidelines and marking points on your paper, and proceed with the lettering (Step 5).

The recipe book itself could either be a pre-bound book containing good-quality paper, or you could instead make and bind a simple book yourself. If you are making your own recipe book, first cut sheets of paper to form double-page spreads, allowing generous margins so that you can accommodate larger areas of text if necessary.

When you have a large enough collection of recipes (for example, six double-page spreads) to make a volume, bind them together with a title page and cover. You will need a thick, decorative paper for the cover. Alternatively, you could buy some purpose-made binding paper that has been strengthened with a mesh of fabric.

Step 4. The ingredients are centred down the page, with the method split into two columns.

Step 5. Proceed with your lettering.

Step 6. A large needle and thick binding thread are needed.

The pages are sewn together using binding thread and a large binding needle (Step 6). Sew them along the central crease through five evenly spaced marks as shown in fig.7. Push the needle through all the sheets each time. (Step 8). Bring the ends of the thread to the centre of the pages and knot them together around the central thread. (Step 9).

Step 7. This diagram indicates the direction the sewing thread should take.

Step 8. Carefully sew the pages together.

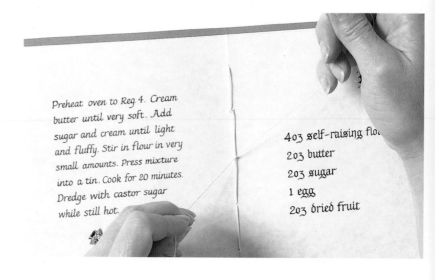

Step 9. Knot the ends around the central thread then cut them off leaving about an inch.

The uncial hand 9

The uncial hand

The uncial letters that can be seen in eighth- to tenth-century Celtic manuscripts have a squat, rounded appearance that can be useful for many types of decorative work. The letters are widely spaced, being closer to the round, or foundation, hand that we learned first than to the compressed styles that we subsequently moved on to.

The letters shown in fig.1 are a simplified and modern form of the original uncial hands that were used during the Dark Ages. Because the letter height is slightly shallower than in most other styles, a height of four-and-a-half times the width of the nib will give a better effect than the normal five (fig.2). A slightly shallower pen angle is also required (fig.3).

The ascenders and descenders should be kept very short. In addition, as in the blackletter style, the height between the writing lines should be the height of one letter only (fig.4). In conjunction with the greater width of the letters, this will result in lettering that takes up a lot of space horizontally, but not vertically, so if you are writing a piece of text that contains a large number of short lines this style will give the piece greater width.

The small, wedge-shaped serif of this hand is very easy to construct. The point that is given to the ascending strokes (fig.5) is simply a short, diagonal stroke taken to the left, and then to the right, before the downward stroke is begun. At the end of the horizontal stroke, the thickened, terminating stroke to such letters as 'e', 'f' and 'l' is formed in a similar way, that is, by making another short stroke diagonally downwards near to the end and then drawing the nib back up to the end of the horizontal to join the two strokes (fig.6).

The letter 'a' begins with a diagonal stroke that is curved at each end to follow the natural direction of the pen. The narrow, loop shape that forms the rest of the letter is one continuous stroke that balances the diagonal. The 'b', 'c', 'd' and 'e' are all well-rounded letters. Remember, however, that when you are forming the top stroke of the 'd' you should take care to bring it round to the correct position so that it completes the circle that was begun by its first stroke.

fig.1. Modern uncial alphabet.

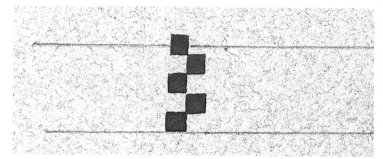

fig.2. The writing line height for uncials is 4.5 times the width of the nib.

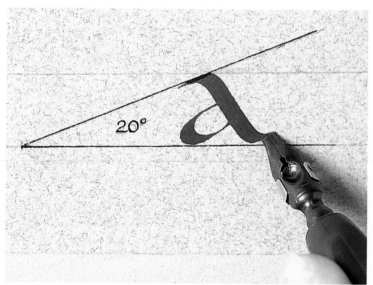

fig.3. The pen is held at an angle of 20°.

fig.4. Keep the ascenders and descenders short and allow one letter height between the writing lines.

The horizontal bar of the 'f' extends slightly beyond the end of the top stroke, while the descending stroke finishes just below the bottom writing line. The 'g' differs from the 'c' only in having a slight tail at the bottom, which can be made without lifting the pen from the page after making the second rounded stroke. The 'h' is usually given the rounded second stroke that is shown here, and care must be taken not to bring the final, trailing stroke too close to the first upright stroke, otherwise the letter will look like a 'b'.

Although the 'i' and the 'j' were not originally dotted, in order to make the lettering easier to read they can be given a thin, sideways stroke to form a 'dot'. The bottom of each of the aforementioned letters, as well as several others, is given a small serif in the form of another thin, sideways stroke, but in this case it should be less pronounced than that used for the 'dot' – make it with little more than a diminishing flick of the pen. The 'k' and the 'r' are the same, apart from the lengthened first stroke of the 'k'. Because the squatness of these two letters can make them look quite cramped, and the looping second stroke and final diagonal are compressed into a small area, make sure that you write them as clearly as possible. The 'l' has a bottom stroke that is the same length as the horizontal stroke of the 'f'.

An 'm' formed with rounded outer strokes and an 'n' with a rounded second stroke have been illustrated here, but remember that there are various alternatives to these two letters (some of which are shown below), any of which may be used in combination in a piece of lettering. When you are writing the rounded 'n', do not take the end of the curved stroke too close to the vertical. A completely circular 'o' is used, while the 'p' is composed of only two strokes, with no extra small stroke joining the vertical to the rounded stroke. The end of the rounded stroke is carried around to meet the vertical, with the corner of the pen finishing the stroke. Although the rounded shape of the 'v' is almost circular, the curve of the

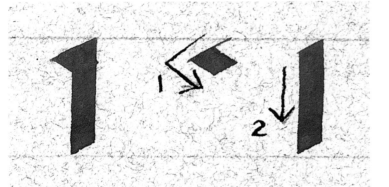

fig.5. The small wedge shaped serif given to vertical strokes.

fig.6. The thick terminating serif to horizontal strokes on the 'e', 'f' and 'l'.

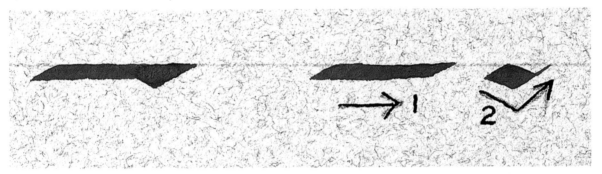

second stroke has been modified slightly, so that although there is a gap at the top, the second stroke still meets the first at the bottom in a matching curve that makes the letter look as though it were round.

Alternative uncial letters

Fig.7 shows some of the alternative uncial letters that can be used in place of those given above. The unusually shaped 'g' is more likely to be encountered in an original uncial alphabet, but because it is not very recognisable in a page of text, you will need to decide whether clarity or authenticity is more important to the particular piece of lettering that you are working on. Note that the 'l' illustrated here has the same curve as that used for first stroke of the 'b' in the letters shown here.

The alternative 'y' is not found in Celtic manuscripts, but is shown here because it can be helpful when you want the text to be very legible (the version given above can closely resemble a 'u' at first glance).

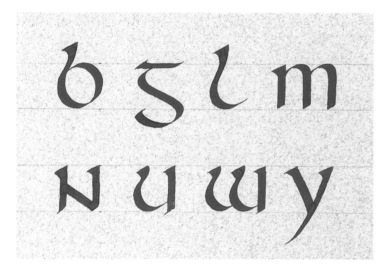

fig.7. Some alternative uncial letters.

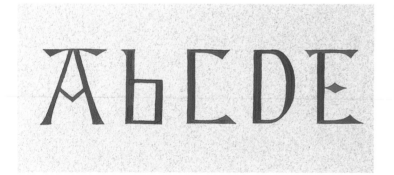

fig.8. Angular capital letters often found accompanying uncials.

Enlarged miniscules

Uncial text did not contain capital letters at the beginning of sentences. Where it was necessary to place emphasis on particular letters, an enlarged version of the minuscule was used instead, often with a little extra embellishment of colour and decoration. Large, very angular letters can be found in groups in some Celtic manuscripts, and these can be used as capital letters. Because they were usually drawn and painted rather than being written with a pen, however, their shapes do not lend themselves to being written as part of an ordinary block of text (fig.8).

The enlarged versions of the minuscule letters are made with a nib of the same size as that used for the rest of the text, but are built up with several stokes of the pen to create the extra weight needed for their increased height. If you have trouble with these large-sized letters, work on them on layout paper until you have formed a pleasingly shaped letter. You can then trace the outline of this letter and use the tracing as a guide, either for subsequent letters or for your final pieces, until you have become proficient enough to write them freehand. Fig.9 shows an alphabet of letters based on Celtic-manuscript uncials that can be used as capitals.

The Irish saying (with its translation) shown in fig.10 is a typical uncial text, with larger, lightly illuminated letters scattered over the page. The centres of the large letters, as well as the spaces around them, were filled with another colour and then surrounded by red dots (fig.11). Fig.12 shows another example of uncial lettering that was used to make a retirement card.

The original uncial letters were written with the pen held at a very flat angle (fig.13). If you look at old manuscripts, however, you will see that it would not have been possible for the scribe strictly to adhere to a constant pen angle when producing some of the strokes, so you can use a little latitude when writing this alphabet. Indeed, there are many variants to some of the letters, which nevertheless retain a Celtic feeling.

ABCDE
FGHIJK
LMNOP
QRSTU
VWXYZ

fig.9. Large uncials used as capitals.

Tum fosgladh dorus na
bliadhna Uire chum Sith
Sonas is Samchair

May the door of the
coming Year open for you
to Peace happiness and
Quiet Contentment

fig.10. An Irish text scattered with lightly illuminated letters.

fig.11. The letter is filled with a colour and surrounded with red dots.

With Best
Wishes
on Your
Retirement

From all at

GVP

fig.12. Retirement card.

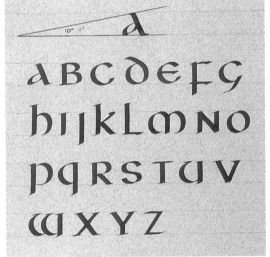

ABCDEFG
HIJKLMNO
PQRSTUV
WXYZ

fig.13. Eighth century Uncial alphabet.

PROJECT *Designing a Celtic greeting card*

We will now make a greeting card that features the well-known Irish saying Caed Mille Failte ('One-hundred-thousand blessings'). You will need a fairly stiff card of at least 150gsm (grammes per square metre) for this project.

Because you will probably want it to fit into an envelope, the card has been designed with dimensions of 210 x 105mm (around 9 x 4"). Not only are there plenty of envelopes available in this size, but it will also suit the wording very well.

Because the design includes few words, you will need a large-sized nib. Experiment a little until you have found the best size (Step 1). Here, a size 1½ nib was first used, which worked quite well. Since there was still plenty of unfilled space on the card, however, the lettering was then written with a size 1 nib. Not only did the lettering produced also fit within the required space, but it also had a bolder, more striking appearance. The size 1 nib was therefore chosen over the size 1½ (Step 2).

Write out and centre the smaller lettering of the translation (Step 3). A size 4 nib was used here, with the writing lines 4mm

(about 3⁄16") apart. This size seemed ideal, so no further experimentation was needed.

Now decide on the decoration. In this example, the three initials will be given the simple, filled centre and surround of dots that was mentioned above (Step 4).

Cut the card to size – 210 x 210mm (about 9 x 9") – and leave it unfolded while you are working on the lettering (it is easier to measure the writing lines accurately from a straight, cut, top edge rather than from a slightly uneven, doubled-over edge).

Work out the position that the text will occupy on the bottom portion of the unfolded card and rule in the writing lines (Step 5).

Step 6. Write the text and then decorate it. (Always leave the decoration until the text has been written in case you make an error that may necessitate you having to start again.)

Fold the card, matching up the corners carefully, and crease it slightly. Use a bone folder to finish the crease, which will give you a crisp, sharp fold. The finished card is shown in Step 7.

Step 1. Choosing the best nib size.

Step 2. Experimenting with an alternative nib.

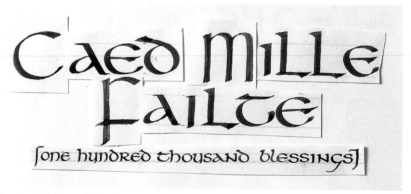

Step 3. Add the small lettering.

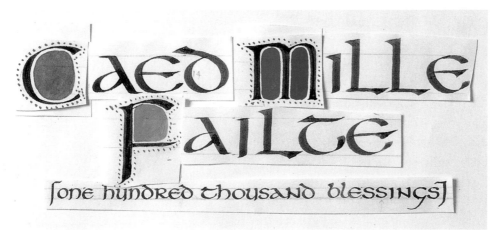

Step 4. Add the decoration.

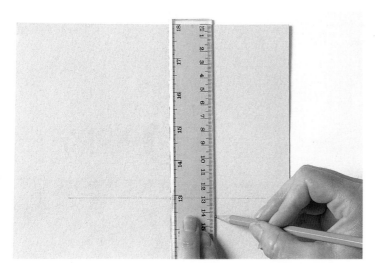

Step 5. Measure and rule the writing lines on the unfolded card.

Step 6. Use a bone folder to give a crisp fold to the card.

Step 7. The finished card.

Celtic decorative motifs

A Celtic new-year greetings-card design is illustrated in fig.14. (Bliadhna Mhath-ur means 'Happy New Year').

Celtic manuscripts abound in wonderful motifs with which to decorate texts: knotwork patterns interwoven with animals and birds can be used to enliven any piece of lettering, for example, and many good source books feature illustrations from such great Celtic manuscripts as the Book of Kells and the Lindisfarne Gospels.

fig.14. A New Year greetings card.

PROJECT *Celtic birthday card*

The design for the birthday card pictured in Step 1 was arrived at by first writing the lettering in uncials, using large initial letters for each word. When centred beneath one another on the draft (Step 2), the three words suggested a square, rather than a rectangular, shape for the card, and because the corners were obvious areas to decorate, an outer pattern of Celtic knotwork that concentrated on these areas was decided upon. One corner was first designed using a linear pattern (Step 3), which was repeated in each corner (Step 4), the corners then being joined with twisting bands to form a complete border. The card used was Marlmarque.

Step 1. A Celtic knotwork card.

Step 2. The centered words suggest the overall proportions of the card.

Step 3. Beginning of the linear pattern.

Step 4. The border is a repeat pattern of each corner.

Paper and card for calligraphy

Paper and card for calligraphy need to have various suitable characteristics, the most important being surface texture. Paper that is not porous enough will result in the ink sitting on the surface and not penetrating the fibres properly. Although the ink will dry after some time, the letters are unlikely to be sharp and clear. By contrast, paper that is too porous will cause the ink to spread among the fibres like blotting paper, and crisp, sharp-edged letters will again not be produced. Two very good papers that have just the right degree of absorbency are the Fabriano Ingres and Arches papers (fig.15). Others that you may be able to find locally are T H Saunders, Waterford and Canson papers. Such papers are usually sold in large sheets, and the Fabriano Ingres and Canson papers come in a wide range of colours (fig.16), as well as a choice of thicknesses.

Apart from its absorbency, the correct surface texture is also important because some papers can be quite rough, in which case the nib may catch on any loose fibres, resulting in either a spatter of ink across the page or badly formed letters. This is less of a problem when you are using larger nib sizes than those numbering from 3 to 6. Although you can sometimes use a rough texture to your advantage, in that you can produce an interesting effect, a fairly smooth surface is generally preferable.

When you are buying handmade papers, you will find that they are described according to their surface texture. 'Rough' papers have been pressed between sheets of felt before being dried, with the result that the texture of the felt is impressed onto the paper. 'Not' papers are smoother, because the sheets are pressed together several times, while 'hot-pressed' (HP) papers are given a much smoother surface by being pressed between hot metal plates.

When paper is made, a pulp consisting of its fibres is shaken in a large tray until the pulp is evenly spread over the whole surface of the tray. In the case of handmade paper, the fibres end up lying in a more random manner, which gives a less pronounced general direction to the fibres than when they are shaken by machine, which produces less variation in movement. The dominant direction of the fibres will give the paper a more pronounced grain direction when it has dried. This can be seen when a sheet of paper is torn: the tear produced across the grain is far more jagged than a tear made along the grain, that is, in the same direction as the fibres. Remember this when you are cutting paper and card – perhaps for greeting cards – as not only is it easier to fold, but you will also achieve a neater, sharper crease when folding along the grain rather than against it.

A laid surface can be given to the paper by making it in trays whose wire mesh has a more pronounced pattern. Watermarks are similarly produced, in that the wires are

fig.15. Some good papers for calligraphy - Arches Aquarelle, Canson Mi-Teintes, Fabriano Ingres, Fabriano 5, Waterford.

fig.16. A selection of the Canson and Ingres paper colours.

fig.17. Vellum effect papers - real vellum, Parchmarque, Pergamenata (vegetable parchment), Elephanthide.

fig.18. Textured and patterned papers: Ingres pastel paper, mottled green; Canson Mi-teintes- mottled dark grey and light grey; Countryside; Kashmir; Marlmarque in a range of colours; Cloud Nine paper in six colours; hammer embossed; linen embossed.

fig.19. A selection of Japanese papers.

formed into a specific shape. Because fewer fibres lie on the raised parts of the wire's design, a variation in surface texture that corresponds to the shape of the wires is produced when the paper is turned out of the tray.

Paper thickness is measured in grammes per square metre (gsm). The average writing or office-stationery paper weighs between 90 and 110gsm, which is rather thin for calligraphy because it is likely to crinkle when it is dampened by ink and paint. A good weight for most calligraphic lettering is 150gsm. If you require card, you will find that 300gsm is a fairly stiff weight that will stand up on its own.

The durability of the paper could be an important factor when you are planning a piece of lettering. If you want to ensure that your paper will not deteriorate too quickly, look for an acid-free, conservation-grade paper. Most good paper shops will be able to tell you the acid content of their papers and advise you on which to choose.

Paper manufacturers have long been trying to produce acceptable substitutes for vellum and parchment, writing surfaces that are very good for lettering. Not only can mistakes be fairly easily removed from these animal skins, but their veining can look very attractive, too. Some of the papers that have been made in an effort to reproduce some, or all, of these qualities are shown in fig.17. All are very good-quality papers, with different characteristics.

A selection of coloured papers that have different textures and patterns, such as a mottled or marbled effect, are pictured in fig.18. Japanese paper manufacturers produce some very attractive, decorative papers, some of which are shown in fig.19. Many are suitable for lettering and can add a lot to your designs. Woodgrain paper, which is available in a large range of colours, has a surface that is perfect for lettering. And although some of the lace- or string-effect papers can be more challenging, they can also be written upon successfully.

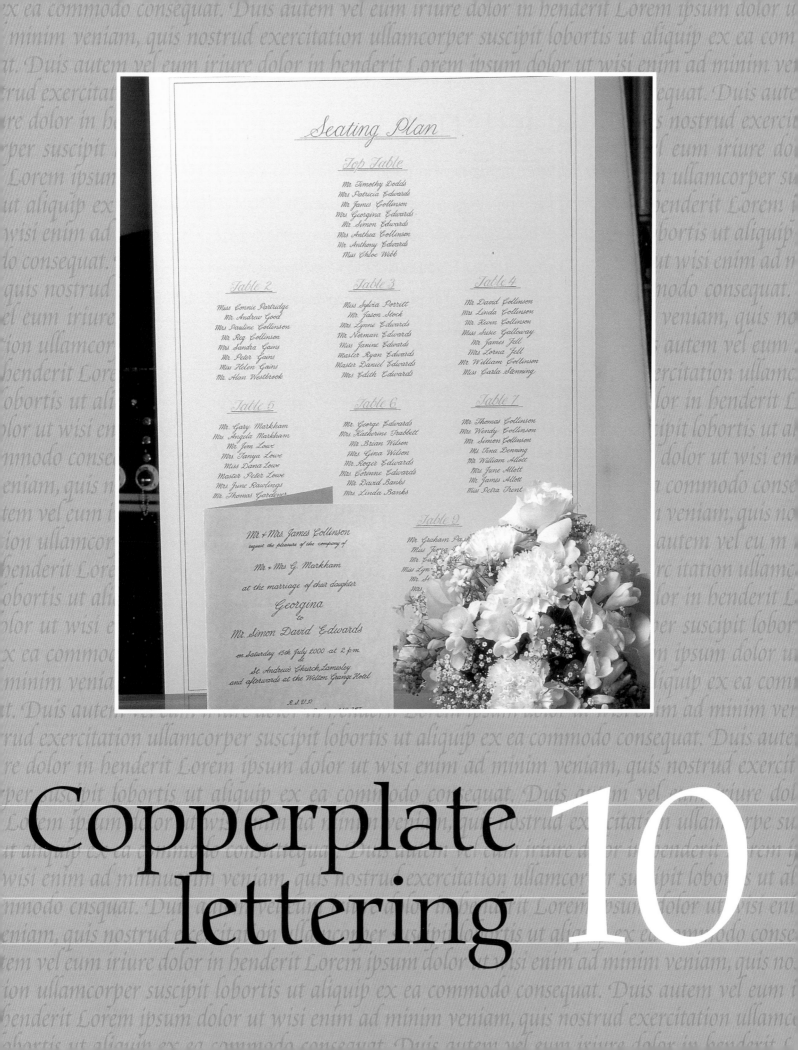

Copperplate lettering 10

Copperplate lettering

The final lettering style that we shall learn is copperplate, which printers usually call palace script, or just script. This is the style that is most commonly associated with invitations and wedding stationery, and is also useful for filling in the blank spaces of a form or certificate that has been printed in copperplate (fig.1). If you need to write on a pre-printed card such as this, make sure that it will take the ink acceptably, as some printed cards can be quite shiny and unabsorbent. When removing any writing lines, be especially careful not to smudge the ink, which may have dried on the surface of the paper without penetrating the fibres sufficiently and could therefore be removed more easily than you expect.

Copperplate was also the hand that was used for writing official documents during the eighteenth, nineteenth and early twentieth centuries, and many old vellum deeds can be seen that are inscribed in beautiful copperplate handwriting. Indeed, certain longstanding establishments still continue to write some of their prestigious documents in this way.

Copperplate lettering

Of all of the lettering styles, copperplate is the least forgiving of error and needs a great deal of practice to master. The nib required to write this hand is different from the broad-edged nib that we have used for all of the other styles that we have learned, in that it has a thin point (fig.2). The William Mitchell copperplate nib also has an elbow bend to make it easier to use. No reservoir is required, as quite a few of the letters can be written each time that you dip the nib into the ink. Take care not to press down on the nib too heavily as you make your strokes, however, or else its fine points will splay apart and the ink will not flow from it properly.

There is no need for a range of nib sizes for copperplate lettering, because the same nib makes all of the lettering sizes, as illustrated in fig.3. As you can see, in the case of the smaller lettering heights, a difference of half a millimetre in the width of the writing lines can make quite a difference to the lettering size. The angle of slope of the letters is about 45°, but you can vary the angle to suit your own preference to a certain extent, the only requirement being that you keep whichever degree of slope you choose constant throughout the piece of lettering.

The basic copperplate alphabet is shown in fig.4. The main difficulty that this hand will give you is keeping the constant

fig.1. Copperplate lettering on a printed certificate.

degree of slope to the words, and if this causes you real problems, use diagonal guidelines, as well as your normal writing lines, to ensure that you keep the angle constant (fig.5). The height between the writing lines should be at least two letter heights, and three or four letter heights can often look better because the ascending and descending strokes are long, elaborate flourishes (fig.6).

The difference between this style and those that are written with a broad-edged pen is that you form the letters with fewer lifts of the pen from the paper. The nib can be moved backwards where necessary, giving the style an attractive fluidity. Words are written in continuous streams, with only the occasional break being taken to cross or dot letters like 't' or 'i'. Because the nib point is so fine, you will need to write on a fairly smooth-surfaced paper, as one with too much texture will not enable the pen to glide freely over the surface and thus create the hand's long, smoothly flowing strokes.

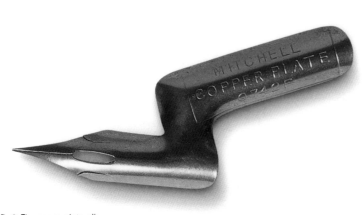

fig.2. The copperplate nib.

two millimetres
two and a half
three millimetres
three and a half
four millimetres
four and a half
five millimetres
six millimetres
seven millimetres
eight millimetres

fig.3. Different lettering sizes can be written with the same nib.

a b c d e f g

h i j k l m n

o p q r s t u v

w x y z

fig.4. Copperplate minuscules.

the flowers of

the

fig.5. Text with diagonal guidelines behind to help maintain a constant angle of slope to the letters.

the quick brown

fox jumps over

the lazy dog

fig.6. Lines of copperplate text with three times the writing line height between each pair of lines.

In their simplest form, the ascending strokes are broad and blunt-ended. Letters never commence from the top of an ascending stroke; instead the pen is first taken upwards in a sweeping stroke from the left, as if it were coming from another letter. Where the pen stops and then begins the downwards stroke, a neat, squared end is made (fig.7). When you become more proficient in this style, you could try giving the uprights looped ascenders (figs.8-10). The larger your lettering, the easier it is to produce looped ascenders and descenders, and the more they complement the writing (see the 8mm- (5/16"-) high letters in fig.3 (page 119). When making the looped ascenders, the pen stroke from the left sweeps further across, before looping back to make the letter's downstroke.

The linking of copperplate letters is vital if the rhythm and flow of the words are to be maintained. Each letter is linked by a fine stroke leading from the bottom right of the previous letter to the top left of the new letter. Where there is no natural connecting stroke – as with such letters as 'r' and 's', which finish with the pen in the wrong position to start the next letter – a break in the flow is necessitated, the next letter commencing with an initial sweeping stroke from the left (fig.11). Alternatively, versions of some of the letters (fig.12) can be formed to include a connecting stroke.

The letter 'f' may cause you problems, as the central crossbar is often formed with a continuous linking stroke leading from the bottom loop to the crossbar (fig.13). The descender having been formed, the pen either sweeps backwards to run up to the crossbar or forwards to make the bottom loop, before crossing back over the descending stroke to form the crossbar. The 'k' can be given either a looped or straight second stroke (fig.14). It is also possible to make rounded and curved versions of the 'v' and 'w', while the 'z' has both a normal and a tailed version.

The capital letters for the copperplate hand are shown in fig.15. Some alternatives are shown in fig.16. These can be greatly embellished to make them attractive, illuminated letters with which to accompany texts (fig.17).

fig.7. Squared ends to the ascenders.

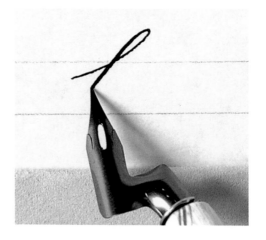

fig.8. Looped ends to the ascenders.

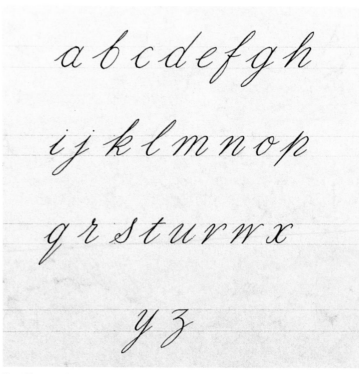

fig.9. Keep the height of the ascenders contant.

fig10. The complete alphabet with looped ascenders and descenders.

fig.11. Connecting strokes for difficult letters.

fig.12. Some letters can be formed differently to incorporate a connecting stroke.

fig.13. Two versions of the letter 'f'.

fig.14. A few other alternate letters

fig.15. The capital letters.

fig.16. Alternative versions of some capitals.

fig.17. Embellished capitals.

PROJECT *Making a wedding-invitation card*

When making a wedding-invitation card, first make a rough draft of the lettering to the size and shape required, emphasising the most important lines of text: the names and places (Step 1).

Start by guessing the sizes of lettering that will look best, and then cut and paste the alternative versions until you have achieved the best combination (Step 2).

When you are happy with your draft, measure and rule the guidelines and marked points onto your chosen card and proceed with your lettering (Step 3).

Step 1. Wedding invitation card draught.

Step 2. The cut and pasted draught.

Step 3. Proceed with lettering.

PROJECT | *Addressing envelopes*

Before addressing envelopes, first make a template so that you won't have to rule a set of writing lines on each. Carefully measure and cut a piece of card to the size of the envelope so that the card fits quite snugly inside it (Step 1). This will prevent the card from shifting slightly and displacing the lines.

Lettering with a height of 3mm (about ⅛") is about the right size for most envelopes. Six sets of writing lines will suffice for most addresses. Rule up your writing lines on the card, leaving 7mm (about 5/16") between each pair in the central portion of the envelope. Allow a reasonable margin at the top- and left-hand sides.

Step in each line by an equal amount. For smaller, squarer sizes of envelope (Step 2), step in each line by about 5mm (about 3/16"). For a longer envelope (Step 3) step in the lines at 10mm (about 7/16") intervals to make better use of the area available.

Rule in the guidelines, making them quite thick so that they will show through the envelope (Step 4).

If an address has only four lines of text, start writing it on the second pair of lines so that the lettering will be more centrally positioned on the envelope (Step 5).

Step 1. Make a template for addressing small envelopes.

Step 2. On a small envelope each address line is stepped in by 5mm.

Step 3. The address lines are stepped in 10mm on longer envelopes.

Step 4. The lines should be thick enough to be seen through the envelope.

Step 5. Short addresses should be started at the second pair of lines on the template.

PROJECT *Making a seating plan*

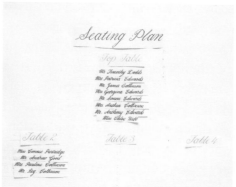

Step 1. Calculate the text size needed for the size of mountboard.

Step 2. Proceed with lettering.

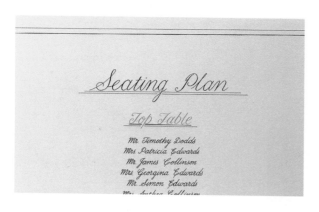

Step 3. A simple border can be added in matching colours.

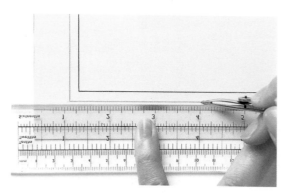

Step 4. A ruling pen is used for the border.

Our next project is a seating plan, which has to be quite large so that several people can see it at once when it is on display. If it needs to be freestanding, write it on mount board, which has a good surface for calligraphy and is available from most art shops in a wide range of colours.

Arrange the tables of guests – 9 in the example shown – on your draft in the same position in which they will be placed in the dining room.

Use a lettering size that will allow you to fit all of the text within the board that you are using. The mount board sold by art shops is usually about 60 x 85cm (about 23¾" x 33⅝") (Step 1), but you may be able to buy larger pieces from picture-framers.

Write the guests' names and the title (Step 2). Given the quantity of guests in this example, lettering 3mm high was needed to fit in all of their names without making the text appear too cramped. The title was written with 10mm high lettering balance the rest of the text.

Add a simple border (Step 3) to decorate the design. This is made with a ruling pen (Step 4).

Against Idleness and Mischief

How doth the little busy Bee
Improve each shining Hour,
And gather Honey all the Day
From ev'ry op'ning Flow'r!

How skilfully she builds her Cell!
How neat she spreads the Wax!
And labours hard to store it well
With the sweet Food she makes.

In Works of Labour or of Skill
I would be busy too:
For Satan finds some Mischief still
For idle Hands to do.

In Books, or Work, or healthful Play,
Let my first Years be past,
That I may give for every Day
Some good Account at last.

Isaac Watts

Mounting, framing and care

11

Mounting, framing and care

As you progress to working on more complex pieces, and spend more time and trouble on them, you will probably reach the stage where you want to frame a piece. When you take your work to be framed, consider asking the picture-framer to mount it, which can greatly improve the appearance of many pieces (fig.1). Not only are picture-framers used to advising people, but they generally also know what will look right, so it is worth asking for their advice. The range of coloured mount boards that picture-framers stock is usually very extensive, which means that you should be able to choose one that will either match or complement the colours in your work. The picture-framer will cut the mount with a bevelled edge (fig.2), and can also rule in extra lines of colour near the edge of the mount if you wish, which adds further to the overall effect (fig.3).

fig.1. A simple mount can improve a piece if it is to be framed.

Whether or not it will have a mount, always give your piece ample margins so that it does not look as though it has been squashed into its frame (fig.4). If you are planning a piece for a particular wall space in a house, you will need to take into account how much its overall size will be increased by its frame and mount.

For the frame, you will be offered a wide range of mouldings, mainly gold colours or varnished, or polished, natural woods. In addition, an increasing number of frames with coloured mouldings, as well as stained and painted effects, are becoming available, so you will have many options to choose from. The sample frames take the form of corner sections, which you can hold against the work, along with a corner piece of mount board, to get good impression of the final effect (fig.5).

The picture-framer will probably offer you the choice of reflective or non-reflective glass (fig.6). Although non-reflective glass has a slight texture, which prevents the light from shining back at the viewer, a degree of clarity is lost because the glass slightly reduces the sharpness and overall brightness of the work. You will need to balance this disadvantage against the possibility that the work will be hung in a position where the light will be shining directly onto it, thereby making it difficult to view without looking at it from many different angles. Note that it is generally better to hang calligraphic works in positions that do not receive direct sunlight, because this will age the surface and can also bleach many colours as time goes by.

As you will appreciate, you will have to make a lot of compromises when having your work framed, and it is therefore worth weighing up all of the options in advance to enable you to choose the best solution for your requirements.

Calligraphic inspirations

In order to build upon some of the projects that you have learned in this book, you cannot do better than to examine historical examples of calligraphy. The British Library displays

many fine, medieval manuscripts in cabinets, including the Lindisfarne Gospels – one of the best-known examples of calligraphy. The Bedford Psalter is also worth looking at on account of its fine illumination. Arabic manuscripts usually contain some stunning colour schemes accompanying their distinctive texts, and you can also draw on pieces from many other countries for inspiration. You can often buy postcards and books featuring such exhibits that you can study at home at your leisure.

Look out for exhibitions of the work of contemporary scribes, which may give you fresh ideas for execution and presentation.

fig.2. Bevelled edge to a mount.

fig.3. Coloured border lines around the aperture.

fig.4. The first of these examples has margins which are too small, the second has correctly proportioned margins.

fig.5. Corners pieces of frame and mount are useful for deciding which combination to use.

fig.6. Reflective and non-reflective glass.

Illuminated lettering

12

Looking at some of the fine illuminated manuscripts that are on display in various parts of the world, with their richly decorated gilded letters and texts, will prove a real inspiration for anybody who has an artistic bent and knowledge of calligraphy. The British Library in the St Pancras district of London, for example, is blessed with a wealth of such manuscripts, many of which are in a good state of repair and still exhibit much of their original glory. Other museums around the world boast some equally fine examples, in particular the incredibly complex Book of Kells that can be seen at Trinity College, Dublin, Ireland, and the Winchester Bible, which is housed in Winchester Cathedral, Hampshire, England. Many beautiful manuscripts can also be seen in the J Paul Getty Museum in Malibu, California, USA, as well as in many other national libraries' collections, such as those of Sweden, in Stockholm, and of Austria, in Vienna. Wherever possible, original sources have been given for all of the examples of illuminated letters that appear in this book, which are all reproductions of the original works, as well as the repositories where the manuscripts are currently kept (these change from time to time, however, so before making a long trip to see a specific piece, always check that it has neither been sent away on a long loan nor been permanently re-homed).

An examination of the methods that were used to produce these fine works reveals the use of materials and equipment from times long past, when mass production was not possible. Instead, time and effort were needed to create books of incredible richness and complexity, whose purpose was to glorify God, to satisfy rich men and to educate the privileged. Such materials can still be procured, and the methods of construction that the original scribes used will be illustrated and described in this book to enable the student to create contemporary works of a similar nature.

The history of illuminated letters

During the period known as antiquity, before the decline of the Roman Empire during the fifth century, lettering was principally unadorned. It wasn't until the spread of Christianity – which Emperor Constantine had established as Rome's official religion in AD 311 – throughout the Western world that the importance of the written word began to increase as a result of the desire to transmit and reinforce the word of God. Books were therefore produced in increasing

numbers by means of the only method available: copying them by hand from borrowed texts. It is in the early Christians' efforts both to increase the stature of their holy books and to reflect the reverence in which they were held that we can see the beginning of the art of illumination.

Illuminated letters are chiefly found in books of the scriptures. For the origins of the texts that were used in early illuminated works, we have to go back to about the year 382, when, on his arrival in Rome after years of travelling, St Jerome was commissioned by Pope Damasus to edit and revise the old Latin texts of the four gospels. As well as complying using the available Greek texts, Jerome went further and studied Hebrew to enable him to revise the books of the Old Testament. He produced three versions of the Hebrew text, two of which are written side by side in parts of the Winchester Bible, although in some other works all three translations appear together. Until the Reformation, Jerome's Latin text (which was known as the Vulgate), was used by the Christian Church throughout the West for most medieval bibles. Indeed, it is still used by the Roman Catholic Church today.

Scripts of the Dark Ages

The Germanic peoples who settled in, or conquered, parts of the western Roman Empire formed isolated settlements. Throughout what are termed the Dark Ages, such new states as the Frankish kingdoms, Visigothic Spain, Ostrogothic and Lombardic Italy, as well as Anglo-Saxon England, emerged. And from the pens and brushes of the scribes and artists who were working in the isolated religious centres of these lands blossomed superb, illuminated texts in different styles.

The scribes of Britain and Ireland were responsible for some of the earliest – as well as the finest – illuminated works of the Dark Ages. The conversion of the Anglo-Saxons to Christianity occurred in AD 597, when Pope Gregory the Great sent St Augustine to Canterbury to accomplish this end. The style of the work produced as a result has become known as insular, and the scribes and scholars that used the insular style influenced the work of early illuminators throughout the rest of Europe.

It was mainly monks who produced the illuminated manuscripts of this time. The monasteries were centres of learning and culture, and monks taught young men of good families such skills as they knew. Newly founded monasteries, or those whose monks were less skilled, requested books from

Fig. 1. 'T', Book of Kells.

those that were well established. Indeed, some monasteries specialised in producing books for other communities, which were often passed from monastery to monastery so that new generations of monks could learn the skills of writing and illumination.

Figure 1 shows an illustration from the Book of Kells. Although the origins of this impressive manuscript are uncertain, it is thought to have been produced in either Ireland or Northumbria during the eighth century. The initial 'T', shown here, commences text which leads into a page full of rich, Celtic patterns and intricate detailing. The Lindisfarne Gospels (Figure 2), which is currently on display at the British Library, was produced in Lindisfarne, in the north of England, at the end of the seventh century. A wonderful example of illuminated work, the Lindisfarne Gospels is full of very complex, interwoven decoration consisting of animals and birds arranged in beautifully stylised patterns. Although not all insular manuscripts reached the same high standard as the Book of Kells or the Lindisfarne Gospels, they all shared incredible complex, imaginative designs. And even though the years have robbed them of some of their original strength of colour, the rich hues and delicacy of some of the paintings that they contain remain stunning to behold.

Fig. 2. 'Q', Lindisfarne Gospels.

Another wonderful piece of illumination is the *Codex Aureus*, which is thought to have been written in Canterbury during the mid-eighth century, and can today be admired at Stockholm's Kungliga Biblioteket. It is an incredible work that boasts large amounts of gilding, as well as intricate patterns. A marginal note in the book, written in beautiful, Anglo-Saxon script, records that during the ninth century one Aldorman Aelfred paid a ransom of gold to pagan Norsemen in order to procure it.

Not all of the illuminated books of the period were based on the scriptures, however. Books on astronomy began to be produced from the mid-ninth century, which were important for determining the dates of religious festivals. Herbals have also survived. These were manuscripts that were illuminated with paintings of plants, while their descriptions and uses, along with other medical details, such as operations and attempted cures, were conveyed by both the text and illustrations. Another type of illuminated book was the bestiary, whose origins lay in Greek writings and biblical tales, which contained details of both real and imaginary creatures. Bestiaries served as books of instruction, and although the texts were generally illustrated with representations of plants or creatures, they contained few illuminated letters.

The Carolingian script

Under the patronage of Charlemagne, the king of the Franks who was created the first Holy Roman Emperor in AD 800, learning and the arts flourished. The many fine illuminated works that were produced during his reign were written in the Carolingian style that was named after the emperor. The appearance of the manuscripts written in the Carolingian style differed greatly from those of preceding styles. The precise, minuscule lettering of the text was accompanied by single, large and well-defined illuminated letters, while additional words in title pieces were picked out in simple, coloured, capital letters. Pages of Carolingian text did not have the busy, cluttered appearance of Celtic manuscripts, but instead displayed a composed dignity and sense of order that remained popular for several centuries.

Fig. 3. 'P', Winchester Bible.

Alcuin of York, an English scholar who was closely associated with Charlemagne, used the Carolingian script to write a text of the Latin Bible that was subsequently used as a model for the production of many other illustrated bibles. Because of their great size and weight, such large bibles, which were intended to be read aloud from a lectern, were usually bound into several volumes. The initial letter of each book of the Bible would often be illuminated, while smaller illuminated letters would be used to emphasise particular portions of the text. Later in this book, we will examine various pages from the beautiful Winchester Bible that was produced between 1160 and 1175 (a large illuminated letter 'P' from this manuscript is shown in Figure 3).

The Romanesque style

The Romanesque period and style, which dates roughly from the late eleventh to the twelfth centuries, followed the Carolingian in the West. Although it derived its name from its attempt to recall Roman principles of construction and style, it actually incorporated an international range of styles, including influences from many parts of the Western world, as well as ancient Roman, Byzantine and even Islamic styles. The late eleventh-century Carilef Bible, which is today in the care of the Dean and Chapter Library, Durham, has examples of this type of painting, in particular a large inhabited letter 'B' (Ms

Fig. 4. A historiated initial 'B'.

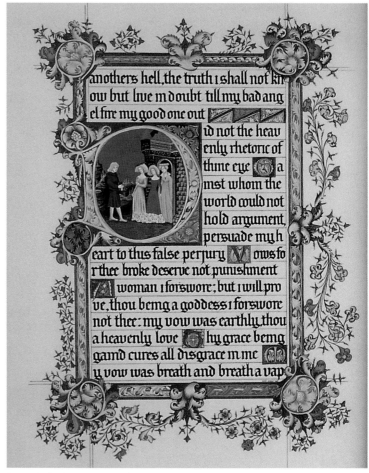

Fig. 5. 'B', Bedford Psalter and Hours.

A11 4 folio 65). With its thin, penwork modelling and few colour washes, the construction of the letter is fairly simple, leaving much of the surface of the vellum to show through the design. The Byzantine influence can be seen in manuscripts that include hard-edged figures, heavily outlined in black, that have been adorned with damp-fold drapery (a way of depicting cloth to make it look as though it is wet and clinging to the figure).

During the tenth and eleventh centuries German scribes produced some magnificent manuscripts, while the Worms Bible, which was created in about 1148, contains a beautiful letter 'U' that commences the Old Testament Book of Hosea. Although the Italian texts that were created at this time were strongly influenced by Byzantine painting, their quality did not generally match that displayed by the texts that were produced in much of the rest of Europe. However, there is an interesting example of an illuminated letter in the opening initial 'B' of the Camaldoli Psalter, which was made in Italy during the mid-twelfth century and can now be viewed in the British Library.

The Gothic style

By the end of the twelfth century, manuscript illustration was moving from the Romanesque to the Gothic in style, as can be seen in an early Gothic manuscript called *La Charité* Psalter (Figure 4), which was produced in France and contains an attractive letter 'B' illustrating the story of David and Goliath. A wealth of fine manuscripts, richly embellished with gold leaf, bright colours and medieval decoration, date from the Gothic period. Decorative borders emanating from large initial letters now became popular, leading to the production of many manuscripts whose angular Gothic-script texts were completely surrounded by detailed foliate borders full of figures, animals and birds set against richly patterned backgrounds.

Fig. 6. 'A', San Salvatore Hymnal.

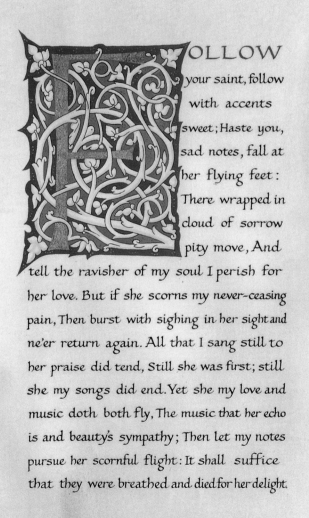

OLLOW your saint, follow with accents sweet; Haste you, sad notes, fall at her flying feet: There wrapped in cloud of sorrow pity move, And tell the ravisher of my soul I perish for her love. But if she scorns my never-ceasing pain, Then burst with sighing in her sight and ne'er return again. All that I sang still to her praise did tend, Still she was first; still she my songs did end. Yet she my love and music doth both fly, The music that her echo is and beauty's sympathy; Then let my notes pursue her scornful flight: It shall suffice that they were breathed and died for her delight.

Fig. 7. White-vine stem.

Psalters, books of hours and music books

Following the foundation of universities and the general increase in literacy, the demand for books increased from the beginning of the thirteenth century, causing growing numbers of secular scribes and illuminators to emerge. In addition, the trend for religious books for public use gradually shifted towards books of a more personal nature, such as psalters. Psalters were popular, scriptural books that were used for private worship and usually contained a selection of prayers, as well as a calendar of the principal feast days. The Bedford Psalter and Hours, which was created in around 1420, is an impressive example of English illumination. About a quarter of the page is taken up by a historiated initial, while the text itself is surrounded by a border that contains scenes from the text. A letter 'B' from this psalter is illustrated here (Figure 5). Although the pages of the Bedford Psalter and Hours are large, measuring as they do 405 x 280mm (about 16 x 11"), during this period many pocket-sized bibles containing tiny illuminated initial letters were also produced, and these were regarded as valuable possessions.

The next type of book to appear was the book of hours, which gradually succeeded the psalter as a work of private devotion. Thousands of books of hours, whose quality and content differ greatly, survive in libraries all over the world. One of the most famous is the *Très Riches Heures* that was made for Jean, Duc de Berry, the brother of the king of France, in about 1400. This work (which you can view today in the Musée Condé at Chantilly,

France) is renowned for its magnificent miniature paintings of scenes of medieval life. The artists who created them were very highly skilled, and the lettering and illumination that accompany the paintings are also of the highest quality.

Music books, for example, hymnals – large, illuminated books containing liturgical music – were often well illuminated. A fine Italian example, which was created at San Salvatore, Sienna, Italy, in 1415, includes an elaborate 'A' that orginally enclosed an illustration of the Resurrection (Figure 6). The musical notation of such hymnals was usually very simple, and the accompanying lettering styles were typically well adapted to the scale of the manuscripts. (We will cover music books in more detail in Chapter 18.)

The Renaissance and the advent of printing

From the mid-fourteenth century, the Renaissance, which originated in the Italian city of Florence, brought about many changes of style. As a result of scholars' attempts to emulate the classical texts of antiquity, the style of illuminated work gradually became more dense and overpowering, while the illuminated letter became less significant as detailed, naturalistic miniatures and heavy borders assumed greater prominence. White-vine-stem (Figure 7) and trompe-l'oeil borders (Figure 8) are two very attractive Renaissance styles that are particularly eye-catching, and we will cover them further in Chapter 20.

Although printing was introduced during the mid-fifteenth century, the illuminated manuscript continued to flourish, and many masterpieces were produced in the Renaissance styles in Flemish workshops during the second half of the fifteenth century. As the sixteenth century approached, the production of printed books escalated, and they therefore became more widely available. Many fine manuscripts were still being created, especially in France, Italy and Flanders, but they were now luxury items that were commissioned for special occasions, whereas printed works were becoming available to the masses. At this stage texts and outline border designs would often be printed and the colours then added to the border by hand. As printing techniques gradually became more advanced, however, the scribe and illuminator had a decreasing role to play in book production.

Inspirational illuminations

Although they are no longer created as a matter of course, we can still enjoy perusing the beautiful illuminated works of the past ten centuries. This book explores how you can spend your leisure time either recreating pages from some of these manuscripts or, by using them as your inspiration, producing new, more contemporary, designs.

Illuminated letters are very beautiful in themselves, of course, but remember to give some thought to the text that they introduce and decorate, so that you endow them with meaning. Many attractive calligraphic hands are associated with different styles of illumination, and, along with their corresponding illuminated letters, some of the principal ones are both described and used to construct the pieces in our projects.

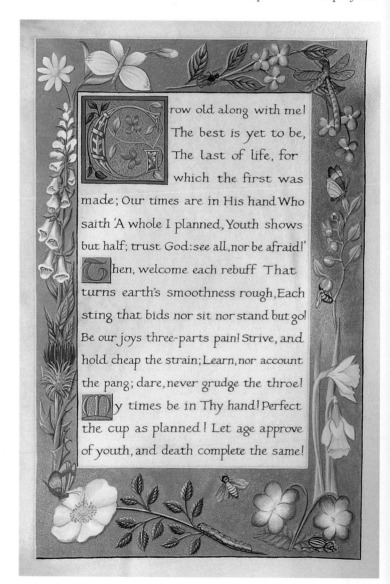

Fig. 8. Trompe l'oeil.

Materials and Equipment 13

Materials and Equipment

Many old manuscripts contain illuminated letters that are not completely finished, which is useful for us as students, because when we see pages in various stages of completion we can follow the construction process with ease

In order to give your work the same durability as manuscripts whose appearance has remained unchanged over the course of centuries, you will need to use materials and methods that are as similar as possible to those that were employed when these works were produced. Although some of the methods are quite involved, and the materials expensive, because they will result in the best-quality work, it is nevertheless worth using them. You could, of course, use modern pigments, which are easy to acquire and work with and may furthermore produce works that look as good as those made with the original materials, but remember that they do not have the same durability.

Writing surfaces

Vellum – calfskin – is the surface on which most illuminated manuscripts were written and painted (Figure 1). Although a few were written on paper, these are rare, and all of the examples mentioned in this book were created on vellum, which has by far the superior surface. Because vellum is expensive, however, if you are new to illumination and are unfamiliar with this surface material, you should practise on paper first and reserve vellum for your best work.

William Cowley Parchment Works is one of the few remaining manufacturers that treats and prepares skins to produce a fine, smooth, vellum surface for lettering and illumination. Various grades of vellum are made for different uses, as follows.

- **Manuscript vellum** is the best-quality vellum. The skins are bleached of most of their natural pigment until they are a creamy-white colour. Both sides of the surface are prepared for working, which means that it can be used for books.

- **Classic vellum** has less of the colour bleached out of the skins than manuscript vellum, with the result that a lot of the skins' veining and yellowish-brown markings remain.

- **Natural vellum** retains the natural pigment of the skin and can be quite dark in colour.

- **Binding vellum** is used for bookbinding, but its surface has not been prepared for lettering and illumination.

Because parchment is made from the skin of sheep, the pieces are smaller, thinner and more delicate than vellum. It is difficult to remove errors from parchment without spoiling the surface, so I therefore recommend that you use vellum instead. Although goat skin can also be written on – and, indeed, has a pleasant surface – it is usually peppered with small dots where the hairs of the animal used to be.

If you intend to begin by using paper, try to find one of good quality, such as T H Saunders or Waterford papers, which are often stocked by art shops. Ask for advice on a watercolour paper with a smooth surface that will be suitable for fine work with a pen and tiny brushes. Specialist papers and vellum can be bought by mail order.

Fig. 1. Vellum (manuscript, classic and natural) and parchment.

Preparing vellum

Before it can be worked on, the surface of the vellum needs to be prepared with a powder called pounce, which is made up of powdered pumice, gum sandarac and cuttlefish. Although manuscript vellum will have been prepared with pounce before you buy it, after the piece has been cut to the required size, a final application of pounce will remove any dirt or grease and will also raise a slight nap, which will help the ink and paint to be absorbed into the skin evenly (an unpounced skin is usually too waxy to absorb ink and paint well).

Making pounce

You can buy readymade pounce or you can make it yourself. However, making your own is not only easy, but you will be sure of having mixed the ingredients for your particular requirements correctly. Powdered pumice and gum sandarac are available, while dry cuttlefish can be bought from pet shops.

Pigments

The pigments that were used by early scribes were coloured substances (Figure 4) that were mixed with water and egg yolk or gum to bind them together. Organic pigments were obtained from plants or animals, while mineral pigments came the earth or were manmade substances.

The chief requisites of a pigment are, firstly, that it should have a strong, brilliant hue that has no impurities, secondly, that it will not fade when exposed to sunlight for long periods, thirdly, that it does not become discoloured and, finally, that is capable of being made into a smooth, finely ground fluid that can be applied to the writing surface with great accuracy. Many of today's pigments contain acids that will cause discolouration over time, a consideration that you will need to bear in mind if you want to produce work that will still look as fresh as when you created it after many years. Artists' Colourmen produce finely ground pigments that you can buy in the quantity that you require, however small. A wide range of colours is available, of which the most suitable for illumination are given below.

Making Pounce

1 Use a pestle and mortar – available from cookery shops – to grind up the powdered pumice, gum sandarac and cuttlefish into a very fine powder (Figure 2). Roughly equal proportions of each ingredient should be used, so grind up one or two cuttlefish and then measure out the other ingredients in matching proportions and grind them together well. You will need about a level tablespoon to a square foot (about 30.5cm2) of vellum.

2 When the ingredients have been ground together to make a very fine powder, shake the mortar from side to side. Remove the larger particles that come to the surface, which could scratch the vellum if you rub in the pounce too hard. You can store the prepared pounce in a clean jar (covered with a lid) and keep it indefinitely – any left-over pounce can similarly be saved for future use.

3 To prepare the vellum for writing or painting, first sprinkle the pounce over the surface as shown in Figure 3. Using a small offcut of vellum, work the powder into the skin using steady, circular movements. You will need to apply a reasonable amount of pressure so that you remove any dirt and grease and raise a slight velvety nap on the vellum, but be careful not to mark the surface. Most skins will require about 8 to 10 minutes of rubbing. As you are rubbing, watch the surface carefully, and if you think that you may be damaging it, stop. Most vellum can take quite a lot of pouncing, but it is important that you do not raise too much of a nap, which will make writing or painting fine lines difficult.

4 When you have finished, return any excess pounce to the storage jar and then dust off the skin. Hold it up by one corner and flick the surface lightly with a tissue so that the texture is not disturbed but a minimal dusting of powder remains. The vellum is now ready for use.

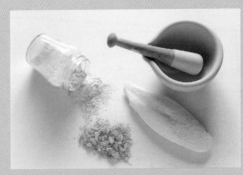

Fig. 2. Pestle, mortar and pounce ingredients (powdered pumice, cuttlefish, gum sandarac crystals).

Fig. 3. Pouncing vellum.

● **BLUE:** the two blue pigments that were chiefly used in medieval times were genuine ultramarine (ground and purified lapis lazuli) and azurite (a copper carbonate). These are very difficult to obtain, but artificial or French ultramarine is a good substitute. Although it contains sulphur, which may become discoloured in the presence of acid, this can be avoided with care. Cerulean blue is a strong, permanent colour, while cobalt blue (which is also permanent) is paler than ultramarine, but capable of producing good results.

● **RED:** vermilion has been used for over a thousand years and still remains the illuminator's principal colour. A compound of mercury and sulphur, it possesses all of the required characteristics of a good pigment: permanence, opacity and a smooth texture. Scarlet vermilion produces the shade of red that can be seen on most early manuscripts.

● **GREEN:** viridian (emerald oxide of chromium) is the best shade of green to use. Although it is both permanent and brilliant in hue, it requires the addition of an opaque pigment, such as lemon yellow or Chinese white, to remove its transparency. The medieval scribes used malachite – a basic carbonate of copper – which was a beautiful colour. The cost of its preparation has made it very difficult to obtain today, however.

● **YELLOW:** lemon yellow has both a good consistency and a bright colour. Note that chrome yellows are made from lead, which will blacken with age. Although it is a permanent colour, yellow ochre (an earth pigment) is rather dull for use in illumination.

● **BROWN:** burnt sienna and umber are the earth pigments that artists most commonly use. Although they are rather heavy and dull, and can also be difficult to apply with a really fine touch, as with other earth pigments the colours are permanent.

● **BLACK:** lamp black and ivory black are charcoal-based pigments that are suitable for illumination. They are derived from the carbon in burnt materials, such as bones and oil.

● **WHITE:** Chinese, or zinc, white is a smooth-textured and permanent pigment that will not darken with age. Do not use flake white, however, because this contains lead and will turn brown when exposed to sulphur.

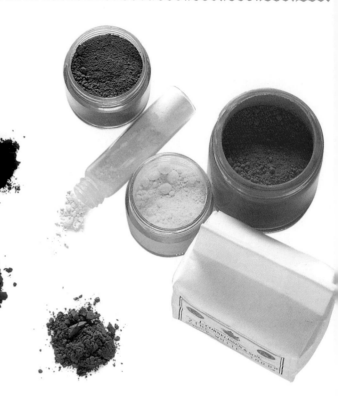

Fig. 4. Powdered pigments (ultramarine, vermilion, zinc white, lamp black, viridian, lemon yellow and burnt sienna).

Mixing media

The easiest pigments to use are those that have been bound together with gum in cake form, which only have to be mixed with water before use. Because one of the main charms of illuminated work is its brilliance, it is important to keep your colours as clean as possible. Remember that it is all too easy to make a pigment dull by mixing it with impure water or using dirty brushes, so take care to avoid contaminating your pigments. Tap water contains many undesirable chemicals as regards illumination, so try to use distilled water, which is readily obtained from chemists, as you progress. You should also eventually aim to use powdered pigments, as well as making your own binding media, all of which will produce stronger, brighter colours.

The preparation of three types of binding media – gum water, egg whites and egg yolks – that were used in medieval times are described below. Although each takes some time to prepare, they will all produce the long-lasting results that were achieved in medieval manuscripts.

Making Binding Media

1 To make gum water, first mix one part gum-arabic crystals to two parts distilled water and leave the mixture to dissolve overnight. The next day, strain the liquid through a piece of muslin. The resulting mixture can be kept in a glass jar for use as and when you need it.

2 To begin with, dilute the mixture with an equal proportion of water to make the required strength. You will soon learn which pigments require a stronger or weaker solution of gum water. If you use too much gum, the colour may either crack when it is dry, or, if you are using it with a pen, the paint may not flow smoothly. If you use too little gum, the pigment may not be fixed to the page firmly enough. Always test the colour on a scrap of paper or vellum to see what happens when it dries. Try rubbing the pigment with your finger to make sure that it is firmly fixed to the page. Remember that you can easily make adjustments at this stage, and that it is very discouraging when you have spent a great deal of time painting areas of colour only to find that problems later occur.

3 Egg white is used to make glair, or clarea, a binding medium of early medieval times. First separate the white of an egg from the yolk and beat the white thoroughly in a shallow bowl until it is stiff enough to remain in the bowl when you turn the bowl upside down. (This step is vital if you want the eventual fluid to have the correct texture.) Tilt the bowl slightly and leave it overnight.

4 The following day, pour the distilled liquid (which should have run to the bottom of the bowl) into a jar. The liquid will only keep for a few days, after which it will thicken and dry up. Mix the glair with the pigment and a little distilled water until you have obtained the consistency that you require.

5 Egg yolk can also be used as a binding agent. First, separate the yolk from the white, making sure that the yolk remains intact. Carefully lift and then break the yolk into a container, so that the liquid runs out of the yolk's skin into the bowl. Add a roughly equal quantity of water to the yolk, but remember that the exact proportions required can vary slightly from colour to colour, as you will learn with practice.

6 Mix the egg-yolk liquid with powdered pigment until its consistency resembles thin cream. You will find that the yolk's yellow colour disappears from the pigment, which becomes very hard when it has dried.

7 If you find that you have problems with paint that has not adhered sufficiently to the page, you can paint over these parts with a weak version of any of these binding agents. Make sure that you do not use too strong a mixture, however, because this could give an unpleasant gloss to your work.

Brushes, pens and inks

You will need very fine brushes made from sable fur to produce the precise detail that is required for illuminated work, and most art shops stock brushes of this quality. A size 0 or 1 is small enough for the finest details, while a slightly larger brush can be used for painting large areas of colour. In order not to spoil your sable brushes, use larger-sized brushes of a less good quality to mix your pigments.

Because quill pens – the favoured writing instruments of the Middle Ages – produce very fine, delicate strokes, you should use one for writing the text if you can (art shops or specialist outlets sometimes stock them). Otherwise, use a pen with a square-cut, metal nib that has been specifically manufactured for calligraphy. I recommend William Mitchell's Round-Hand series nibs, which range in size from 0, the largest, to 6, the smallest (there are 12 nib sizes in total, including half sizes).

The inks that were used by medieval scribes were made either from oak gall nuts or from the carbon obtained from lamp black. Many modern bottled inks are not permanent, so you should ideally use Chinese stick ink, which is ground with water in an ink slate, instead.

PROJECT **Applying colours**

Each style of illumination is given unique distinction by the combination of colours used. The medieval monk's palette did not incorporate the range that is available to us today, and a deep, vibrant blue, an almost terracotta-hued shade of red and a green the colour of lead roofs are the colours that immediately spring to mind as being characteristic of medieval illumination.

The letter illustrated in Figure 5 is taken from a late-thirteenth-century Italian manuscript and uses ultramarine blue and vermilion red, plus a popular shade of pale pink that was obtained by mixing white with a little vermilion. We will begin by making this simply decorated letter.

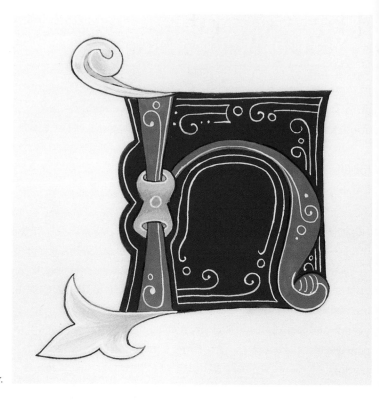

Fig. 5. The finished letter.

1 Draw a very faint outline of the letter on the page. Mix the powdered pigments with your chosen medium of either glair, egg yolk or gum water and some distilled water. Use either a ceramic palette that has a lid or a small, deep container, such as an egg cup, which will prevent the paint from drying out too quickly.

2 Apply the paint with a small sable brush to give a smooth, even covering on which you can later paint detail if you want. This opaque covering of paint can be seen on most early manuscripts, especially in the case of the more dominant colours. Although some of the secondary colours, which required more preparation and were not used with such regularity, were often applied with less precision, the better-quality manuscripts maintained a solid, opaque covering. This is what you should try to achieve on all of your letters, whether they are quite small and simple, like this one, or will later be given further layers of detail and special treatments.

3 In order to give it precision and crispness, outline the letter in a darker colour. Some medieval artists outlined the original drawing in ink and then painted in the base colours. This method can be advantageous for some pieces, particularly Celtic work, which frequently requires many intricate outlines to be drawn, but virtually no subsequent detail to be added. If you decide on this method, remember that you will often have to retouch and redefine the outline after you have added the colours.

The Use of Gold

If gilding is required, this must be done before any of the paint is applied. Gold forms such an integral part of most illuminated work that we will cover the various methods of application in some detail.

There are basically three types of real gold that can be used for illumination: gold powder, transfer gold leaf and loose gold leaf (Figure 6). Although various metallic-gold paints are also available today, which may initially appear very effective, in a side-by-side comparison they cannot compete with the brilliance and depth of colour of real gold (Figure 7).

After gold has been applied, it is polished, or burnished, to give it as bright a shine as possible. You will therefore need burnishing tools, and there are three types of burnisher that you will find useful at various stages: dog-tooth, flat and pencil burnishers (Figure 8). You will also need a pair of sharp scissors that you should use exclusively for cutting sheets of gold, as well as a soft brush for removing excess gold.

Fig. 6. Gold powder, loose leaf and transfer leaf.

Gold powder

Illuminating gold, which usually measures 23 carats and comes in powdered form, is available in 1g quantities. Although this equates to only half a teaspoon of powder, it goes quite a long way. It can be purchased in small pots. These little pots, or another small, deep container with a lid, such as a 35mm-film container, can be used for mixing the gold with distilled water and liquid gum arabic to create the correct consistency for painting (gum arabic is sold in small bottles by most art shops).

When working with gold, it is important that you keep your materials as clean as possible. Ordinary tap water contains too many chemicals to be used with gold, because the purer the gold the brighter its brilliance. Wash any brushes that you use for painting with gold in a pot of distilled water and keep the brushes separate from those that you use with paint. Although you can also use a pen to write with gold powder, the gold particles tend to separate from the liquid so quickly that you will painstakingly have to remix and refill your brush with the correct mixture after every few strokes.

Working with powdered gold

You will need only one or two small drops of gum arabic per 1g of gold powder. Dip a small paintbrush into the bottle of gum arabic and let a drop fall into the gold powder, then repeat the process with a second drop. About half a teaspoon of water is all that is required, so use a measuring spoon until you get used to judging the quantities by sight. Using a paintbrush that you have reserved for working in gold, mix the water

Fig. 7. Types of gold for illumination – imitation gold paint, gold powder, flat transfer gold leaf, raised loose gold leaf.

with the gold powder until all of the gold particles have dispersed throughout the liquid. Note that the gold powder will gradually separate from the liquid and that it will therefore have to remixed at intervals while you are working.

Check that the consistency is correct by painting a small test area – about 1cm ($\frac{7}{16}$″) square – with the gold powder. Give it about 15 minutes to dry. Then, using a dog-tooth burnisher, polish the surface gently, until it has become smooth and has a good shine (figure 9). If the gold sticks to the burnisher, it is probably not dry, so leave it a little longer. If it flakes away from the surface, there is not enough gum arabic in the mixture. On the other hand, if the burnisher makes dark streaks on the gold, there is too much gum arabic in the mixture. It is easier to add more gum arabic than to remove it from the mixture, so err on the side of caution when you are mixing the gum arabic with the gold powder, as you can easily add more later.

Fig. 9. Test piece of gold powder, half burnished.

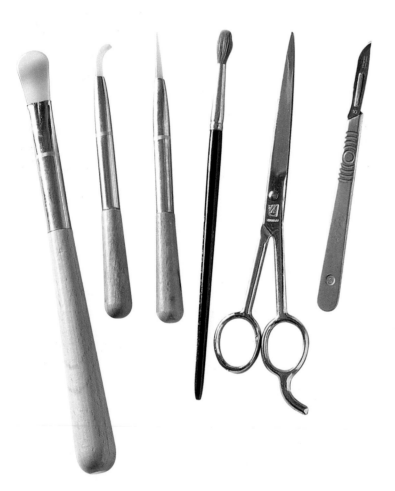

Fig. 8. Burnishing tools (Flat, dog-tooth and pencil burnishers, scissors and soft brush).

Loose gold leaf

Loose gold leaf is purchased in books of 25 sheets that are the same size as sheets of transfer gold leaf. Two thicknesses – single and double – are available, and you will need a book of each in order to achieve the best results.

The loose gold leaf should be applied over gesso, a thin plaster base. Although a few outlets sell readymade gesso, it is better to make your own.

Although creating raised gilding with loose gold leaf is a painstaking process, the results are spectacular, and if you manage to apply the gold leaf successfully you will be rewarded with a real sense of achievement.

PROJECT Making and Using gesso

INGREDIENTS

8 parts slaked white plaster of Paris

3 parts white lead

1 part preserving sugar

1 part Seccotine glue

A pinch Armenian bole

Distilled water

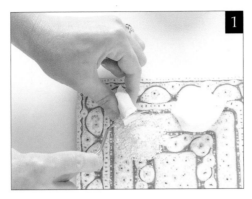

1 Grate the plaster to a rough powder by grinding the edge with a palette knife.

2 Measure the correct amount into the mortar using a small measuring spoon.

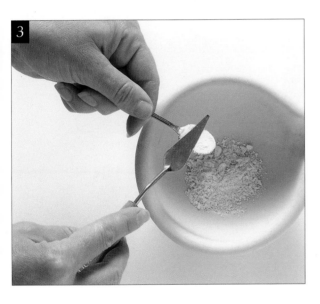

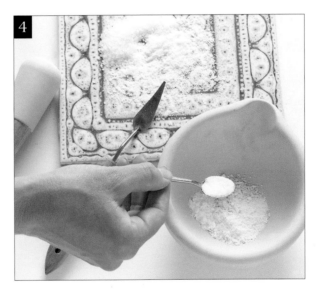

3 Add white lead, levelling off the spoonful carefully with a palette knife before adding it to the mortar.

4 Add a spoonful of finely ground preserving sugar (grind it with a pestle).

5 Add a level spoonful of glue.

6 Add a pinch of Armenian bole. The point of the palette knife can be used to pick up the small quantity required.

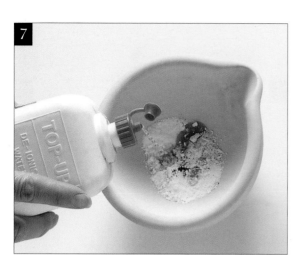

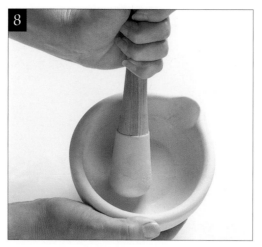

7 Add distilled water, taking great care to allow only a few drops at a time to drip from the container.

8 Grind the gesso ingredients to the consistency of treacle. It is very important that the ingredients are both completely mixed and finely ground. Pour the gesso on to a piece of aluminium foil, making a small, circular shape. Leave it to dry overnight.

9 Cut the gesso into diagonal segments. It is vital that you cut it in the manner shown because the ingredients will have separated slightly, some moving to the inside and others to the outside of the pool of gesso, and this method of cutting will therefore ensure that there is an even quantity of ingredients in each portion.

10 When you are ready to use a piece of gesso, peel a segment away from the foil, touching it as little as possible. Break it up into small pieces in a mixing palette or egg cup. Add about half a teaspoon of water, so that the water surrounds all of the pieces. Leave the gesso to soak for about half an hour.

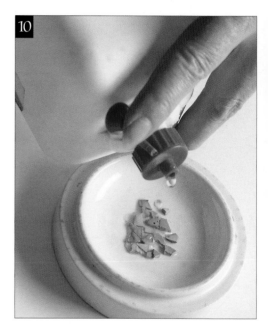

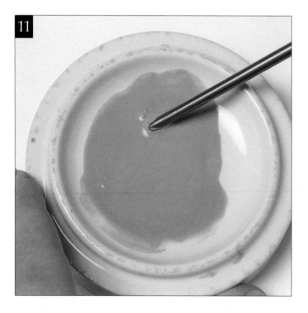

11 You will have to mix the gesso very carefully so that you don't introduce any air bubbles. Using the end of a paintbrush, stir the gesso slowly and carefully, until all of the pieces have dissolved and the mixture is smooth, with a consistency resembling single cream.

12 The gesso can now be painted on to the areas of the work that will be gilded. Work on a flat surface, so that the gesso does not run down to the bottom of the letter. Using a small brush, paint on a thin layer of gesso, taking care to keep it smooth and even. Now leave it to dry overnight.

PROJECT *Using Gold Leaf*

When the gesso is dry, you can apply a layer of single-thickness loose gold leaf. Note that because it is so thin and fragile, loose gold leaf is quite difficult to cut. Using a pair of scissors that you have reserved exclusively for this purpose, first cut a piece of loose gold leaf to roughly the size required, cutting through the backing paper, too. When large areas are to be gilded, work over the gesso using squares of gold no larger than 2.5cm (1") square, applying them piece by piece until the whole area is covered. Then brush away the excess gold.

1 Holding the book of loose gold leaf open as shown, make a decisive cut of the length needed.

2 Now make the second cut, letting the piece of gold leaf and its backing paper slip onto the work surface. Now close the book of gold leaf and put it down, away from your immediate work area, so that you do not disturb it as you work.

3 Pick up the square of gold leaf that you have cut by a corner, so that you are holding only a tiny portion of it before you apply it.

4 The gesso must now be moistened in the same way as gold size (see page 147), that is, by breathing on it several times. Start with ten breaths. As soon as you have finished the tenth breath, place the gold leaf over the gesso, with the backing paper facing upwards.

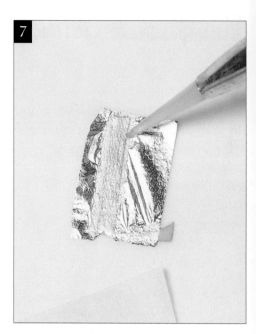

5 With a dog-tooth burnisher, smooth the gold on to the gesso by rubbing over the backing paper. Use light, circular motions, so that the gesso is not dented while it is in its softened state.

6 Remove the backing paper and burnish the gold itself with the dog-tooth burnisher. If it has stuck to the gesso successfully, you should be able to polish it to a beautiful shine.

7 With a pencil burnisher, carefully work around the edges of the gesso to make sure that the gold has adhered to these parts.

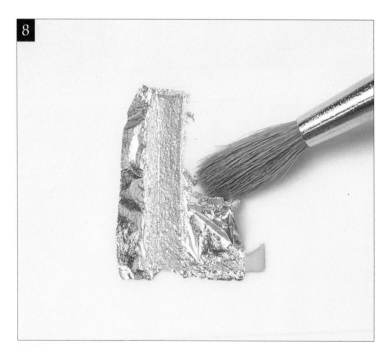

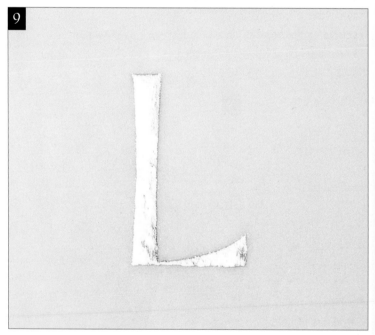

8 Using a soft brush, brush away the excess gold around the edges. If necessary, you could now apply another layer of single-thickness loose gold leaf to any areas that have not been fully covered. Because the gesso will have retained some its dampness, any subsequent layers will require fewer breaths than the first.

9 Here is the finished letter, with the whole of the gesso covered with two layers of gold leaf.

Working with transfer Gold Leaf

Transfer gold leaf can be purchased in small sheets about 10cm (around 4") square, and in books of 25 leaves. It is fairly easy to apply, and gold size, a strong-smelling, yellow liquid made with ammonia, is the medium that you should use.

1 Paint the gold size on to the area that will be gilded and then let it dry. Work on a flat surface, so that the size lies in an even layer on the page. When it is dry, moisten it slightly by breathing on it until it becomes adhesive. Breathe on the size as if you were breathing on a mirror, and do not touch it with your lips. The number of breaths that you will need to use varies, depending on the weather conditions. If you are working on a hot, dry, summer's day, for example, as many as fifteen breaths may be needed, while in cool, damp conditions only four or five may be required.

2 Transfer gold leaf is very forgiving, and you can apply and reapply it to the surface until all of the size has been covered. Lay a sheet of transfer gold, gold side down, over the dampened size.

3 Then smooth over the areas of the letter that will be gilded with a dog-tooth burnisher. You should start to see an impression where the gold has stuck to the size.

4 Take away the sheet when you think that the gold has attached itself to the letter. If it has done so successfully, you should see a perfect, negative impression of your letter on the gold sheet. If one or two areas of the gold size are not fully covered, breathe on the work again and reapply a fresh section of gold from the sheet. Because gold blends into itself, you should be able to eradicate any overlapping edges. Using a soft brush, lightly brush away any excess gold that has adhered to the vellum.

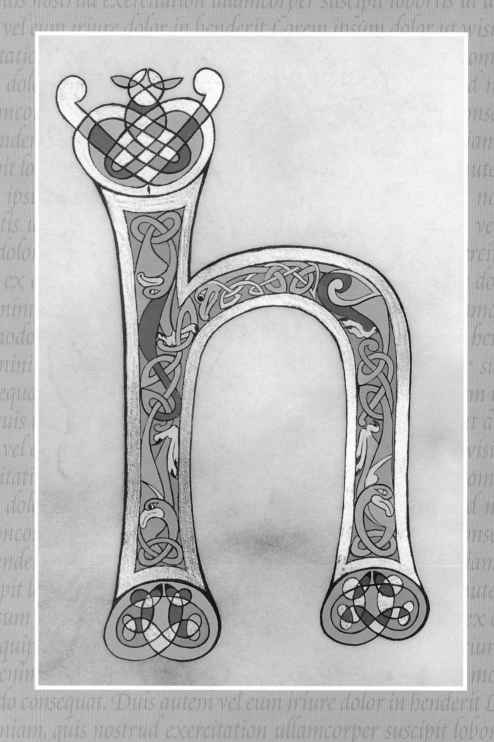

14

Celtic Lettering & Illumination

Celtic lettering and illumination

Having learnt the basic application methods for colours and gold, we shall now move on to making use of them on specific styles of letter, starting with Celtic lettering.

The origins of the very distinctive Celtic lettering and illumination lie in the finely decorated religious books that were produced in Ireland and the north and west of England and Scotland during the sixth to ninth centuries. The finest, as well as the best-known, example is the Book of Kells, which is housed in Trinity College, Dublin, Ireland (see page 130, Figure 1), whose lettering is so detailed and intricate that it is quite stunning to behold, even though the years have dulled the brilliance of some of the colours. Different pages are displayed from time to time, and although some very good books contain excellent reproductions of the manuscript, they can't compare with the original. Standing in front of the Book of Kells, you can picture the monks at work, laboriously painting the tiny details day by day, using carefully prepared pigments and writing tools.

The text of most Celtic manuscripts is in Latin. The shape of the illuminated letters varied from artist to artist, but the general shape and style of the letters of the alphabet shown in Figure 1 are a good starting point and will match the decoration that we will cover later in the chapter. Because some of the letters, such as the 'K', were not part of the Latin alphabet, these have been formed in the same style as the others.

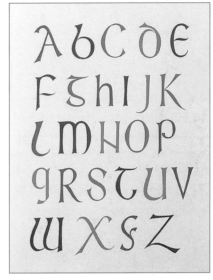

Fig. 1. Celtic letters used for large initials.

PROJECT *An Illuminated 'U'*

We shall first construct a simply illuminated 'U'. The example shown in Figure 2 formed part of the Latin word *uae*. The letter 'A' sits inside the 'U', and the 'E' followed on in uncial script (uncial script will be explained further later in the chapter).

Letters of this degree of complexity were often written for the initial letter of each paragraph down the left-hand border of a page, so there could be four to ten illuminated letters on a page. The height of the letters was usually between 2 and 4cm ($^{13}/_{16}$ and 1 $^{9}/_{16}$"). Larger, more detailed, Celtic letters were made up of a complex collection of patterns that were pieced together to form the required letter shape. The various types of pattern used are discussed below.

1 Make a drawing of the letter on either thin layout paper or tracing paper. If you need to position the drawing so that it matches up with other parts of a piece of work, it will help if you use tracing paper, because you can see exactly where you are placing the design. You will need to use a very hard, sharp pencil when you are making the drawing, however, as tracing paper tends to blunt pencils very quickly.

2 Trace the drawing onto your piece of vellum or paper using red transfer paper or else trace over the back of the design and then trace down the lines from the front again, which is a more painstaking process.

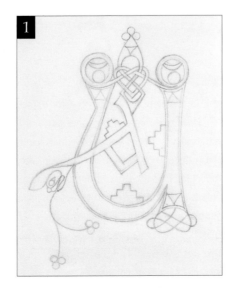
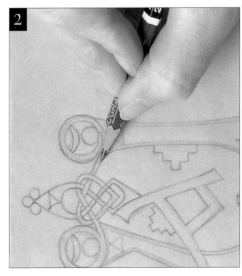

3 Red transfer paper can be made by rubbing some Armenian bole or burnt sienna pigment into greaseproof paper or tracing paper. The only parts that need not be traced down and outlined at this stage are any details that will be painted over the top of other colours, which you should trace into place after the base colour has been painted. There are no areas of this sort in the 'U', but the 'T' shown later in the chapter has detailing on the head of the animal that was not included in the first tracing of the design because it was necessary to paint in the cream-coloured background first.

4 Outline the whole letter using ink and a fine mapping pen. You will be able to see where the design needs sharpening up – some lines can be rather blurred or uneven after having been traced into place. Smoother, rounded curves can be given to all of the lines, and you can now fill in any parts of the design that were not transferred from the tracing properly. You should end up with a complete line drawing of the image. Note that you will need a steady hand on some areas where the lines are extremely thin and curved.

5 When you have finished inking the outline, rub out any surplus red transfer powder, or graphite powder from the pencil, to leave a strong, clear image that has no blurred or incomplete areas. The next step is to apply a gold colour to the designated areas. No gold was used in the Book of Kells, the material used instead being orpiment (arsenic trisulphide), which had a bright, shiny appearance. If orpiment is placed alongside other pigments, however, it will discolour them, a fact of which the illuminators of the Book of Kells were well aware. In order to prevent the orpiment coming into contact with the other pigments, they therefore either painted a border of ink around gold-coloured areas or else left a thin margin of blank vellum between the gold colouring and other pigments. You could use one of a variety of gold paints or gold powder, which is a good medium for this sort of design.

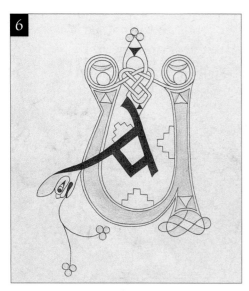

6 Winsor and Newton's gold gouache was used for the example shown. Take care to overlap the outlines as little as possible when applying the gold, because although you can go over the outlines again to neaten the letter at a later stage, it is not easy to cover over gold leaf because it will resist ink.

7 To complete the letter, now add the colours. Note that many of the inner parts of the letter have not been coloured, which means that the surface of the vellum can be seen. Very little modelling (the use of light and dark shades of colour to give the effect of three-dimensional shapes) was used in Celtic illumination. Various effects were instead created by using different textures and weights of line or patterning, as well as changes of colour.

Fig. 2. Illuminated 'U' from a book of Kells' original.

PROJECT *Making a knotwork Pattern*

Knotwork patterns are complex, interwoven pieces of decoration that should consist of a single, continuous line that weaves under and over itself in a carefully designed pattern. They have to be constructed with precision, so that each piece of the pattern weaves in and out correctly. An easy way to see how this works is to practise the following method.

Decide on a simple, linear pattern to make into a piece of knotwork and sketch it lightly. When you are drawing the pattern, take care not to make any areas too small to outline (Figure 3) – a little trial and error will soon teach you which patterns to avoid.

Outline the shapes that have been made where the lines cross, and also draw an outline around the outside of the shape.

Next, working around the pattern, connect the outlined areas with heavier lines, or perhaps a coloured pencil, until the whole pattern has been constructed with under- and over-bridges. This example only needed two crossovers, but more detailed designs will need dozens. If you ensure that you always alternate under- and over-pieces, the pattern should work out correctly. When you are drawing the outlines, remember to go around every part of the pattern, because if you leave one piece out the crossovers will not work correctly. When the middle line is removed you can see the effect of the woven pattern.

Strips of knotwork

Strips of knotwork are often needed for illuminating letters, and you should start by drawing a guideline consisting of a row of dots. Figure 5 illustrates a simple plait that has been formed by one row of dots spaced at equal intervals.

Make a row of dots as illustrated in Figure 5, and then link every other dot with a pencilled arch, as shown.

Next, draw in the outline pieces that have been made by the crossing lines in each section, as well as around the outer edges.

Now work on the crossovers so that you form a continuous, weaving line. When you have finished the pattern, trace the lines

Fig.3.
a Make a simple linear pattern to form the basis of a piece of knotwork.

b Outline each part.

c Form bridges where each line crosses.

d The finished pattern.

Fig. 4. Avoid patterns with areas which are too small to be outlined properly.

Fig. 5. A simple knotwork plait formed from a row of dots.

Fig. 6. A plait formed from two rows of dots.

Fig. 7. Vary the pattern by breaking and rejoining the line at different points.

Fig. 8. Three rows of dots and several breaks are used to create this pattern.

Fig. 9. Fit knotwork into irregular shapes around a pattern of dots. The ends of the knotwork need to be carefully worked to fill the area fully.

Fig. 10. Knotwork pattern used for the letter 'T' on page 162.

that you require for your work so that you lose the guideline dots and arches that helped you to form the pattern and use the tracing instead.

Figure 6 shows a plait pattern that was formed in the same manner, but from two rows of dots.

In Figure 7 a variation has been added to the plait by turning the weaving line back on itself at intervals. This is done by breaking two of the lines and joining each broken end to a new partner, so that the weave continues correctly. In order to turn the direction of the weave where you decide to break the lines in a pattern, make sure that you round off both broken ends and reconnect them with the correct new pieces.

Figure 8 shows a pattern based on three rows of dots. The weaving lines have been broken and reconnected in several places to form an interesting effect.

In order to fit a knotwork pattern into a letter's outline, you will first need to draw the area that will be filled with the pattern and then, working by eye, add rows of dots until you have filled it (Figure 9). Follow the procedure of linking the dots together, then drawing the outline pieces and so on. The ends of pointed areas should be carefully worked so that the pattern fits the shape neatly, but without breaking the continuously weaving line.

More complex patterns can also be made, and figures 10–12 illustrate the construction of a few others, broken down into stages. Figure 10 shows the knotwork pattern that was used for the letter 'T' later in the chapter. Although the pattern is straightforward around the thicker parts of the letter, it was too wide for the whole area along the thinner strip at the top, so it was worked into a simpler design at either end. Note how the artist carefully linked the two parts of the letter.

In order to join two different knotwork patterns, you will have to break them both off at a suitable point and then link the broken ends of each pattern. For now, you will only need to make one break in each pattern (Figure 13). When you become more skilled, however, you can work out really complex connections that link different patterns in several places.

When joining two different pieces of knotwork, if you find that you have two under-crosses to connect and two over-crosses that would not form the correct sequence, you will have to flip one of the patterns over to make the lines join correctly. If the reversed image is not the correct shape, you will have to rework the design. Make sure that the new design has lines that follow the reversed pattern direction, so that the broken ends join the other piece of knotwork correctly.

Fig. 11. Looped pattern.

Fig. 12. Box-shaped pattern.

Fig. 13. Joining together two different pieces of knotwork requires careful planning.

Spiral patterns

Spiral patterns were used a great deal in insular decoration, and some great manuscripts contain extremely complicated patterns consisting of whole panels of interlocking spirals. Although these pages can look dauntingly complex, the individual spirals are actually quite simple to draw – it's just a matter of learning some of the basic designs, as well as how they are linked. You can then work up a pattern that links as many spirals as you need to fill the available space in, or around, a letter.

The construction of the simplest forms of spiral are shown in figures 14-16. A one-coil spiral starts either from the centre point or from a small, central circle. Two- and three-coil spirals enable you to interweave different colours (figures 17-18).

Variations can then be given to the centres of the spirals in the form of smaller circles that turn back on themselves (figures 19–20), with tiny, pointed ovals being used to separate areas of colour (Figure 21) within each spiral.

Joining the spirals creates further large areas, which are frequently subdivided by three pointed shapes (Figure 22). (Remember that neither the spirals nor their surrounding shapes have to form a balanced, repeating pattern.) You can gradually build up an intricate piece of pattern constructed of spirals and joining filler shapes to fit any area that you want to decorate. The space in the centre of the 'O' shown in Figure 23 has been filled with spirals in this manner.

Fig. 14. One-coil spiral from centre point.

Fig. 15. One-coil spiral from central circle.

Fig. 16. A variation on a one-coil spiral.

Fig. 17. A two-coil spiral.

Fig. 18. A three-coil spiral.

Fig. 19. Varying the centres of spirals with inner coils.

Fig. 20. Three central spirals are used in this pattern.

Fig. 21. Pointed ovals used to separate areas within spirals.

Fig. 22. Joining spirals together is very simple.

Fig. 13. A letter 'O' with a spiral-filled centre.

Key patterns

Key patterns are another distinctive feature of Celtic illumination that often form either part of a large, illuminated letter or a carpet page of intricate design. The use of linear patterns of this sort dates from ancient times, and the insular artists made use of a complex array of patterns with which to adorn their manuscripts.

To begin with, you will need to use a grid of small squares to form the interlocking patterns (a few simple ones are shown in figures 24–26). Borders can be made of strips of pattern (Figure 27). Having devised a colour scheme, you can strengthen the pattern after you have painted in the colours by reinforcing the partition lines with dark outlines (figures 28–29).

Fig. 24. Simple key patterns – 1.

Fig. 25. Simple key patterns – 2.

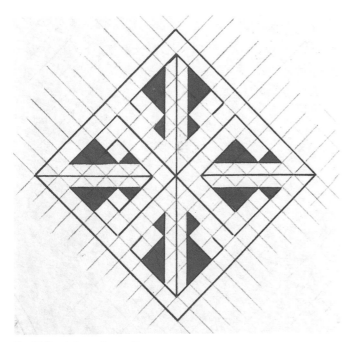

Fig. 26. Simple key patterns – 3.

Fig. 27. Key-pattern borders.

Fig. 28. Key-pattern colour schemes – 1.

Fig. 29. Key-pattern colour schemes – 2.

Once you have mastered the basics, you can create more complex designs, filling in areas of solid colour to break up the monotony of large areas of tiny squares (figures 30–31). The strips of pattern can be made to curve around other shapes (Figure 32), as well as to fit into specific areas (Figure 33). They can be intermixed with knotwork to good effect, too (Figure 34).

Fig. 30. Sketch the pattern.

Fig. 31. Paint in the colours and outlines.

Fig. 32. Curved key patterns.

Fig. 33. Irregular shapes.

Fig. 34. Knotwork and key patterns together.

Zoomorphics and anthropomorphics

Celtic work is full of delightful little birds, animals and human figures that intertwine with letters and fill gaps between paragraphs. The animal and bird patterns are known as zoomorphics, while those using the human figure are called anthropomorphics. Figure 35 shows a small bird that appears in the middle of a large block of text and acts as a letter 'Q', while the dog-like animal pictured in Figure 36 also appears within the body of the text on a page, preceded by a large and elaborate capital letter. The heads of all of the Celtic animals and birds are constructed similarly (Figure 37), with a long mouth coloured differently from the neck and body, a small, round eye and an oval-shaped head leading into the neck. Repeating patterns – of birds in particular – are used to form borders and large areas of pattern within letters (Figure 38). Panels of each of the forms of pattern mentioned in the last two pages can be linked to form larger letters with bands of different colours (Figure 41). These bands can in turn be worked into animal heads and bodies, further linking the letters or bringing them to interesting terminations (Figure 42).

Fig. 36. A Celtic dog.

Fig. 35. A Celtic 'Q' designed as a small bird.

Fig. 37. Heads of animals and birds.

Fig. 38. A repeat border pattern of birds is frequently found in Celtic manuscripts.

The human forms are also very stylised. A beautiful portrait of St John appears in the centre of folio 291v of the Book of Kells, illustrating the typically formal, curling arrangement of the hair and the simple facial details (Figure 39). Slightly more crudely constructed faces – always sharing the same basic, pen-formed design – were often slipped into any available space within a letter (Figure 40).

Fig. 39. A portrait of St John from the Book of Kells.

Fig. 40. Simpler, cruder faces are often used.

Fig. 42. Animal heads used as terminals to banded blocks.

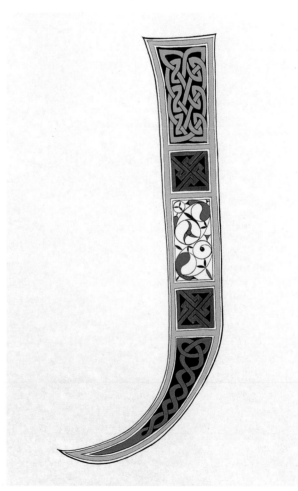

Fig. 41. Bands of colour enclose patterns, forming this letter 'J'.

Creating a Celtic Initial Letter 'H'

We will now reproduce a large, initial letter 'H' (Figure 43), which begins a long strip of lettering that reads Hic est Iohannis ('Here is John') (Figure 50). The second letter, an 'I', sits inside the 'H'. The remaining letters accompanying the initial are written in the heavy, angular style that often preceded the main body of the text on the illuminated section of a page. A full alphabet of these letters is shown below.

1 Trace the outline of the 'H'. The original knotwork pattern is quite complex, so this version has been slightly simplified. As you draw the interwoven portions, make sure that each piece weaves in and out correctly, following regularly over and under without missing a crossing point.

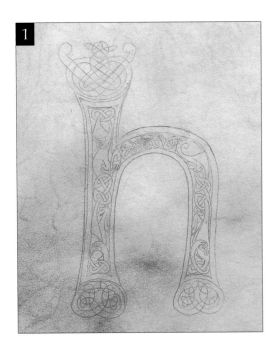

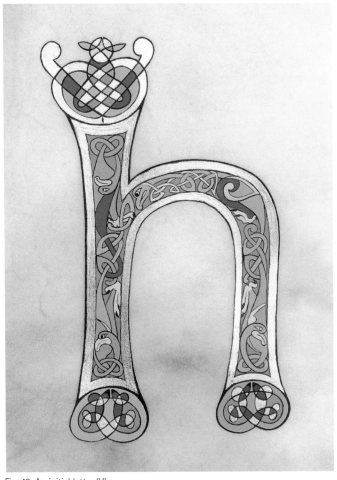

Fig. 43. An initial letter 'H'.

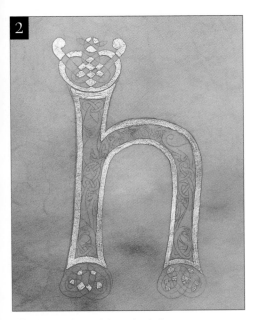

2 Apply the gold work to the outer borders.

3 Now outline the whole of the letter.

4 Apply the colours to complete the letter. If necessary, go over any parts of the outline that were lost when you added the colours so that the image is sharp and clear.

PROJECT *Creating a Title Strip*

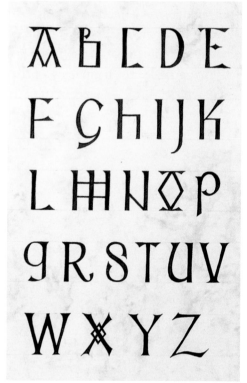

An alphabet of angulated capital letters is shown in Figure 44. These are used for the remaining letters of the title strip.

1 If you wish to continue writing the title strip that was begun with the letter 'H', make a drawing of the 'I' within the 'H' (see step 1, page 36) and the remaining letters. Trace these into place on the vellum (see step 1, page 159), then add the gold, followed by the colours.

Fig. 50. The completed title strip

Writing and illuminating uncial letters

The script that makes up the body of the text in Celtic manuscripts is called uncial. In order to write uncial letters, you will have to hold your pen at a much shallower angle (about 30°) than for most of the later scripts. Practise holding the pen at this angle by writing the pen patterns shown in Figure 45, and then try the alphabet illustrated in Figure 46.

The top stroke of the 'T' is often elongated to give the letter a very attractive appearance (Figure 47), and this treatment can be applied to other letters, too. If it is used at the end of words, this sort of stroke can break up the text and improve the legibility of a lettering style that may be difficult to read.

Line-fillers, patterns of dots and lightly embellished letters are also liberally scattered throughout pages of Celtic illuminated work (Figure 48). Random initial letters may be filled with colour and surrounded by small, red dots, a treatment that was often used for large letters in the Lindisfarne Gospels. The illumination in the Lindisfarne Gospels has a lighter touch than the decoration in the Book of Kells, and the letter shown in Figure 49 reveals the use of finer knotwork, lighter colouring and many surrounding and filling red-dot patterns.

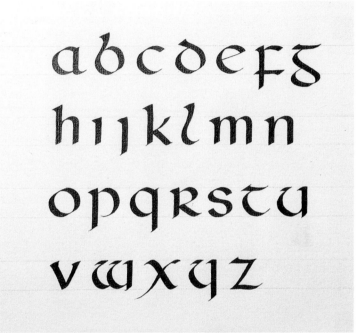

Figure 46: Uncial letters.

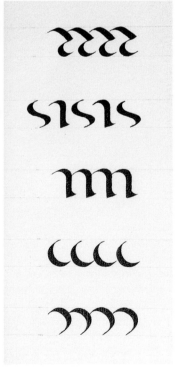

Fig. 45. Pen patterns for establishing the correct angle for writing uncials.

Fig. 47. An elongated 'T'.

Fig. 48. Celtic line-fillers.

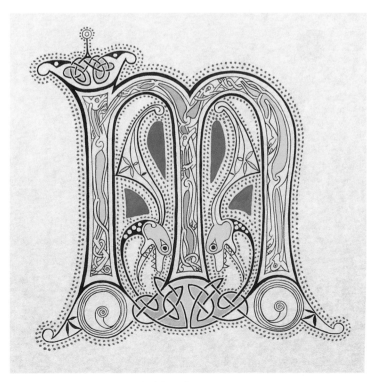

Figure 49: A letter 'M' from the Lindisfarne Gospels.

PROJECT *Creating a Celtic Letter 'T'*

A letter 'T' that begins the text *Tunc crucifixerant* from the Book of Kells is illustrated. A long-tailed creature, with a cat-like head and feet, forms the whole of the main part of the letter, enclosing a knotwork pattern that is fairly simple in its widest portions, but develops into a more complex, haphazard pattern around the more difficult areas of the body, although it still maintains an unbroken thread. The animal's teeth clasp a tangled mass of prey, which fills the space between its head and body.

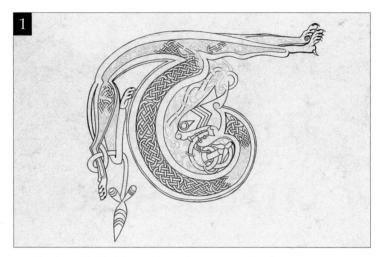

1 The letter is first traced into place and outlined.

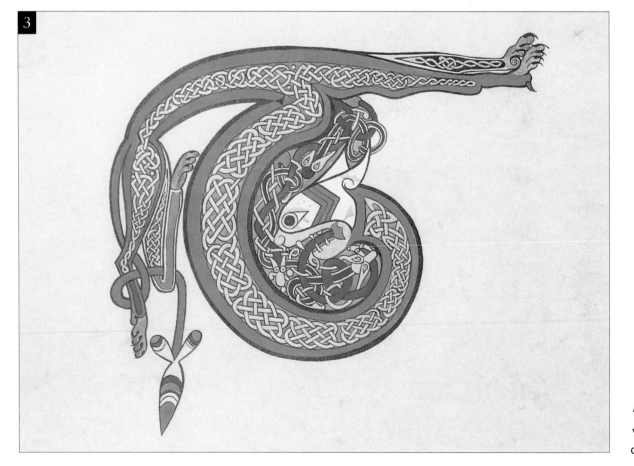

2 Next the gold and colours are added.

3 To finish, the head is overlaid with colours.

Carolingian Letters 15

Carolingian letters

In this chapter we will look at the Carolingian style of lettering and illumination that is found in such works as the Winchester Bible, a manuscript that we will use as our principal source. The description 'Carolingian' is derived from the name of Charlemagne, who was crowned king of the Franks in 771 and had great influence over arts and learning, which he promoted and patronised throughout his reign. On his death in Aachen in 814, his library was sold and the proceeds distributed amongst the needy, according to his directions. The style of lettering that we call Carolingian is considered to be the basis of the minuscule alphabet that we use today. It represents the first real attempt to create an alphabet of letters that was separate from the capitals that were used for emphasis at the beginning of verses and chapters.

Although you will find that many different pieces of lettering are described as Carolingian, individual characteristics sprang from the hands of different scribes from area to area. Figure 1 shows a Carolingian alphabet that is a fairly modernised version of some of the original Carolingian styles. The ascending strokes have a thickened termination, yet there is a general simplicity to the letters. The lines of writing are widely spaced to allow plenty of room for the elongated ascenders and descenders, and at least two-and-a-half times the width of the writing lines can be left between each line of text (Figure 2). The alphabet is often written between guidelines that are only three times the width of the nib, giving the letters a squatness and strength that is very attractive. Some Carolingian texts can be quite thin and spindly in appearance, however, with a writing-line height of about six times the width of the nib (Figure 3).

If you want to recreate the appearance of the lettering that accompanies a particular manuscript exactly, you will have to take the time to study the lettering and working in order to achieve a good copy. Remember, however, that some historical texts contain lettering that has many idiosyncrasies, which can be hard to copy. In this case, rather than slavishly trying to reproduce the text word by word, it may be better simply to adapt the writing to your own style. It should then be possible to produce a good, flowing piece of lettering instead of laboriously trying to achieve what may turn out to be a very stilted reproduction.

The illuminated letters that accompanied the Carolingian script were initially fairly simple. The example shown in Figure 4 is a pen-formed letter with animal terminations at the end of each stroke. (It is thought that the elephant's head may represent Charlemagne's pet elephant Abulabaz, a gift from Caliph Haroun-al-Rachid in 802.) The manuscript, which was kept at St Denis from about 802 to 810, is today housed in the Bibliothèque Nationale in Paris, France.

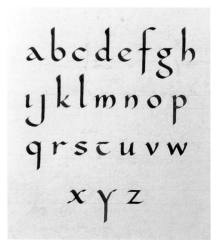

Fig. 1. The Carolingian alphabet.

Fig. 2. The composition of the letters.

Fig. 3. Squat and thin letters.

The band of gold in the main stem of the 'B' consists of gold leaf on a nicely raised, gesso base. The sweeping curves of the 'B' are quite difficult to produce well and will need a lot of practice. In order to construct the letter, first make an outline drawing of it to ensure that you have formed the shape correctly. Experiment with this outline to achieve the proper pen directions for making the strokes, using the full thickness of the nib for the wider parts of the letter and tapering strokes for such thinner parts as the elephant's tusks. When you have become accustomed to forming the letter, you can either try writing it freehand, if you feel confident enough to do this, or else trace down your outline onto the vellum and use it as a guide to help you to draw the letter as accurately as possible (Figure 5)

Fig. 4. A letter 'B' from a ninth-century manuscript – the letter is outlined in ink, then the raised gold is applied.

Fig. 5. The coloured strokes are added to complete the letter.

PROJECT *Creating a Pen-formed letter 'C'*

Using the ninth-century example that we have recreated as a guide, we can form a new set of initials in a similar style for use with any piece of lettering.

1 A letter 'C' in the same style. Make a draft letter and trace it onto the vellum. Add the inked outlines, then the gold.

2 The heads do not represent any particular animals, but instead use the general qualities of the animals in the original letter loosely to depict a variety of either real or imaginary creatures.

3 The finished letter with some Carolingian text added.

Although the letter 'N' in Figure 6 was a bit more challenging to design because it required a lot of terminal figures at the end of the uprights (Figure 7), with a little imagination any letter can be given the same treatment.

Fig. 6. The outline of a letter 'N' with animal terminations is traced onto the vellum.

Fig. 7. The finished letter 'N'.

The Winchester Bible

As we have already noted, many slightly different texts come under the general description 'Carolingian', including the Winchester Bible (Figure 8). During this period, all of the great churches were required to possess a copy of the Vulgate – St Jerome's translation of the Hebrew and Greek scriptures – and Henry of Blois (who was bishop of Winchester at the time), the brother of King Stephen, appears to have been the most likely person to have commissioned the work. Indeed, at the beginning of the Winchester Bible is a representation of a bishop holding a large, red volume under his arm, which further supports this theory. In addition, before Henry died, he gave money to the cathedral's scriptorium (the monks' writing room), possibly so that the work would be continued. It was

not completed after his death, however: although the text, which was entirely written by one scribe, is complete, many of the illuminated letters were never finished and therefore appear in various stages of construction.

The Winchester Bible was produced in the cathedral's priory between around 1160 and 1175. It is a very large work – the vellum leaves measure 583 x 396mm (23 x 15″) – and it was originally bound into two volumes, comprising 468 leaves in total. Since then, it has been rebound at least twice, once into three volumes and more recently into four, which means that four double-page spreads can be seen at once.

Some of the original letters in the Winchester Bible are missing: about nine have been identified as having been acquired by private collectors, a few of which are now on show to the public at various galleries around the world. The Bible itself, however, is believed to have spent most of its existence in Winchester and to have been loaned out for special exhibitions only seldom. It is today on display at Winchester Cathedral's Triforium Gallery, along with other illuminated manuscripts and books of importance. The pages that contain the most elaborate initials are much darker than the others, indicating that these pages have been displayed the most.

If you study the letters of the Winchester Bible carefully, you will see that the gold leaf appears to lie quite flat on the page. (Through the gold, you can often see veins on the vellum, as well as other markings on the surface, such as ruled writing lines.) Some of the unfinished letters show that the gold leaf was laid on a gesso base, and some also have the raised appearance that is normally associated with gesso. The general flatness of the gold areas is due to an extremely thin application of gesso, and the shine achieved is quite remarkable – it has survived in this beautiful condition for more than 800 years.

anathoth interra beniamin quod

Fig. 8. The lettering style used in the Winchester Bible.

PROJECT *An illuminated Letter 'P'*

The illuminated letters in the Winchester Bible have an incredibly rich, vibrant quality, with beautiful, stylised ornamentation and vivid, clear colours. Figure 9 shows a reconstructed letter 'P'. It is taken from the opening page of the Second Book of Kings, and begins the sentence Prevaricatus est

Moab ('And Moab rebelled [against Israel]'). Although this is a complex initial, we will work through the individual components of letters of this type gradually, so that the style is learnt in small portions, making larger projects less daunting.

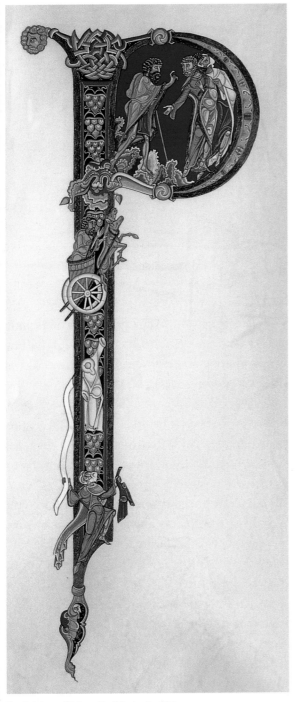

1 The letter is drawn in outline.

2 The design is traced onto the vellum.

3 Paint gesso onto the areas to be gilded.

Fig. 9. A letter 'P' from the Winchester Bible.

4 Apply the gold leaf.

5 Add the base colours, then outline the shapes.

6 Add modelling and detail with a fine brush.

Detailed study of the illumination techniques used in the Winchester Bible has enabled scholars to identify the principal illuminators, whom they have given descriptive names, such as the Master of the Leaping Figures, the Master of the Apocrypha Drawings, the Master of the Genesis Initial and so on. It is clear that two illuminators often worked on one initial, the first designing the letter and the second adding the gold and colours, as well as adapting the flow of the drapery, the facial features and other details to suit his particular style.

The 'P' in Figure 9 was worked by the Master of the Leaping Figures. It shows Elijah, who, having made prophesies and performed miracles with God's assistance, is depicted in the midst of a windstorm being taken up to heaven in a blazing chariot drawn by fiery horses. Elijah leaves behind his companion, Elisha, who asks Elijah to give him part of his spirit. As Elijah ascends to heaven, his mantle drops, and Elisha, taking up the garment, proceeds to perform miracles of his own, the men of Jericho thereby recognising that the spirit of Elijah has settled upon him. This account, which is contained in the first two chapters of the Second Book of Kings, is simply and vividly portrayed. Elisha, who is depicted watching his friend depart, holds up a scroll on which is written his parting cry, 'My father, my father, the war chariot of Israel and his horsemen'. The main bowl of the letter portrays Elijah, his feet licked by flames, being received into heaven. The stem of the letter is decorated with heavily stylised bunches of grapes that form a backdrop to the brightly coloured figures. The letter runs the full length of a page and measures approximately 45cm (17 3/4") from top to bottom (the reconstruction is of the same size).

When trying to recreate a medieval letter, it is helpful if you have some idea of the size of the original and make your work the same size, which will enable you to carry out the painting techniques properly, and as they were originally executed. Although creating a larger letter does not present much of a problem, if you try to work on a smaller scale you may find some of the detailing very difficult to achieve. When you have fully understood a particular style's method of construction, you can design differently sized pieces in full knowledge of the limitations that you may thereby be imposing on your painting and gilding.

Figures, drapery, trees, plants and stylised patterns in the Winchester Bible

The human figures depicted in the Winchester Bible's illuminated letters have been given a very stylised treatment, with exaggerated folds to their drapery and thin, elegant limbs. (Figure 10 shows a figure of a man contained in the initial letter 'H' at the beginning of the Book of Exodus.) Bright orange, green, deep pink and blue are the principal colours that have been used for the clothing, and the robes often have thin, gold edges. Hair is made up of a neat series of curls that have been carefully painted and outlined. Parts of the body have received the same linear treatment as the clothing, while green tints have often been added to the flesh colours.

Trees and plants have been heavily stylised, too. The tree (Figure 11), which has been taken from a letter 'U' in the Book of Jeremiah, demonstrates the stylised treatment of vines, with

Fig. 10. A stylised human figure.

Fig. 11. A stylised tree.

their large bunches of grapes. Note that the branches have been portrayed as growing from pockets in the trunk of the plant. Figures are sometimes depicted standing on rocks, or perched on part of the letter, but they can also appear as if they were floating within the design, having been given no footing at all.

Attractive bands of patterning have been used everywhere to form parts of the upright or curved portions of the letters, for example, the scalloped band running down the upright of a letter 'F' (Figure 12). (The repeating pattern of the scallop,

flanked by curving arches that terminate in a tight coil, can be continued in a full border if necessary.) The background is black, as is usual for most multicoloured strips of pattern, while the scallops are alternately coloured a deep, reddish pink (obtained from a mixture of madder carmine and white), bright cadmium orange, scarlet, cobalt blue and green. Each piece on the black background has been coloured before being shaded with a darker shade of the same colour. Thin white highlights have then been added.

Stage 1

Stage 2

Stage 3

Fig. 12. A pattern formed using scallop shapes.

Figures 13–14 are part of a letter that is composed of a double band of gold bars interwoven with scrollwork. The scrollwork doubles back and forth, revealing different-coloured sides with each fold, the topsides in blue and green and the undersides in orange and purple. Red scallop shapes have been painted between each set of folds on the black background. Figure 15 illustrates another portion of the same letter, which has wide, curved pieces of pattern folding around the outside of the gold bars before joining to form a floral centrepiece. This pattern is repeated to fill the required area. Figure 16 also uses double bands of gold, with a simple inner pattern of orange scallop shapes, followed by diagonally divided portions in alternating colours of green, blue and red separating each scallop. Figures 17–18 show the construction

Fig. 13. Double gold bars and coloured scrolls are used to form this pattern.

Fig. 14. Outlines and modelling are added.

Fig. 15. Constructing a pattern of double bars with floral centres.

Fig. 16. Double bars with scallops.

of a geometric pattern, whose diamond-shaped boxes of alternating colours give a three-dimensional appearance to the strip of pattern. The black background has been overpainted with gold flowers.

Some of the patterns in the Winchester Bible are based on shades of one colour, such as the portion of a letter 'O' shown in Figure 19. The design has been painted on a pinkish-red background, then overpainted with paler-pink scallops between shapes that terminate in alternate red and blue tips. White highlights have been added to complete the pattern.

More detail has often been added outside the main portion of the letter by means of interesting terminal points to various parts of the letter. The terminals to an 'E' (shown in Figure 20) are in stylised floral work, while those in Figure 21 have animal and human heads. Lattices of interweaving bands may also be used to terminate letters and connect strokes (Figure 22).

Fig. 19. A pattern in shades of one colour.

Fig. 7. A geometric diamond pattern.

Fig. 18. The colours are outlined and the final detail is added.

Fig. 20. Stylised floral terminations are given to this letter 'E'.

Fig. 21. Human and animal terminals.

Fig. 22. Lattice terminals.

Fig. 23. Knots.

Another neat design feature is the small knot or decorative flower that is used to tie two bands of pattern or parts of a design together (Figure 23). These devices are usually placed on the curved parts of letters, as you can see at the top and bottom of the 'O' in Figure 19, as well as the orange knots on the 'P' in Figure 9. The heads of animals and people are also used in this way, as can be seen in the centre of the 'B' in figures 25–26.

Fig. 24. Interlocking versals.

The initial letters themselves are large versal letters that are extremely regularly shaped and well balanced. (The complete versal alphabet will be covered in more detail in Chapter 17.) Smaller red, blue and green capital letters accompany many of the illuminated initials, making up the remainder of the phrase or title piece. In contrast to the superb quality of the illuminated letters, however, in the Winchester Bible many of these capital letters have been rather poorly executed. Their placing within words to fit the available space nevertheless makes interesting patterns and contributes to the whole design (Figure 24).

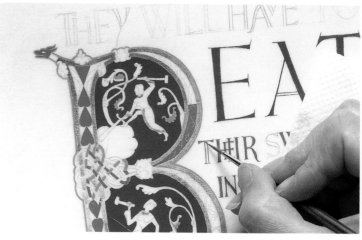

Fig. 25 below: This illuminated letter 'B' is based on a fine example in the Winchester Bible. Transfer leaf is applied, then the base colours are added.

Fig. 26. Coloured versal letters are used for the words needing emphasis.

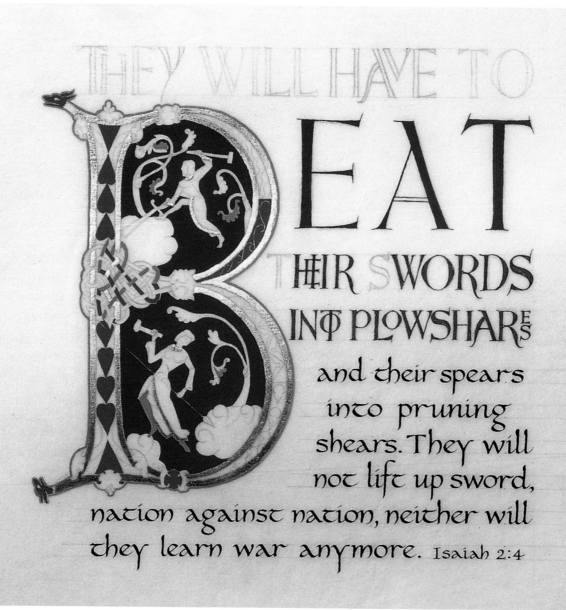

Designing your own pieces

By working on the various components of letters, such as those that appear in the Winchester Bible, you will gradually build up an understanding of the techniques that were used, as well as the style of the illuminated letters. You will then be able to design new letters for your own pieces of lettering.

The illuminated piece shown in Figure 28 starts with an initial letter that is based on a 'B' that opens the Book of Psalms. The central scenes illustrate the text, which consists of coloured versal capitals and Carolingian lettering. The whole letter is surrounded by a narrow border of pale green, a treatment that is given to many of the letters in the Winchester Bible.

Designs in this style tend to be the most successful when they are contained within a fairly compact area. The versals were carefully fitted into the piece's required width by using overlapping and reduced-size letters. Not only did this give a pleasing effect, but it also ensured that exactly the right amount of space was used. The size of the black text was also chosen to fit the space available, in order to give a neat, compact design.

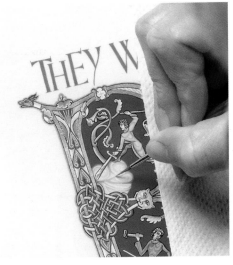

Fig. 27. Fine detail is added to the rock.

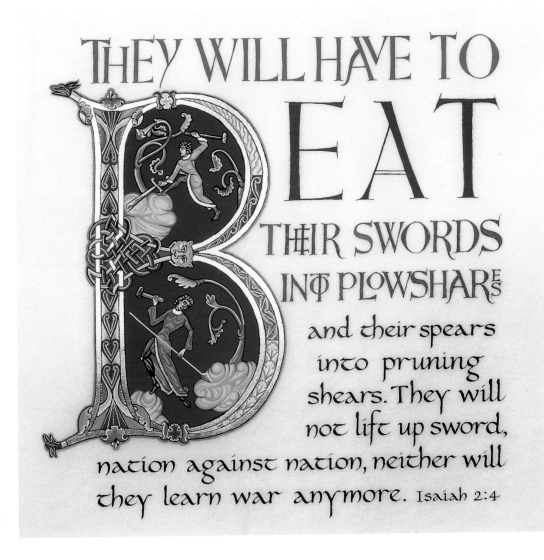

Fig. 28. The completed piece.

Gothic Decoration 16

Gothic Decoration

A variety of terms are used to describe the components of illuminated letters, and we will cover a selection of them in this chapter, mainly concentrating on those that date from the Gothic period. The Gothic period, which lasted from the late twelfth to the early sixteenth centuries, has given us a rich selection of styles and types of ornamentation for illuminated letters.

Types of Initial Letters

The decorated initial

The decorated initial, which contains no human or animal figures, is the most straightforward type of illuminated letter. The letter is embellished by extending and elaborating some of its strokes, so that they intertwine with both themselves and each other to form a decorative unit. Figure 5 on page 140 illustrates this type of illumination for a simple letter 'H', while Figure 1 shows a decorated letter 'P' with a floral interior. Although these examples are quite simple, the decoration may also be incredibly complex, as can be seen in some of the great insular manuscripts, like the well-known letter 'X' in folio 34R of the Book of Kells, as well as another 'X' in folio 29R of the Lindisfarne Gospels.

The inhabited initial

The term 'inhabited initial' is used to describe an initial that contains figures or animals that do not depict a specific scene. The figures are usually intertwined with scrollwork emanating from the extremities of the letter, and some charming and lively patterns are often the result (Figure 2).

The historiated initial

Historiated initials first appeared in illuminated manuscripts written in the insular style in about 750 and became very popular during the medieval period. They contain a recognisable scene, usually relating to the text. The 'D' in Figure 3, for example, depicts Christ making a blessing. (This letter is taken from a page of the Grey-FitzPayn Hours that was created between about 1300 and 1308 and can now be seen at the Fitzwilliam Museum in Cambridge, England.) Many well-known stories from the Bible may be portrayed, a particular favourite being that of David and Goliath, as illustrated in Figure 4. This example has been recreated from the French original contained in the La Charité Psalter (folio

Fig. 1. A decorated initial 'P'.

51b), which dates from the end of the twelfth century. Whole borders can be historiated with a series of scenes that recount a particular event or a series of related events.

Fig. 2. An inhabited initial 'R'.

Fig. 3. A historiated initial 'D'.

Fig. 4. A historiated initial 'B'.

Types of Ornamentation

Diapering

Diapering is a type of ornamentation that involves the painting of a tiny – often repeating – pattern over a letter's background surface. The term is derived from the French word diapre, which means 'variegated'. It is a very attractive type of ornamentation that is characteristic of medieval illumination (having been used as early as the eleventh century) and that is a common feature of Gothic art, too.

The pattern used in the above-mentioned letter 'D' (Figure 3) is a blue, red and white design that is built up as shown in Figure 5. The background is painted dark blue and is then divided with a grid of black squares. Small, white squares are painted in the centre of every other square, which are joined diagonally from corner to corner. Red squares are painted into the other boxes, which have been finished off with a central white dot. The pattern is simple, but effective, giving a rich depth to the design. The background of the letter is gold leaf, which should be applied before any paint is added so that the gold does not stick to the gum that the paint contains.

Diaper patterns can be divided into three groups: geometric, floral and embossed (or gold) patterns.

Fig. 5. A simple geometric diaper.

PROJECT *Creating a fifteenth-century geometric diaper design*

Figure 8 shows a geometric diaper design taken from a page of the Hours of Peter II, Duke of Brittany, which was created between 1455 and 1457. Every other box has been painted gold, and three other colours - red, blue and sepia - have also been used. The resultant pattern is a series of alternating diagonal lines which rises to the middle of the area that will be covered and then descends to the outsides.

Fig. 6. Red, blue and sepia diaper.

1 Draw a framework of vertical and horizontal lines, with the lines at a distance of about 5mm (3/16") apart (see Figure 6). Find the central square of one of the top rows and start painting in the relevant row of squares to either side with one of the colours, in this case red. Remember to leave the next two rows beneath this one blank for the other colours. Calculate which rows in the rest of the grid of squares will need to be the same colour and then paint them. Using the next colour, blue, paint the row of squares below the red. Now use the final colour, sepia, to paint the remaining blank squares, so that you have filled the whole grid.

2 Add a pattern of three dots to each of the coloured squares using a lighter shade of the background colour. Having been lightened with white, the sepia has also been mixed with a touch of lemon yellow to brighten the colour a little.

Fig. 7. Fill the ruling pen with a brush.

Fig. 8. A ruling pen can be used for the partition lines of diaper patterns. Here it is shown ruling the lines for the diaper pattern shown in Figure 5.

Fig. 9. Mapping pen and rule.

3 Use a ruling pen (Figure 7) and black paint to draw in the dividing lines. Ruling pens are available from art shops and are simple to use in conjunction with a rule. Set the ends to the required width and then fill the gap between them with paint. Draw the pen along the rule's bevelled edge, but make sure that the paint does not come into contact with the ruler itself (Figure 8). Take care not to make the black paint too thin, as the painted surfaces over which you will be ruling will be very porous. If too much paint, or paint that is

too thin, is drawn over other painted areas, it could flood out of the pen too quickly and cause the lines to be thick or blotchy. Alternatively, you could use a mapping pen and rule (Figure 9).

Creating a diamond-shaped and perspective diaper

The diaper pattern shown in Figure 10 is taken from a page of the St Omer Hours, which was created in around 1350 in northern France. The overall effect is of circles and squares, the joined white lines giving the red-crossed boxes the appearance of rounded corners.

This pattern is most easily achieved by painting the whole area to be diapered with the background colour, in this instance a pale pink. Draw a grid of squares over the background and then use red paint to rule in all of the boxes with fairly thick lines. Give every other square a red cross. Add a small, white, linear box to the centre of each of the remaining boxes. Join the corners of each white box throughout the design.

The diamond-shaped diaper illustrated in Figure 11 comes from the Hours of Mary of Guelders, dated 1415. This design, with its alternate, vertical rows of red and blue between gold rows, is a good example of how diamonds must be accurately drawn so that they appear in neat lines one above the other. When drawing the grid for the diaper, be sure to make the angle of all of the diagonal lines the same, because if you do not draw the two sets of lines at the same number of degrees from vertical the diamond shapes will not be correct and will

Fig. 10. A fourteenth-century geometric diaper.

slant sideways to form unpleasant shapes. Also try to ensure that the rows of diamonds are parallel with the sides of the page that you are working on.

It is often better to work on diaper patterns before painting other areas of the work so that you can neaten up any untidy edges. The figures that appear immediately below the diapered area have head-dresses that should have smooth edges, for example, and these can be painted in accurately when the diaper is complete.

Perspective is achieved in medieval miniatures by the use of diapered floors. The Hours of Giangaleazzo Visconti, Duke of Milan, which dates from about 1388 to 1395, contains some very elaborate historiated initials, as well as displaying much

Fig. 11. Diamond-shaped diaper.

Fig. 12. Perspective diaper.

use of diapered backgrounds. A fine initial 'D' from folio 115 depicts King David sitting beneath a canopy. The floor was created using the diaper pattern shown in Figure 12, and its sepia-coloured background has alternate, linear squares of red and white, with counterchanged dots in each square. When recreating this pattern, first draw the grid on a separate sheet of paper so that the horizon point can be marked and the lines drawn to meet it. Draw the horizontal lines parallel to the top edge of the paper and then trace the necessary lines onto the area to be diapered (Figure 13).

Fig. 14. Geometric diaper with regularly spaced flowers.

Fig. 13. Horizon lines are used to form the perspective correctly.

The same illuminated letter also contains two other diaper patterns: one (detailed below) is completely floral, while the other is a pattern of flowers arranged in a geometric layout on a red screen behind King David. Small red and blue flowers tipped with white (Figure 14) have been painted over the red background in regular rows. This manuscript also contains some attractive line-fillers, which will be discussed later in the chapter.

The pale-coloured diaper shown in Figure 15 consists of a grid of thin red lines separating pale-blue and green squares. Each square has been lined with another red square, after which dark-green triangles have been placed within each pale-

green square and small, red circles within each pale-blue square. This pattern is found in the Belle Heures of John, Duke of Berry, folio 30.

Floral diaper designs

The corners of the 'D' mentioned previously have a delicate gold floral diaper on a dark-blue background (Figure 18). The scrolling foliage has been carefully adapted to fit the required spaces. Each corner of the letter contains a shield, around which the diaper has been fitted and neatly worked into the confined spaces.

When recreating this diaper, paint the blue background first

Fig. 15. Pale-green and blue squares with thin red lines form this perspective diaper.

PROJECT *Planning a decorated and diapered initial letter*

Fig. 16. A letter 'N' with diapered centre and shield.

The initial 'N' illustrated in Figure 16 is a decorated initial that has a diapered background of blue and gold checks (shown in greater detail in step 1). Letters of this type, which have a simple, central feature – in this case, a shield – on a diapered background, are common. The letter is typically set within a box that is usually bordered with gold, or another colour, and the extremities of the letter have been given floral terminations. These floral terminations can be extended to form whole borders in the same style (borders in general will be looked at further in Chapter 19).

1 The construction of the central diaper pattern.

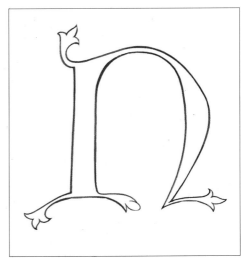

2 Draw an initial letter using the versal alphabet.

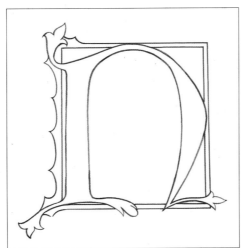

3 Now add the corner terminations.

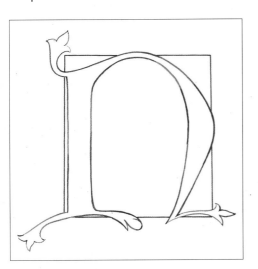

4 Square off the letter with a surrounding box.

5 Add an outer second line and work the left-hand ends of the box into the floral sections using curved fillers, as shown. Give the whole of the left-hand edge of the box this treatment.

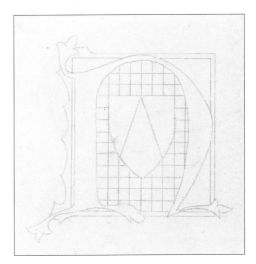

6 Draw the central features and work out any diaper patterns. The letter is now ready to paint.

Fig. 17. Guidelines are traced onto the dark background.

Fig. 18:. Gold on blue floral diaper.

Fig. 19. White diaper over a dark ground.

(Figure 17). Having designed the diaper pattern on tracing paper, transfer it to the background. (When the background colours are dark, the tracing can be difficult to see, but if you work at an angle, so that the light shines on the traced lines, they will show up well enough to be followed accurately.) Finally, working along the traced outline, paint over the background colour in gold (Figure 18).

The background of the large initial 'B' (which is taken from the La Charité Psalter that was mentioned previously) has a fine, white, floral diaper over a dark background (Figure 19). As described above, create the design on tracing paper before transferring it to the work. You will achieve a much more even, well-arranged spread of curls if you work them out in advance rather than trying to paint them directly onto the work freehand.

Figure 20, which is taken from a fourteenth-century French manuscript, has a light, coiling diaper on a red background. The coils are composed of two parallel lines, with small shoots of three short strokes branching off at regular intervals. The remaining gaps have been filled with small dots. The same colour scheme was employed for the diaper shown in Figure 21. This is a looser, more open, pattern, consisting of main branches to which are attached twisting leaves. (A similar pattern, in which gold appears on a dark-green background, was used in the same fifteenth-century French manuscript.) Gold on blue was used for the pattern taken from a fifteenth-century missal that is illustrated in Figure 22, which incorporates flower heads amongst the branches and leaves.

Fig. 20. Gold floral diaper on a red ground.

Fig. 21. A more open floral diaper.

Fig. 22. Gold floral diaper on a blue ground.

Embossed diaper designs

Diaper patterns can be embossed on paint or gold, a technique that is most successful on raised gilding, where the gesso can be impressed with the design. The easiest embossed patterns to make are those that are based on a geometric design, so that the lines can be accurately scored into the gold (Figure 23). Scored lines that make up a grid often have small, floral motifs in each section (Figure 24). The sharp edges reflect the light well and also highlight the contrast of light and shade.

Curving patterns are more difficult to score into the gold smoothly, and can sometimes look a little ragged. The floral pattern – taken from a late thirteenth-century French manuscript – shown in Figure 25 should be very carefully impressed, with care being taken that the gold is not scratched off or the gesso cracked as a result of too much pressure having been applied. A pencil burnisher can be used to make simple dot patterns (Figure 26).

Fig. 23. Embossed geometric diaper on gold paint.

Fig. 24. Embossed geometric diaper with scroll detail on gold leaf.

Fig. 25. Floral embossed diaper.

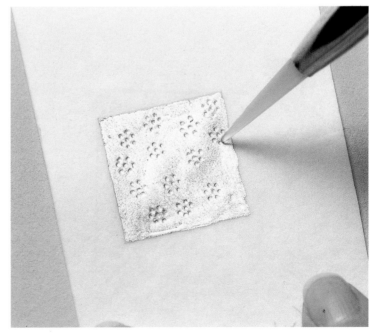

Fig. 26. Dot-pattern diaper.

Drolleries and grotesques

Drolleries are amusing figures that appear in manuscripts dating from as early as the insular period. They were particularly popular from the thirteenth to the fifteenth centuries. Illustrated here is an example taken from a fifteenth-century Italian gradual (now to be seen at the J Paul Getty Museum, Malibu, California, USA) that depicts a monkey playing the bagpipes. The colours of this piece are particularly striking (figures 27–28).

Grotesques are hybrid forms of creature, usually of a comic nature, composed of a mixture of human and animal forms. They are frequently seen in Gothic illumination and often bear no obvious relationship to the accompanying text: they appear in all sorts of places, apparently just for fun, and have no clear meaning. Small grotesques can also be found tucked into corners and attached to the ends of letters.

The fourteenth-century Luttrell Psalter (which is today housed in the British Library) contains many such examples (Figure 29). The lettering in the Luttrell Psalter is a handsome, Gothic script that displays the angular strokes common to all of the Gothic styles, as well as squared feet to the letters. Figures 30-31 shows the alphabet used, along with another, variant alphabet, in a similar style, that accompanied texts throughout the Gothic period. Smaller illuminated letters are spread throughout the text, some examples of which are illustrated in figure 30.

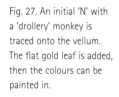

Fig. 27. An initial 'N' with a 'drollery' monkey is traced onto the vellum. The flat gold leaf is added, then the colours can be painted in.

Fig. 28. Vivid colours give this letter a lot of character.

Fig. 29. Grotesques found in the Luttrell Psalter.

abcdefghijklmn
opqrstuvwxyz

Fig. 30. Lettering found in the Luttrell Psalter – a.

abcdefghijklmn
opqrstuvwxyz

Fig. 31. Lettering in the Luttrell Psalter – b.

Fig. 32. Small illuminated initials used in text blocks.

luck the fruit and aste the ple asure

Bestiaries

Bestiaries, or books of beasts, date from medieval times and were very popular during the twelfth and thirteenth centuries, especially in England. Because few illuminators were well enough travelled to have had much knowledge of the animal kingdom throughout the world, a strange array of beasts is depicted in such books, their descriptions having been gleaned from a mixture of classical renditions and recounted tales – both real and imaginary – of beasts seen by travellers, as well as animals of which the artist had first-hand knowledge. Many of the animals that featured in such works were based on a Greek text called Physiologus ('The Natural Philosopher'),

which was possibly created in Alexandria during the second century AD. Nearly 50 creatures and plants were described within its pages, and it was translated into many languages and referred to frequently.

Animals were often depicted in borders that accompanied illuminated initials and text, and some are shown in figures 33-34. A scene containing animals often appeared along the bottom of an illuminated page from the thirteenth century onwards (such 'bottom-of-the-page' scenes are termed bas-de-page, whether or not they contain animals or any other type of illustration).

Fig. 33. Beasts of the chase.

Fig. 34. A hunting scene.

Grisaille and camaieu

Grisaille is a painting technique that employs only shades of grey for an illustration (the term grisaille is derived from the French word for grey, gris). It was more often used for illuminated scenes than for letters (Figure 35).

Camaieu is a similar method of illumination, in that it employs a single colour in varying shades, and letters worked in this manner can be very attractive (Figure 36). Camaieu equates to the same technique as that used in Celtic work, in which one background colour is overlaid with darker shades of the same colour.

Fig. 35. Grisaille.

Fig. 36. Camaieu.

Line-fillers

Line-fillers, which were often used in Gothic illumination, usually take the form of solid, bold-coloured strips of filler placed at the end of any line of text that does not fill the available page width. A selection of line-fillers, taken from various Gothic manuscripts, is shown in Figure 37.

Diaper patterns were also used to form line-fillers, and animals were incorporated into them, too. A set of gold-burnished line-fillers (Figure 38) appears in the Hours of Giangaleazzo Visconti mentioned above.

Fig. 37. Gothic line-fillers.

Fig. 38. Gold line-fillers.

Pen Flourished letters

Pen-flourished letters

From the late twelfth century, a very intricate, filigree type of penwork, called littera florissa, or 'pen-flourished' lettering, was used to decorate some of the smaller capital letters on large pages of text. Although letters of this type were usually only used as secondary illuminations accompanying much larger, and more elaborate, initials, they were sometimes given a greater degree of prominence. By the sixteenth century, filigree-penworked types of illumination had practically disappeared, in favour of the much bolder, heavier styles of the Renaissance. Yet this pleasing style remains worth studying.

The pages of manuscript books have very large margins, and this form of decoration was usually carried well into the borders – and often right to the edges – of the page. Figure 1 shows an extremely elongated letter 'A', the decoration of which is carried to the bottom of the page. Other letters have decoration that runs between paragraphs of text or into the side borders, such as the 'O' and 'V' illustrated in Figure 2. These examples are taken from a manuscript that was created in Paris between about 1180 and 1190 and that is today housed at Durham Cathedral. The pages illustrated form part of the Old Testament Book of Isaiah.

Fig. 1. An elongated pen-flourished 'A'.

Fig. 2. Horizontally pen-flourished letters 'O' and 'V'.

PROJECT *Creating a pen-flourished pattern for use with initial letters*

You will need a small-sized calligraphy nib, such as a William Mitchell size 5, to create this sort of decoration. It is very important that you work on a really smooth surface when drawing these decorative strokes, as an uneven surface will result either in ragged lines, snaggings of the pen or ink blots. If you are using vellum, make sure that it has been well pounced, so that any waxiness or grease has been removed from the surface. A paper called 'Elephanthide' – a good imitation of vellum – is perfect for this type of work, because it has a very smooth surface

1 The pattern around the letter is built up of a combination of basic strokes. Spirals that curve inwards and terminate in a circle are used as the basis of most central portions of letters.

2 Loops are added to the spirals and are then usually filled with a small, unconnected, central loop or circle.

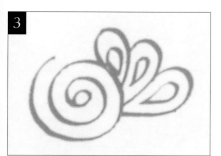

3 Clusters of loops are linked to the body of the decoration

4 Long, straight strokes are drawn from the curved pieces to run down the margin. Always break off and then recommence a stroke if your pen is working at the wrong angle. Trying to push a nib backwards can have disastrous results, especially if you are applying a lot of pressure. Although you can get away with pushing a small nib backwards (the ink will still flow reasonably well), not only is this a bad habit to fall into, but it will not work when you are using a larger nib size. Take care that you blend the recommenced stroke with the halted section carefully, so that the whole appears to be a smooth, uninterrupted stroke.

5 The long, straight strokes terminate in either a small, corkscrew-like set of curls or a waving, zigzag line. The pen will only make these small flourishes well when it is moving in a particular direction, which means that this will sometimes dictate the type of finish that you will give the stroke. Alternatively, you can turn the page to enable you to use the pen at the correct angle for the particular pattern that you want to use in a certain place.

6 Small, frilled patterns can be added so that they run either along the edge of another stroke or parallel to it, without touching it. Small filler loops and extra lines can be added as required until the pattern has gradually been built up to cover the whole area.

7 Letters can easily be linked down the length of the page to give the appearance of a continuous border. Counterchanged letters and decoration, such as the red and blue letters illustrated here, give a nice effect.

PROJECT *Decorated pen-flourished initials*

The letters used for this type of decoration are quite simple, and their corners and centres give the starting points for the penwork. A bold, jagged line often divides the letter into two colours, each of a solid hue, such as blue and red (Figure 3). The 'D' illustrated here is taken from the Hours of Philip the Good, Duke of Burgundy, which can be seen at The Hague's Koninklijke Bibliotheek in The Netherlands. This manuscript measures 27 x 19cm (10 $^{10}/_{16}$ x 7"), and without its decoration the letter is about 4cm ($^{19}/_{16}$") square.

Fig. 3. Versal letters were often divided with a jagged line into red and blue divisions.

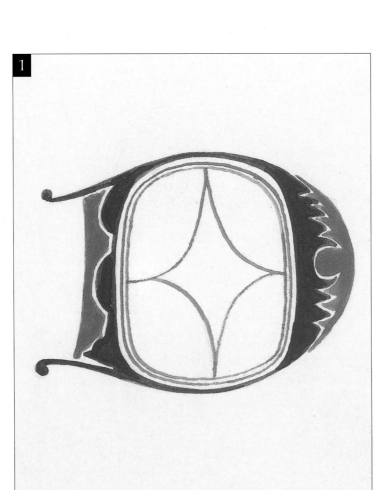

1 The centre of the 'D' is divided into four portions.

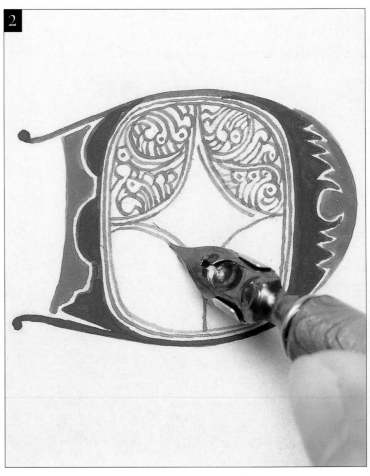

2 These are gradually filled with patterns of lines and circles.

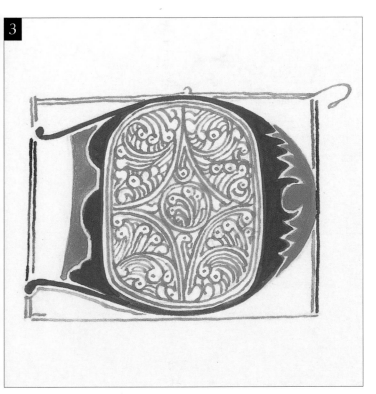

3 Straight lines are added to the outer area to form the square that will be patterned.

4 The square is then filled with similar lines and circles.

5 Finally, the outer decoration is added to finish the letter.

The 'L' shown in Figure 4 is another example of a letter that has been given a red and blue, zigzagged division. It is based on a letter contained in a manuscript at the Bibliothèque Nationale in Paris, dated 1213. A divided initial 'D', this time from a Dutch book of hours, also appears in Figure 5. Dated 1520, it was made much later than the preceding examples, and although the main letter is very similar to its predecessors, a difference can be seen in the surrounding penwork: as well as being a little more symmetrically arranged, the filled portions in parts of the flourished work accentuate the design.

In large pages of text, paragraphs were indicated by the sign shown in Figure 6. These signs appear many times in manuscripts containing pen-flourished letters.

Fig. 4. Red and blue divisions are used again for this letter 'L' with penworked decoration.

Fig. 5. A Dutch letter 'D' in a similar style, but from a later period.

Fig. 6. A paragraph sign.

Fig. 7. A thirteenth-century pen-flourished 'M'.

Fig. 8. This pen-flourished 'P' dates from circa 1470.

Fig. 9. Stylised floral penwork is used to decorate the lower letter 'Q' accompanying the more familiar penworked 'Q' above.

Figure 7. shows a letter 'M' that is filled with pen-flourished work and is based on an example taken from the Canticles of Alfonso the Wise (the king of Spain from 1252 to 1284), that can today be admired at the Real Biblioteca, El Escorial, Spain. The letter formed part of a music manuscript or song book, Alfonso having been a collector and writer of songs, as well as a patron of the arts. The decoration is very finely drawn, and presents a pleasing contrast to the accompanying, heavily painted, miniature portrait of a musician.

An attractive letter 'P' can be seen in a manuscript of theological texts and sermons that was written in about 1470 in Schwäbisch Gmünd, and that is now the Pierpont Morgan Library, New York (Figure 8).

Pen decoration sometimes developed into stylised floral work (Figure 9), in which the pen was used to draw stems from some of the letters, flowers and seed heads then being attached. These motifs alternated with the usual penwork flourishes that can be seen on other letters in the same margin.

Pen-flourished versal letters

The versal letters in blocks of text illustrated with littera florissa usually all have the same intricate surround of penwork, and some protrude well into the block of text, a useful device for breaking up large areas of black text.

Constructing versal letters

Versal letters are constructed as shown in Figure 10. This alphabet shows the letters, which have been written with a pen, in their plainest form. For the height shown – about 25mm (1") – they should be constructed with a fairly small-sized nib, such as that used for the pen flourishes (a William Mitchell size 4 or 5).

1 First draw the outside edges of the letters and then fill the centres with ink or colour, either using the nib or, if the letters are very large, a brush.

2 When drawing the curved parts of the letters, form the inner curve first. Doing this makes it easier to give a good overall shape to the letters than if the outer stroke is made first. Most of these letters are formed with the pen held at a very shallow angle, almost horizontal to the bottom edge of the page. As far as you can, try to maintain the horizontal position of the pen for the curved strokes. A little latitude is needed here and there in order to make pleasing shapes, but remember that the character of the letters will be lost if the angle is allowed to become too steep.

3 The upright strokes taper slightly from top to bottom, narrowing towards the centre and then widening at the foot of the stroke. The very thin, horizontal strokes at the top and base of some of the letters are made with the pen held at the same angle, but moving from side to side. The lines curve very slightly as the pen glides across from left to right in a slight, natural arc.

4 The strokes that close the ends of such letters as 'E' and 'F' are made with the pen turned completely round, so that the nib is vertical to the page. It can sometimes be easier to form these strokes by turning the page at an angle to achieve a very thin line, but if you do this make sure that you keep the strokes upright. Until you are confident of producing them well freehand, it is worth drawing pencil guidelines for these letters.

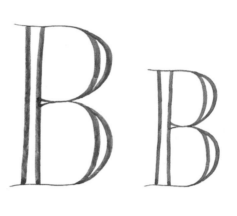

Fig. 10. Versal alphabet.

terminal points of the letters (Figure 15). It also gives centres to letters, which can then be filled to produce an attractive effect.

Figure 16 is based on a letter 'A' taken from Lydgate's *Life of St Edmund*, an English manuscript that dates from around 1433. The initial is coloured gold, with counterchanged red and blue areas overpainted with fine white lines. In this case, the penwork emanates from the corners of the box that surrounds the letter, and is made with a very fine nib. The penwork decoration is further embellished by the use of raised gold dots and green paint.

Figure 11: A letter 'B' written in three different nib sizes.

Fig. 12. A letter 'R' written with the same-sized nib, but in three different sets of proportions.

Most large versals that are used as decorated initials are drawn and painted, being both too large to be pen-made and often composed of complex strips of pattern, but, when writing the letters with a pen, use a size of nib that is appropriate to the letter's size. Figure 11 shows three different-sized letter 'B's, which have been left unfilled to show the construction of their outlines. They were made with a size 2, 3 and 4 William Mitchell nib respectively.

The shape of any letter can be distorted to fit the available space. Letters that have been squashed into rather short, wide shapes to fit below larger scenes and painted miniatures are particularly common in old manuscripts. The 'R' in Figure 12 is shown with additional versions that have been widened and elongated. As described in Chapter 15, versals were sometimes used in large blocks and were worked into each other in interesting ways, as is illustrated in Figure 13.

Historically, basic versal letters have been elaborated on in many different ways to produce illuminated initials. The letters have usually been made more rounded when they are enlarged, and some of the variants are shown in Figure 14. The curving of such letters as 'E', 'M' and 'T' lends itself to the addition of floral work, which can be made to sprout from any of the

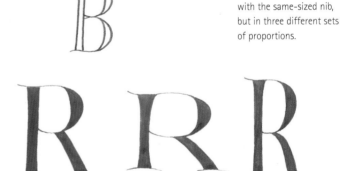

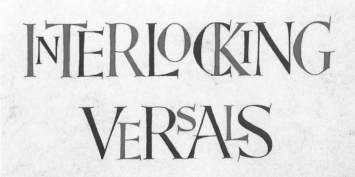

Fig. 13. Large blocks of versals were often interlocked and combined in a variety of sizes to fill the available space and create a pleasing effect.

Many other styles of letter that have been written and decorated with a pen rather than a brush can also be seen. The reconstruction of the letter 'H', dating from about 1330, in Figure 17 is an attractive mixture of curved and straight strokes. Some parts of the design have been filled to give the decoration a little more strength. Figure 18, a copy of a letter 'D' that was made with a very fine pen, and its accompanying, elongated border, dates from about 1480.

An interesting set of letters is found in a scribe's specimen sheet that was made in 1447 in Münster (it can today be seen in the Koninklijke Bibliotheek, The Hague). In these examples, the pen flourishes have been worked around letters composed of broad pen strokes. The main strokes of the letters are set apart and mostly unconnected, being instead linked by the filigree work that fills the central area and surrounds the outside of each stroke (Figure 19). In general, such letters have an angular, Gothic shape. Gothic letters can also be used for an alphabet decorated with flourishes, in which each letter has a face worked into its design. A few of these letters are shown in Figure 20.

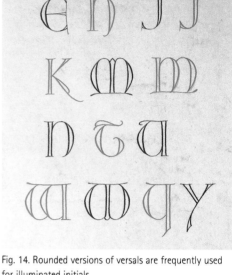

Fig. 14. Rounded versions of versals are frequently used for illuminated initials.

Fig. 15. Curved variations of some versal letters lend themselves to floral decoration.

Fig. 16. An illuminated letter 'A' from Lydgate's Life of St Edmund.

Fig. 17. A letter 'H' dating from about 1330.

Fig. 18. A letter 'D' dating from about 1480.

Fig. 19. Letters taken from a scribe's specimen sheet dated 1447.

Fig. 20. This set of Gothic letters incorporate grotesque faces.

Fig. 23. A pen-formed letter 'I' incorporating a serpent.

Figure 24: A simple pen-formed 'C' with light illumination.

Fig. 21. A pen-formed letter 'P'.

Fig. 22. A pen-formed letter 'T' from the Winchester Bible.

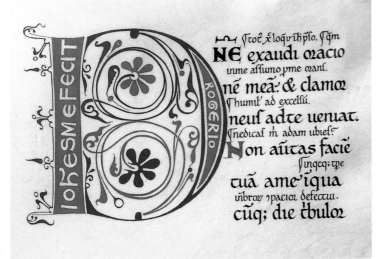

Fig. 25. A letter 'D' with accompanying glossed text.

A slightly heavier form of pen-made letter is illustrated by the 'P' in Figure 21. It is taken from a late twelfth-century manuscript that was created at Kirkstead Abbey (and is now in the British Library) by monks of the Cistercian order. The letters have not been embellished with gold, which was not permitted in their books. Similar letters are found in the Winchester Bible, which dates from the same period: the 'T' in Figure 22, for example, which is taken from folio 197v, has been worked in blue and green paint with a pen. A pen-worked serpent can be seen coiling its way up a letter 'I' (Figure 23) in folio 434v of the same manuscript. The letter 'C' that is illustrated in Figure 24 is based on a mid-twelfth-century manuscript from Reading Abbey, which is now at the Newberry Library, Chicago. Another example appears in the form of a letter 'D' that is taken from a psalter that was created at Reading Abbey in about 1160 (Figure 25) and is now at the Bodleian Library, Oxford. Contained within the letter's strokes is the Latin text *Iohes me fecit Rogerio* ('John made me for Roger'), and it was common practice for a scribe to identify himself by adding some such sort of decoration or marginal lettering to his text.

The gloss

This last-mentioned piece also incorporates another subject of interest: a gloss. Also known as a glossary, a gloss is an addition to part, or all, of the text made in either another language or as a set of explanatory notes. The gloss, which was usually written in a smaller lettering size, generally appeared underneath the main text, but sometimes also to the side or in the margin. Some great works are a complete gloss of the Bible, in which study notes have been placed alongside the relevant biblical sections. The notes frequently occupied more space than the text itself, thereby making a very large volume, such as Peter Lombard's Great Gloss on the Psalms.

PROJECT *Creating a glossed text*

This project shows the construction of a piece of lettering with a gloss written in Welsh. The principal lettering is blackletter, and the smaller, glossed text is written in the Carolingian hand to create a contrast. The main initial letter incorporates an illustration based on the text, while the initial letter of the second verse has been enlarged and given pen-flourished decoration to fill the left-hand border.

1 Write out the blackletter text in the required size on layout paper and then repeat the process for the smaller Carolingian lettering. Compare the two sizes of lettering and decide how much space will be needed between each set of writing lines. Carolingian letters have long ascenders and descenders, so the space allowed should be sufficient to accommodate these.

2 Start laying out the piece by roughly sketching the size and position of the initial letter on a large layout sheet (this can be altered later if necessary). Next, mark and rule guidelines for the sets of writing lines for the first verse of the text in both lettering sizes.

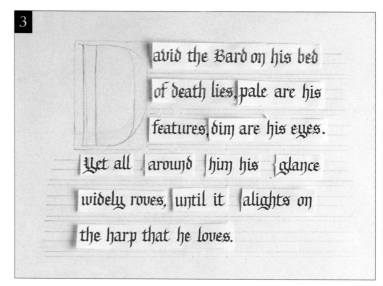

3 Cut the blackletter text into strips and arrange the words so that you end up with a neat block of text with lines of roughly similar length. (Leave the Carolingian-text lines empty at this stage – they will be added to the draft later.) The lines of text to the right of the initial will be shorter than those that run underneath it, starting from its left-hand edge. Place the first few strips of blackletter text in position, breaking the words at suitable points to give lines of as equal a length as possible.

4 Having plotted out the first verse of the large text, cut up and add the smaller text as before. Note that this text will have to be very widely spaced so that it matches the words above. Sketch in the enlarged initial letter for the second verse to determine where you will need to start the first writing line of the second verse. Rule up further writing lines for both lettering sizes and cut and paste the rest of the text in the same manner as for the first verse. If you find that you have space left at the end of either verse, you can use line-fillers to fill the gaps. With the text having been drafted, the initials can now be designed. The 'D' of David contains a simple drawing of David's harp to illustrate the text, and the penwork around the 'G' of the second verse can be worked into the tail decoration of the 'D'.

5 Write out the lettering on your chosen surface, in this instance Waterford paper (widely available from art shops).

6 Trace down the illustration of the initial letter and border. Write in the 'G' and its decoration.

avid the Bard on his bed
of death lies, pale are his
features, dim are his eyes.
Yet all around him his glance
widely roves, until it alights on
the harp that he loves.

ive me my harp, my companion
so long, let it once more add its voice
to my song. Though my old fingers
are palsied and weak, still my fine
harp for its master will speak.

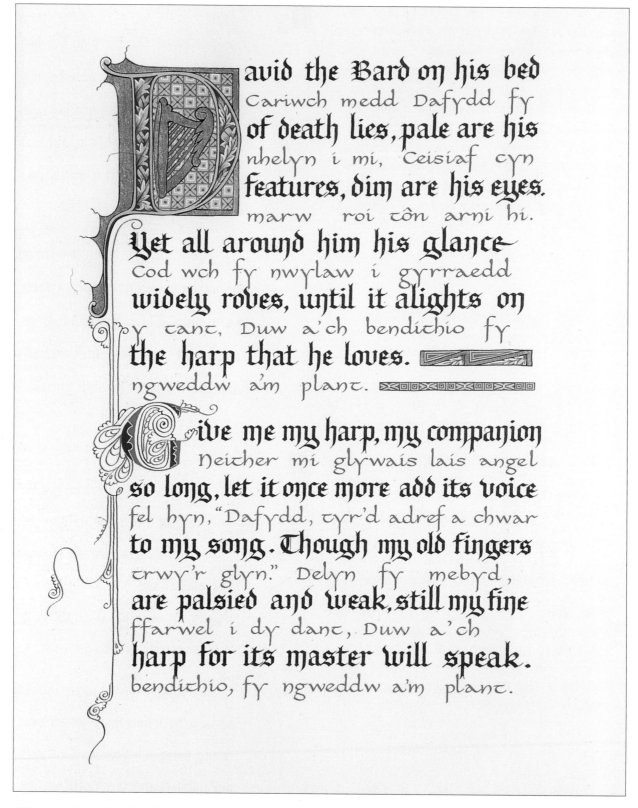

David the Bard on his bed
Cariwch medd Dafydd fy
of death lies, pale are his
nhelyn i mi, Ceisiaf cyn
features, dim are his eyes.
marw roi tôn arni hi.
Yet all around him his glance
Cod wch fy nwylaw i gyrraedd
widely roves, until it alights on
y tant, Duw a'ch bendithio fy
the harp that he loves.
ngweddw a'm plant.

Give me my harp, my companion
Neither mi glywais lais angel
so long, let it once more add its voice
fel hyn, "Dafydd, tyr'd adref a chwar
to my song. Though my old fingers
trwy'r glyn." Delyn fy mebyd,
are palsied and weak, still my fine
ffarwel i dy dant, Duw a'ch
harp for its master will speak.
bendithio, fy ngweddw a'm plant.

7 Apply the gold leaf to the work. Because colours have been used for the text, when working on the gilded areas take care that no loose gold leaf comes into contact with the paint, to which it will probably stick. It is best carefully to cover over all of those parts of the work that you do not need to see with guard sheets. Paint the rest of the initial letter to complete the work.

Music
Books

18

Music Books

Illuminated initials were used to decorate various music-related books of the Middle Ages and early Renaissance. Almost all were religious manuscripts that contained the rites, observances and procedures of public worship (the liturgy, the principal parts of which are the mass and the divine office) with musical components. All have names that you will come across when looking at old manuscripts, but which most of us are unfamiliar with today, and the main books are the antiphonal, breviary, gradual, hymnal, kyriale, missal, sacramentary and troper. Each contains particular portions of the liturgy, some of which will be described in further detail below.

The gradual and kyriale

The gradual – the principal choir book used during the mass – is one of the most common music books dating from this period. Because all of the monastery's monks would gather round to read it on the lectern, the books themselves were very large. The first sung parts of the mass were often introduced by beautifully worked illuminated initials that could measure as much as 25–30cm (nearly 10–12″) across.

Figures 1–4 shows a 'B' taken from a fourteenth-century gradual that is today owned by the Biblioteka Jagiellonska, Cracow, Poland. The historiated letter is fairly simple, having just a few embellishing curls and flourishes, with an attractive crossing-over of the two central curves of the 'B', the ends of which then curve around the first upright stroke with floral terminations.

The letter is enclosed by a straight-sided rectangle, the ends of the first upright stroke of the 'B' then being worked into attractive, floral curls that sprout out of the enclosing box and into the margin. The central scene is neatly arranged, with the head of the figure appearing almost centrally in the top bowl of the 'B', and the arm and raised spear sited in a very eye-catching position. The dragon in the lower part of the letter has been carefully worked into the available space, and its coiled tail flows out of the bordering frame into the margin.

The kyriale contains the ordinary chants of the mass, which remain unchanged throughout the ecclesiastical year. Although the kyriale was usually incorporated into the gradual, it sometimes formed a separate volume during the late Middle Ages.

Fig. 1. A letter 'B', from a fourteenth-century gradual, in outline with gold paint added.

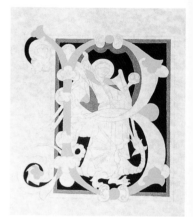

Fig. 2. The background colours are added.

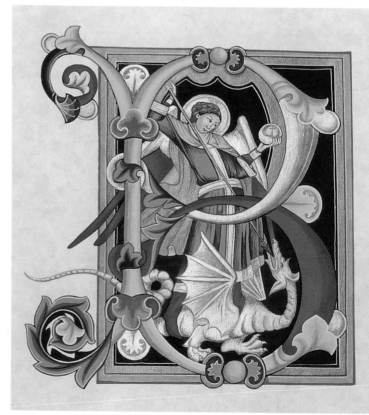

Fig. 4. The finished letter.

Fig. 3. Modelling is added to the base colours.

PROJECT *Creating an illuminated letter for a gradual*

The illuminated letter 'E' in Figure 5 comes at the beginning of a Dominican gradual dating from late fifteenth-century northern Italy. It measures 56.5 x 40.5cm (22 x 16") and is now at the Victoria & Albert Museum in London. This letter is of a slightly later date than those that we have studied so far, and is Renaissance in style. The central decoration is much more naturalistic than that found in the more stylised, Gothic letters. The outer surround of the letter is a solid area of flat gold leaf and a typical biblical scene is depicted in the centre. One of the main differences between this style of painting and Gothic illustration is that the figures and features of the picture are not outlined. The 'E' itself is a strongly designed letter, with its laurel wreaths and scrolling acanthus leaves giving it a weight and formality that contrasts with the illustration that it frames.

Fig. 5. A fifteenth-century gradual contains the original of this letter 'E'.

1 Make a drawing of the letter and trace down the outline onto vellum. Apply the flat gold leaf to the corners. You could use either transfer gold or loose gold leaf on a base of gold size.

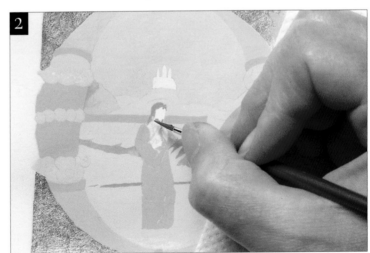

2 Paint in the background colours. Remember that in order to paint this softer type of decoration successfully, you will need to create many layers of modelling, beginning with darker shades of each colour to define the shapes.

3 Use the dry-brushwork technique to achieve a graduating effect from light to dark. This technique involves loading the brush with a minimal amount of paint so that a hazy effect, rather than a solid line, is created by each brushstroke. This also enables you to blend the colours well. Add lighter colours to highlight particular areas, in this case to give the effect of light falling on the left side of the robe and haloes.

Musical notation

During the mid-eleventh century, when musical notation first began to appear in manuscripts, musical notes were not written as we know them today. A simpler system of notes, known as neumes, was used instead, the neumes being written above the text to indicate the rise and fall, or repetition of pitch, of the melody. Various different, regional systems of neumes having been identified, it seems that no single, regular series of symbols was in use.

The neumes were written on staves of four lines rather than the five that we now use. The staves were often drawn in red, while the neumes were usually written in black ink. Draw the staves with a ruling pen, taking care to keep the ink flowing steadily along the whole length of the line (Figure 6). Alternatively, you could use a mapping pen and rule; although the results are less precise than those produced with a ruling pen, this effect can sometimes be more pleasing, as most musical staves on old manuscripts were not perfectly straight (Figure 7). In addition, vellum buckles when it becomes warm, which can also distort the work, giving the appearance of slightly crooked lines. Music pens are available that draw a five-lined stave in one stroke, but note that you are confined to a single size of nib that draws a stave of about 10mm ($^6/_{16}$″) in width and that it is also quite difficult to make the ink flow continuously from all five points for any length of time.

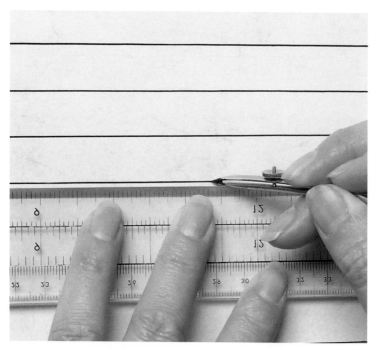

Fig. 6. Music staves drawn with a ruling pen.

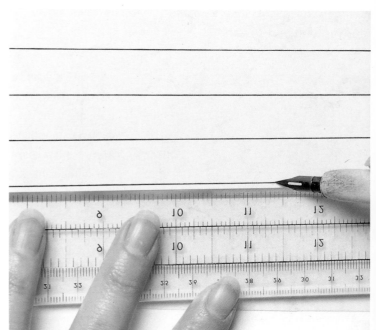

Fig. 7. Music staves drawn with a mapping pen.

In order to indicate the pitch of the notes to be sung, a clef symbol should be placed on the relevant stave line, identifying notes placed on that line as either a 'c' (Figure 8) or an 'f' (Figure 9). The other notes are then pitched in accordance with this indicated note. Our modern treble- and base-clef symbols are a little more complex (Figure 10). Remember that no time signatures or bar lines were used, and that where vertical lines divide the stave into sections this was done to match the notes with the text below.

Fig. 8. The 'c' clef used in medieval music manuscripts.

Fig. 9. The 'f' clef found in medieval manuscripts.

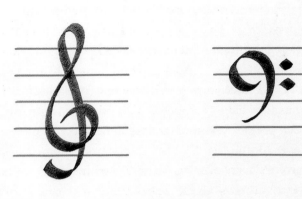

Fig. 10. Modern treble and bass clefs.

Fig. 11. Music notes.

Fig. 12. Tails to notes.

You will need a large-sized nib to write the notes themselves, which is used with the edge held vertically to make a stroke the full width of the nib (Figure 11). The stroke should occupy at least half of the space between the stave lines. Tails were sometimes given to the notes by means of a very thin line that was made by drawing the pen straight downwards (Figure 12). Notes were also occasionally joined together to make a diagonal stroke over several stave lines (Figure 13).

Fig. 13. Notes joined together.

Rotunda lettering

The rotunda lettering style, which was used for many musical manuscripts, is large, bold and written with the pen held at an extremely shallow angle. Indeed, some of the strokes are made with the nib held at an almost horizontal angle to the page (Figure 14). The ascending and descending strokes are very short, and the hand comprises a strongly contrasting combination of thick and thin strokes, some of the connecting strokes being so thin that they are sometimes barely visible.

In the rotunda alphabet, the letter 'i' was frequently either left undotted or was given a very thin, diagonal stroke. Containing as it does a great many similar-looking, upright strokes, the hand is difficult to read, but because the letters were very large and the songs that they spelled out were also probably well known to the singers, this was presumably not a problem. The medieval reader would furthermore have been much more familiar with the lettering style and therefore able to decipher it more quickly than the modern reader.

The letters illustrated in Figure 14, which have been written between writing lines 18mm (¾") apart, are on the scale that you will find in many graduals. The width of the nib used was 4mm (²⁄₁₆"), which corresponds to a size L14 in the William Mitchell poster-pen series, which is recommended for large-sized lettering. Because most large nibs do not have the sharp edge that is required for fine lettering, it may be necessary to sharpen your nib with an oil stone (a small, very fine, grinding stone that can be purchased from hardware

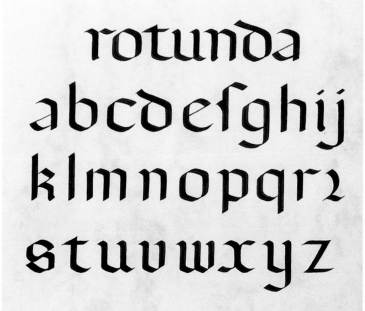

Figure 14: Rotunda lettering.

shops). Using a fairly light touch, draw the nib across the stone three or four times in the direction shown in Figure 15. Draw the nib along the stone on its reverse side (Figure 16) once, and then very lightly along the corners, which should remove any burr or rough edges. Try writing a few strokes to make sure that the sharpened edge is even and that the strokes that the nib produces are crisp. Although it takes practice to sharpen nibs well, and you may spoil a few before perfecting the technique, it is very useful to be able to sharpen nibs when they lose their accuracy.

Fig. 15. Sharpening a nib on an oil stone.

Fig. 16. Draw the back of the nib, then the corners, across the stone to finish.

Planning a musical manuscript

When planning a song sheet or music book, remember that you will need to write the words first, as they take up more space than the notes. The notes should then be placed in their relevant positions on the stave lines so that they tie in with the words.

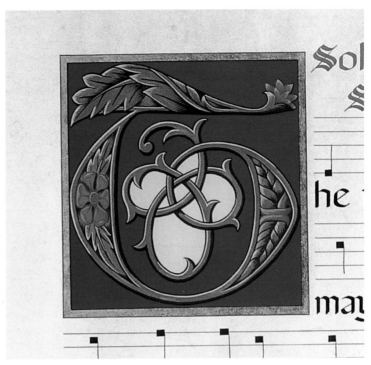

Figure 18: The initial letter with a flat gold-leaf centre and border complemented by strong colours.

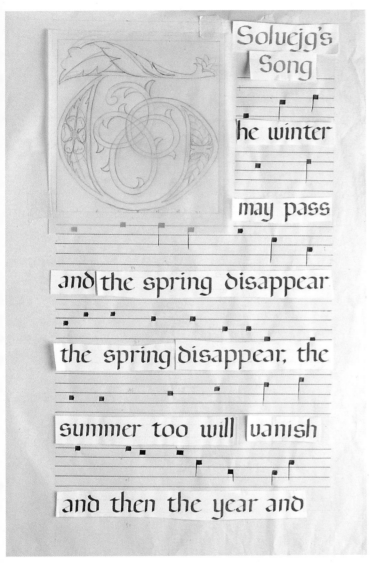

Fig. 17. A song sheet – draft.

Fig. 20. Page plan, margins.

In order to make a truly medieval-style musical manuscript, the size of the page should be large, and the example shown in figures 17–19 is 55 x 40cm (21 x 15 ¾"). The page's outer margin is usually double the width of the inner margin, the edge of which is bound into the book. The two central margins of a double-page spread will together measure the same width as the outer margins. A fifth of the width of the whole page, in this case 8cm (3 ²⁄₁₆"), is used for the outer margin and a tenth of the width for the inner margin. If you plan to make a manuscript book that has several pages, and most songs take up more than one page, you will need to plan the work in terms of double-page spreads, allowing the correct margin width in the centre for both sides (Figure 20).

Fig. 19. Song sheet – finished.

The sacramentary, missal, antiphonal, hymnal, breviary and troper

Another type of musical service book, called the sacramentary, contained the prayers that were recited by the celebrant during the mass (the other parts of the mass were contained in the gradual and other books, such as the evangelary or epistolery).

A missal was a fuller service book that contained chants, prayers and readings, as well as the ceremonial directions that were used by the priest for the performance of the mass. The missal was introduced during the Carolingian period, and because it combined the various parts required for the mass, had supplanted the sacramentary by the late thirteenth century. The 'D' in Figure 18 on page 224 was part of a missal, as was the 'T' in Figure 14 on page 222.

The book that contained the sung parts of the divine office is called the antiphonal. Like the gradual, because it was used by the choir, it was large in format. The antiphonal contained historiated initials that highlighted the principal events of the liturgical year. (Hymns were usually, but not always, contained in a separate book.)

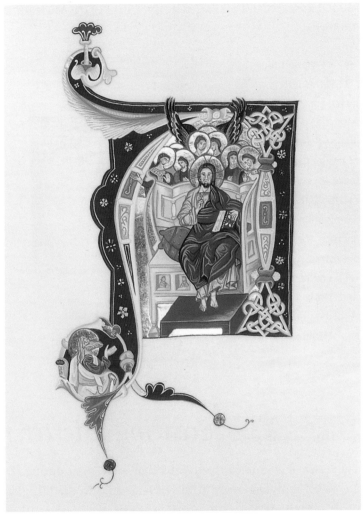

Fig. 21. A letter 'A' from an antiphonal.

Fig. 22. Hair and flesh sides of vellum. The 'hair' is on the back, while the 'flesh' is on the front of the sheet.

Although manuscript vellum is designed for writing on both sides, the hair side is slightly preferable to the flesh side. You can tell which side is which because the hair side – the side that faced outwards on the animal – is smoother and the veins are less prominent (Figure 22). The flesh side is a little rougher – especially the corners of the skin, which frequently reveal knife cuts in the thicker areas – and is also slightly more absorbent . Use the hair side for the front page.

If you are using more than four pages, it is usual to plan the manuscript so that hair side faces hair side and flesh side faces flesh side when the sheets are put together.

PROJECT *Creating a letter from an antiphonal*

Figure 21 shows an initial 'A', taken from a late thirteenth-century Italian antiphonal, whose central scene depicts Christ enthroned. The size of the manuscript is 582 x 402mm (23 x 15 ¾"), and it is housed at the J Paul Getty Museum in California.

1 The vibrant blue of this letter, which contrasts with the raised gold leaf and small areas of brilliant red, make it very eye-catching. The illumination is delicate, the pale-blue strapwork at each end of the final stroke of the 'A' being quite lightweight.

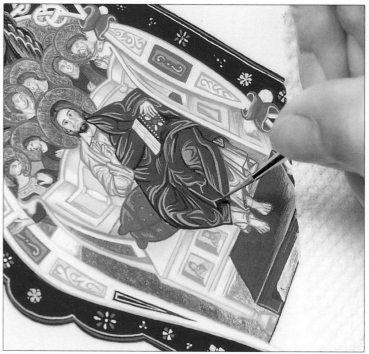

2 The small floral motifs that are scattered over the outer area of ultramarine are intricately worked, as are the hairline red and pale-blue lines around the outer edges. The vibrancy of the colours, however, give this initial great strength.

PROJECT *Creating a letter from a hymnal*

The hymnal contained the hymns that were sung during the divine office, which were arranged according to the liturgical year. Although it could form a separate section in an antiphonal or psalter (a book of the psalms), its contents eventually became part of the breviary (described below).

Figure 23 shows a reconstruction of an historiated initial 'A' from a hymnal. Its construction partly consists of the body of a dragon, which arches up the left-hand side and over the top of the letter. The whole outer decoration of the page comprises a border of matching scrollwork that contains many small figures and faces hidden within the illumination. The style is looser than that of the carefully constructed 'A' of the antiphonal described above.

Fig. 23. This letter 'A', from a hymnal, is formed by an arching dragon.

1 The outline of the letter is traced onto the vellum.

2 Gold is applied to the traced outline.

3 The background colours are painted.

4 The shapes are outlined, then modelling is added.

Dating from the eleventh century, the breviary was a service book that was made up of a collection of other books to comprise the whole text for the celebration of the divine office. The accompanying illuminated initials often contained biblical scenes or scenes depicting the performance of the divine office.

The breviary was originally used only by monks, and all members of monastic orders were committed to its daily recitation. The letter 'B' in Figure 18 on page 237 is taken from a sixteenth-century French breviary.

Another way of adding musical notes to a text is by using tropes, notes placed above the words to be sung, thereby roughly indicating the rise and fall in pitch required. Because no music staves are used, they only give the reader minimal musical assistance. The lines between some of the notes and words are furthermore not bar lines, but instead indicate the corresponding sections of words and notes. Tropers (Figure 24) were books that contained this sort of notation – which was added to the chants of the mass or divine office – that appeared from the early Middle Ages onwards.

Although early transcripts of non-religious music are difficult to find, collections of troubadours' songs dating from the mid-thirteenth century onwards survive. We will conclude this chapter with a small piece of modern music, which has an illuminated initial (figures 25–26).

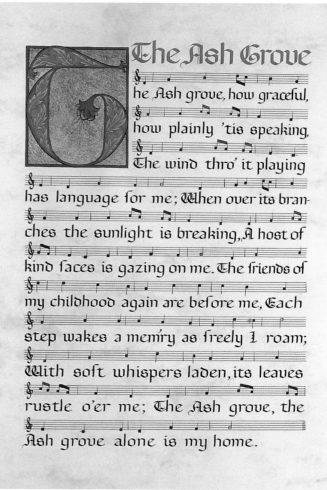

Fig. 25. An illuminated piece of music.

Fig. 24. An example of a page from a troper.

Fig. 26. Detail of the initial letter.

Illuminated
Borders

Illuminated borders

Beautiful borders add so much to the illuminated page, and a variety of styles will be considered in this chapter, along with their accompanying initial letters and lettering styles.

Our first few examples are based on borders found in the Très Riches Heures of Jean, Duc du Berry (which is today in the Musée Condé at Chantilly, France), which contains many stunning pages of rich illumination. The book was made during the fifteenth century by several different artists, and was not completed and bound until some years after the duke's death. Each page measures 29 x 21 cm (11 ⁷⁄₁₆ x 8") and is full of miniature paintings, initials and ornate borders.

Figure 1 shows an initial 'D' from folio 60v, part of a large, illuminated page depicting the coronation of the Virgin Mary. The floral shoots that spring from each corner of the letter emerge from a pink flower, after which alternating shoots of different colours curl back and forth to form the whole pattern. The colours are very bright and the modelling is light and simple, with a little shading and highlighting giving a three-dimensional effect. Large gold seeds also protrude from each corner shoot. The shield in the centre of the letter contains the armorial bearings of France.

Another letter of a similar style, but with a different colour scheme, is shown in Figure 2. It is taken from a page depicting St John on Patmos (folio17v). The large blue, pink and cream flowers are interspersed with small gold stars or seed heads. The decoration again springs naturally from the corner points of the letter 'I' and flows along the border for the length required to balance the other decoration and lettering on the page.

If you are working on a letter that does not have a convenient corner to develop into border, you will need to make a shoot 'grow' from some point along the edge of the letter and then work it into a border in the same way as for other letters (Figure 3). Remember not to add shoots to areas which could result in the letter looking like another one. For example, a shoot emerging from the bottom-right corner of an 'O' could make it look like a 'Q'.

Fig. 1. This simple border springs from a letter 'D' enclosing a shield.

Fig. 2. A letter 'I' with a border in an unusual colour scheme.

Fig. 3. Extra shoots can be added to the rim of a letter.

PROJECT *Types of border*

1 Some borders evolve naturally from the gradual increase in embellishment of the illuminated letter.

2 To begin with, a little extra ornamentation is added to the outer edges or corners of the letter.

3 Then the centre is filled and more embellishment is given to the outer branches.

4 The branches are made to creep further and further outward, along the left margin.

5 Then decoration is taken along the top border.

6 Finally, all four sides are decorated, so that a full-scale border surrounds the whole page.

Reconstructing a border

A more complex border can be seen sprouting from a letter 'K' on a double-page spread (folios 71 and 72) that depicts the procession of St Gregory (Figure 4). The letter leads into a beautifully coloured, scrolling border that flows along the left and top margins of the page. This design can be easily adapted for use on any other piece of lettering by means of lengthening or shortening the floral work, and we will therefore break down this border to see how it is constructed.

Fig. 4. A letter 'K' with an elaborate two-sided border.

1 The ascending stroke of the initial 'K' has a green stem running up the centre, which is the starting point for all of the branches.

2 The branches issue from three points on this stem, each beginning with an opening flower. The shoots forming the border grow out of each flower in various directions. Those for the left-hand border issue from the bottom corner of the 'K', and then the top-left portion peels off from the flower head at the top of the 'K'. The top-right branches emanate from a flower head part of the way up the ascending stroke of the letter.

3 Each of the branches is a continuation of the main green stem inside the 'K'. As the foliage branches out, each piece is reversed back and forth to give a change of colour and direction.

4 After the green stems, blue, red or pink branches are introduced.

5 Here and there a flower is added.

6 Small groups of golden seeds are used to fill the remaining gaps.

The gold background of the 'K' is scattered with a trellis of small, alternating, pink and blue flowers, which gives weight to the letter which might otherwise be overpowered by the complexity and depth of the border. You cannot paint over gold leaf very successfully because it is too resistant to gouache paint; although the paint may seem to stick at first if extra gum is added, it will eventually flake, or be rubbed, off. The small flowers on the gold background were therefore painted into the blank spaces that were left for them when the gilding was carried out.

Bastarda lettering

The lettering in the Très Riches Heures is written in a neat, Gothic style (Figure 5) that indicates a slightly cursive slant. This hand represents a shift away from the upright styles that were previously used towards the lettering style known as bastarda, or batarde bourguignonne. As its name suggests, bastarda lettering is something of a hybrid amalgamation of two other styles: although the letters are basically of a Gothic nature, their forward slant is characteristic of the italic styles that would follow. Bastarda letters are very decorative and were used in the production of many beautiful works.

As with most lettering styles, when you look through reference books on calligraphy, you will see an array of different scripts that are loosely described as bastarda. Indeed, there are so many variations on the general theme that it is difficult to identify any single alphabet of letters as representing the definitive bastarda hand. The alphabet shown in Figure 6 is based on the bastarda lettering that appears on a grant of arms dated 1492 (which can be seen in the Victoria & Albert Museum under the reference MS L 4362-1948).

The most distinctive feature of this hand is the vertical 's'. Although it takes a while for the modern eye to become accustomed to reading the text, as well as to replacing the familiar 's' in the mind's eye with the stroke shown, bastarda is

kyrieleilon

Fig. 5. The lettering style used in the Très Riches Heures.

bastarda

abcdefghijklmn

opqrſstuvwxyz

Fig. 6. Bastarda lettering.

essentially a clear, well-defined style, unlike the many Gothic hands that preceded it that contained too many upright strokes. The deep, curving serif on the upright strokes was developed into a feature by some artists (Figure 7), who would bring the point down to the top writing line using a fine hairline. Bastarda was not used for official church-service books, the more established scripts produced by monks of earlier periods instead continuing to be favoured for such works.

Foliate-bar borders

Borders around three sides of the text became very popular, and figures 8–11 show examples, all of which illustrate the texts of the English author Geoffrey Chaucer.

The first (Figure 8) is dated about 1450, and can today be seen at Glasgow University Library. It illustrates Chaucer's *Romaunt de la Rose*, a translation into Middle English verse of the French *Roman de la Rose* ('The Romance of the Rose'), a very popular medieval text. Although the original illumination work was quite crude, the design of the border is very attractive. The initial letter sits within the block of text and is attached to a bar running along the height of the page. The bar is split, with a coloured band on the letter side and a gold band on the side nearest the margin. The coloured band leads from the letter, with pink being used at the top and blue at the bottom, into the corner pieces, which are composed of leaves and large, lily-like flowers. The large leaves, which are painted in various colours, sprout from the coloured bar. The effect of a gold background in the corner blocks is achieved by filling the space between each leaf with a portion of gold outlined with ink. The top and bottom borders are formed with thin, pen-drawn fronds that terminate in single flowers and leaves. Smaller leaves and seeds, which are painted in green or gold, are drawn along the length of these fronds. The accompanying English text is written in the bastarda hand.

The second example (Figure 9), which is today housed at Lichfield Cathedral, also dates from the mid-fifteenth century and was probably made in London. It depicts the opening of 'The Miller's Tale', from Chaucer's *Canterbury Tales*. The fine sprays of foliage sprouting from the gold-and-blue bar border frame an attractive, bastarda text with an illuminated initial 'W'. Although it conforms to the same basic theme of a letter attached to a bar, the treatment of the border is quite different – in terms of both weight and general appearance – from the first example discussed above. To begin with, the gold

Fig. 7. Extended serifs sometimes used with bastarda letters.

Fig. 8. A foliate-bar border with initial 'T'.

background of the letter, rather than shoots sprouting from the letter itself, attaches the letter to the gold of the bar. The blue-coloured section of the bar furthermore emerges from behind the letter rather than branching out from its corners. The large leaves have serrated edges and cross over the gold bar to form the starting points for the finer details in the border.

Fig. 9. A foliate-bar border with initial 'W'.

Fig. 10. Another border with an initial 'W', in a more evenly spaced design.

The sprays of fine-lined seeds and small flower heads, which are all drawn in fairly tight, single coils, are well spaced along the length of the border. Each small seed head consists of a looped shape filled with green paint, although some of the leaves and seed heads are highlighted with raised gold. Tiny sprinklings of raised gold in borders of this sort can be very attractive, and have just as much of a decorative effect as larger areas of gold. Note the very angular styling of the small gold leaves to form oblong shapes.

The final example (figures 10–11) of this set is another rendition of a 'W' from 'The Miller's Tale', dating from about 1440. This, along with another page from the same work, is in the John Rylands Library in Manchester, while 11 further leaves from the same manuscript are in the Rosenbach Foundation Museum in Philadelphia. The 'W' is drawn in a similar manner to the version discussed above, but the floral

Fig. 11. Detail from the 'W' in Figure 10.

Fig. 12. Draw the outline of the border.

bottom half of the area within the border, commencing from the 'W'. The top half of the border surrounds a simple illustration of the miller on his steed.

A fine, illuminated 'T', taken from a mid-fifteenth-century missal from Ghent, is the starting point for the top and bottom borders made up of small and intricate foliate work shown in figures 12–14. With its terminating leaves to each exterior loop, the central fretwork pattern inside the 'T' is quite unusual. Similar leaves appear in the border, principally in the top and bottom margins of the page, linked by a bar that sprouts a few additional leaves. Two or three different flower and leaf shapes make up the border design (Figure 15),

sprays are more regular and continuous along each portion of the border, with the seed heads and flowers being set at approximately equal distances around the border. The fine lines of the many leaves and seeds (which are best drawn with a mapping pen) form quite a dense covering, giving an interesting texture. The flowers and corner pieces are painted in rather muted colours, which have probably dulled quite a lot over time. Indeed, the gold work on the original manuscript has deteriorated a great deal, with the gesso base showing through in many places, which is a great shame, as the decoration is very accurately painted. The text occupied the

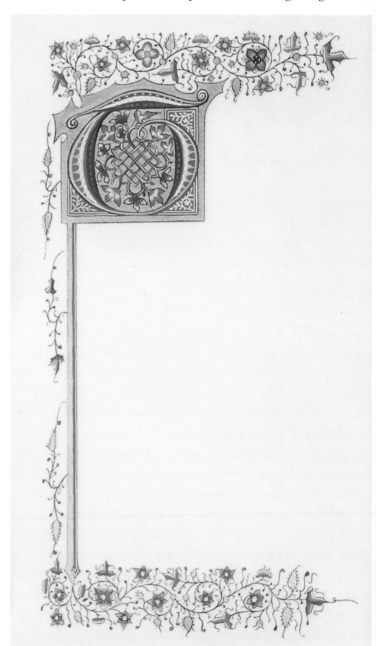

Fig. 13. Trace the design onto vellum, outline in ink, then paint the background colours.

Fig. 14. Add shading and highlighting to complete the border.

which is a simple series of coils alternating from side to side, with a flower in the centre of each coil and another in each large gap above and below. The smaller gaps have been filled with seed heads and leaves, the artist having used a looped or twisted shape for some of the seed heads (Figure16).

Fig. 15. Flower and leaf shapes forming the border.

Fig. 16. Twisted seed shapes.

Fig. 17. This initial letter 'D' with a bar border is based on folio 29 of the Grey-FitzPayn Hours. Many small animals have been incorporated into the design, which is also rich in diaper patterns.

PROJECT *Creating a vine-leaf border*

A type of foliate-bar border that is frequently seen in fourteenth-century manuscripts is shown in Figure 18. (This example is based on folio 242r from the St Denis Missal, at the Victoria and Albert Museum, size 235mm x 170mm). An illuminated letter on the left-hand side is the starting point, from which a fairly straight-sided bar border extends to form the main framework of the page. Stylised vine leaves are the basis of the decoration that springs from the corners and runs along the outer edges of the frame.

Not only is vine-leaf decoration very attractive, but it is also easy to reproduce. The border runs right round the page and often contains a central dividing line that breaks the text into two columns. The bars are heavier than those that we have looked at so far, with deeper, patterned strips (similar to some of the line-fillers that we discussed in earlier chapters) being used for the coloured portions of the bars. The corners are worked with curling branches and arching points to form a link between the top and side bars.

1 To form the vine-leaf border, first run the bar lines from the corners of the initial letter around each margin.

2 Form the main stem of each piece of foliage by making an elongated 's' shape branching off from the bar line either at the ends or at any suitable points in the centre of the line to fill the required space.

Fig. 18. A typical vine-leaf border.

3 The basic vine-leaf shape.

4 This leaf is spaced at regular intervals along the stem, alternating with a blunt stub. Each leaf follows the natural direction of growth of the branch.

5 Smaller, half-grown leaves are sometimes drawn at the beginning of branches, and these can also be useful for filling spaces in your design into which a large leaf will not fit.

6 Carry out the corners of the bar line in a rounded sweep.

7 Draw strips of colour along each side, making them slightly wider than the main bar.

8 Next, fill the areas in the corners that link these strips with a series of pointed curves. These areas are worked in gold and are drawn either on the outside or on both sides of the bar.

9 Although the bar is not usually continued around the top border, the vine stems fill this area, branching out to the left and right of the bars.

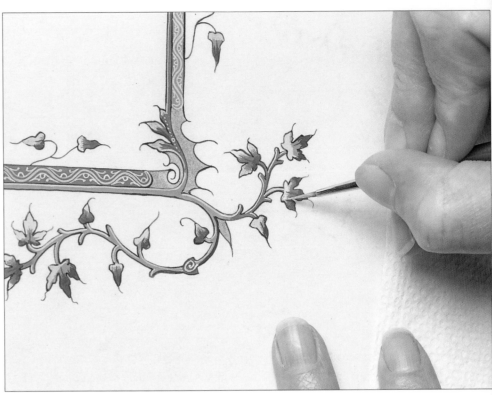

10 The whole border design is drawn, then traced into place on the vellum. The gold areas are painted with gold powder.

11 The vine leaves are painted in deepening shades of blue and red, then finished with a lighter highlighting colour.

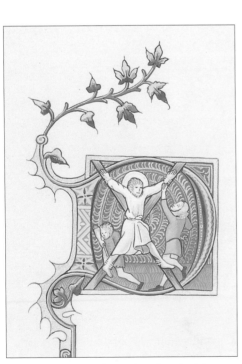

12 The initial letter is painted with a diapered background and lightly modelled figures.

Rinceaux

The vine-leaf border was taken to complex extremes in some later Renaissance manuscripts. Indeed, the close mesh of leaves and flowers spaced evenly over a four-sided and very wide border totally dominated the accompanying text. Decoration of this type is known as rinceaux.

Figure 19 shows a section of an intricate rinceaux border of close-set vine leaves arranged in tightly curling stems that completely cover the border area.

Fig. 19. Rinceaux.

Renaissance
Illumination
20

Renaissance illumination

Markedly different Renaissance styles of illumination followed the medieval Gothic. Renaissance is the French word for 'rebirth', and from the mid-fourteenth to mid-sixteenth centuries the manuscript painting of the Renaissance period saw a revival of the classical styles of antiquity in the work of artists who became known as humanists. We will look at three distinct illumination styles from this period: white-vine stem, humanist antiqua and trompe l'oeil.

The white-vine-stem style

Humanism – whose aim was to revive classical learning – developed in late fourteenth-century Florence and was an important component of the Renaissance for the illuminator. The humanist script was developed by such great Florentine classicists as Niccolo Niccoli and Poggio Bracciolini, the Gothic scripts having been considered too difficult to read, too small and too full of abbreviations. Florence and Rome were the leaders in humanist book production.

As the fifteenth century dawned in Florence, a type of illumination known as white-vine stem, or bianchi girari, developed (Figure 1), one of the earliest surviving Florentine examples of which dates from 1408. Although the Italian humanists were attempting to emulate what they believed to be the antique texts of Greece and Rome, they were, in fact, using twelfth-century Italian manuscripts as their models that dated from no later than Carolingian times. (Perhaps they thought that the interweaving white-vine stems were based on the acanthus foliage that is found on Roman marble columns.) A letter 'C' taken from an Italian model book of initials dated about 1200, which is shown in Figure 1, is clearly a model for the white-vine-stemwork of the Renaissance. Whatever its origins, however, the style became a very popular accompaniment to humanist texts and quickly spread northwards throughout Europe during the early fifteenth century.

Fig. 1. A letter 'C' from an Italian model book dated circa 1200.

Fig. 2. White-vine-stem construction.

PROJECT · *Creating a white-vine-stem letter*

The initial shown in Figure 3 is based on a letter 'F' taken from a Florentine manuscript dating from between about 1460 and 1470. (The original manuscript is at the Österreichische Nationalbibliothek in Vienna and another volume from the same set can be seen in the Spencer Collection in the New York Public Library.) The letter is accompanied by a text written in humanist script, and a border in the same style appears on three sides of the manuscript. The work is signed by the scribe Giovanni Francesco Martino.

Fig. 3. A white-vine-stem letter 'F' with humanist text.

1 After writing the text, trace the drawing of the letter onto the vellum.

2 Gold leaf is added to the letter 'F'. The letter that was complemented by white-vine-stemwork was usually illuminated in gold leaf, while the white-vine parts of the design comprised a fairly simple trellis of curling stems branching off at intervals to form either small, unadorned shoots or floral and foliate terminations.

3 The branches are outlined with black ink, then the red guidelines are removed.

4 The background colours are painted; they were frequently divided into blue, green and red portions.

5 The white-vine areas were either left as blank parchment or vellum or were modelled slightly with light-beige or cream-coloured paint.

6 These coloured areas are then given further embellishment in the form of small groups of three gold or white dots overpainted on the background colours.

A Florentine manuscript, dated 1448 and now housed at Balliol College, Oxford University (reference MS.78 B, f.108v), is the source of the illuminated 'D' illustrated in Figure 4. This is the only illumination on a large page of humanist text, Roman capital letters forming the rest of the title words. The letter occupies almost half of the width of the block of text and a third of its length. Apart from the two shoots of vine that spread along the left-hand border, the letter is designed within the usual squared block. The circular, gold seed heads on thin tendrils are a novel feature on this type of manuscript, however.

Fig. 4. A white-vine-stem 'D' based on a Florentine manuscript dated 1448.

The humanist, humanist-antiqua and cancelleresca hands

Owing much to the Carolingian styles of lettering (Figure 5), the humanist hand was small and neat, with quite light and simple letters that had a rounded appearance. The 's' was almost invariably written in the long form illustrated. Two or three versions of some of the letters were used within the same manuscript, however, for example, an upright 'd' and a flat-topped 'd' (Figure 6), while the 'g' had several variants. The diagonally stroked letters 'v' and 'w' are sometimes hard to pick out in a Latin text, as they were usually written in the rounded form shown in Figure 5. (The capital letters within the same text were written using the more recognisable diagonal strokes.) Some minuscule texts used diagonally stroked versions, however, while the 'y' was written as shown in Figure 6. The serifs tended to be fairly large and formed quite a pronounced hook at the end of ascenders and descenders (Figure 7).

The spacing between the lines of text was quite wide, between two and two-and-a-half times the height of the letters, which creates a feeling of spaciousness that contrasts with the rather dense covering and intricacy of the illuminated letters and borders.

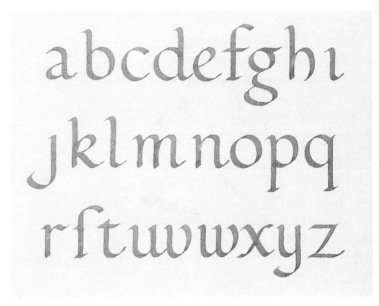

Fig. 5. Humanist lettering.

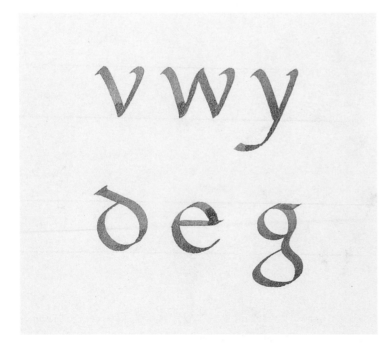

Fig. 6. Alternative forms of some of the humanist letters.

Fig. 7. Serifs for humanist antiqua.

Fig. 9. The design is drawn and traced onto the vellum and gold is added to the letter.

The Roman influence on Renaissance illumination appears in very formal, classical designs, such as the 'D' illustrated in Figure 8, which is taken from the Bentivoglio Hours, an Italian book of hours dating from about 1500 that is today in the Victoria & Albert Museum. A pedestal effect surrounds the letter, with lighter scrollwork at the top and bottom forming a border piece (figures 9–10). Penwork was used for the fine strokes contained within the decoration at the top and bottom. The accompanying text is written in the humanist-antiqua style.

Humanist antiqua is a much more formal style than the rounded humanist hand. The letters are written with the pen held at a very shallow angle, thereby enabling the terminations of the strokes to be squared off to make a strong stylistic reference to classical Roman roots. This stylistic reference is further underlined by the accompanying boxed initial letters and decoration that appears throughout the text.

Figure 11 shows a full alphabet of humanist-antiqua letters, based on the text of the Bentivoglio Hours. The script resembles printers' letters and could conceivably have been influenced by the printed books that were then starting to be produced. The smaller, boxed Roman capitals that appear throughout the text are usually painted letters that were constructed as illustrated in Figure 12.

An illuminated letter 'G' (Figure 13) that was used in conjunction with the humanist-antiqua script in a Florentine manuscript dated about 1522 is in the same style, albeit larger. It also has a little more embellishment in the form of a fine, white outline to the letter and finely worked, floral detail in the

Fig. 8. A letter 'D' with elongated border decoration.

Fig. 10. The background colour is painted, then modelling can be applied to the decoration.

Fig. 11. Humanist-antiqua lettering.

corners and centre of the 'G'. The 'P' shown in Figure 14, which is again in the same style as the previous examples, has a small, additional piece of decoration at the side. This letter, which is taken from a diminutive Florentine book of hours dated 1540, accompanied text that was written in a script known as cancelleresca.

Cancelleresca is a slanted lettering style that was one of the forerunners of the italic hand, and the alphabet is shown in Figure 15. It is a fairly quick and uncomplicated hand to reproduce, with easy, flowing strokes. Note that the 's' was sometimes written in the long, 'f' form. The spacing between the lines of lettering was usually twice the width of the writing lines, giving a light and elegant texture to the page. Softer, floral decoration accompanied this script more often than in the case of its predecessors. Small pieces of floral and scrollwork were either used as line-fillers (Figure 16) or to make decorative patterns within the text (Figure 17). In this last example, which begins with a simple, boxed Roman 'M', the lines of text are formed into a 'V' shape to make room for the floral embellishments.

The antiqua style of illumination was carried to extremes in some very lavish pages of rich, classical ornamentation full of columns, arches, urns and trophies. Heads of Roman emperors, shields and spears were painted in strong colours. An example that can be seen in the Herzog August Bibliothek, in Wolfenbüttel, Germany, that was made for the king of Hungary between about 1485 and 1490, includes many of these features. (Most of these ornate manuscripts were produced for the book collections of rich and powerful Italian families.) In some of the more elaborate pages, the style of

Fig. 12. Boxed Roman capitals used with humanist-antiqua text.

Fig. 13. A letter 'G' based on a Florentine manuscript dated circa 1522.

Fig. 14. A letter 'P' based on a Florentine book of hours dated 1540.

Fig. 15. cancelleresca lettering.

many of the pieces becomes very static, with heavy blocks of colour and ornamentation surrounding small pieces of text. The grotesques of medieval art were replaced by putti (naked infants, often depicted with wings), masks, vases and other classical motifs. Detailed architectural frames were furthermore built up around the page with vibrant colours and an extravagant use of gold to produce overpowering and ostentatious effects.

Mirabile mysterium decla:
ratur hodie: irmouantur na:
turæ: Deus homo factus est:
id. quod fuit permasit:
et quod non erat. af:
sumpsit: non co:
mistionem
passus.
neq: dimsionem.

Fig. 17. Cancelleresca text with boxed Roman initial and decorative floral motifs.

The trompe-l'oeil style

Another very striking style of the Renaissance period was the development of letters and borders with a heavy, solid, background colour – particularly gold – with naturalistic objects strewn around the borders in a manner that has come to be known as trompe l'oeil (a French expression meaning 'deceives the eye'). The aim was to make the images that were painted on the background appear to be resting on, or projecting from, the page, and this was done by using shadow effects and modelling to create a three-dimensional effect. This style of illumination emerged from the fifteenth-century Flemish Ghent-Bruges school, from which it spread through France and Italy.

An early example of this style can be seen in the illuminated 'B' (Figure 18) which is taken from a breviary that was made in northern France in about 1525. (The manuscript, whose reference number is MS.Laud.misc.419, f.433r, is today owned by the Bodleian Library, Oxford University.) The scroll effect on the first stroke of the 'B' is a common feature of the trompe-l'oeil style. The pale outline of the letter combines with the sprouting branches in the curved parts of the letter's right-hand side, while the horizontal stems work their way back into the upright stroke to form the scrolls around the upright. The strawberry plant that forms the central decoration is painted in a semi-naturalistic manner. Smaller, slightly simpler initials in the same style, each contained within a square box, begin each verse of the text. The accompanying lettering is written in a Gothic style, which gives a slightly heavier effect than the humanist lettering that would later be associated with trompe l'oeil.

Fig. 18. A trompe-l'oeil letter 'B' based on a French breviary dated 1525.

PROJECT *Creating a trompe-l'oeil letter and border*

Figure 19 shows a piece commencing with an illuminated letter 'G'. The letter and text are surrounded by a full trompe-l'oeil border, in which an array of plants and creatures has been painted in a fine, naturalistic style.

Colours other than gold were sometimes used for the background, too. When designing a trompe-l'oeil piece, a green or a purple background can give an interesting effect, but red tends to be rather overpowering, while dark colours, such as brown and black, can look very sombre. You will find examples of all of these background colours in manuscripts of the period, however.

Fig. 19. A trompe-l'oeil letter 'G' and border.

1 Make a complete draft of the text and border. The humanist-antiqua lettering needs to form a neat block to fill the central area. Rule the page margins and lines, then write the lettering.

2 Now trace the border design into place.

3 Paint the background with gold powder and then burnish it, leaving spaces for the plants and insects to be added afterwards.

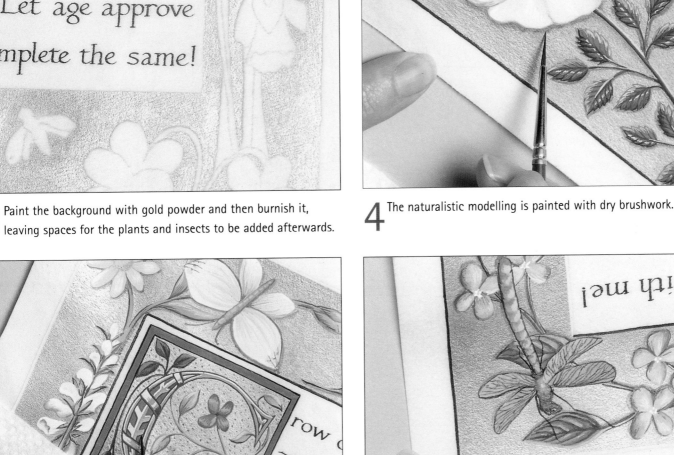

4 The naturalistic modelling is painted with dry brushwork.

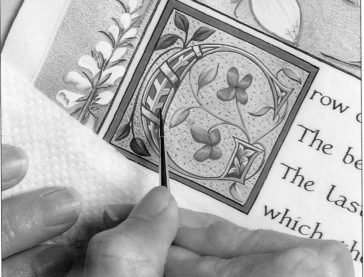

5 Build up each part of the letter and border with shading and highlighting to give as natural an appearance as possible.

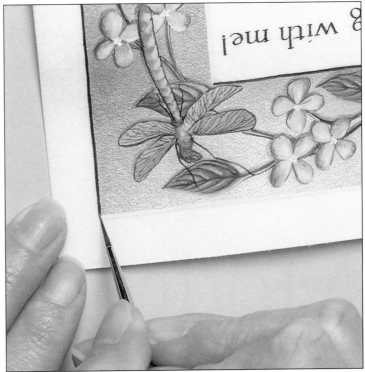

6 Add dark and light outlines to the edges, as shown. The overall effect is of a very lavish mixture of gold and colours that contrasts strongly with the lightness and simplicity of the accompanying text.

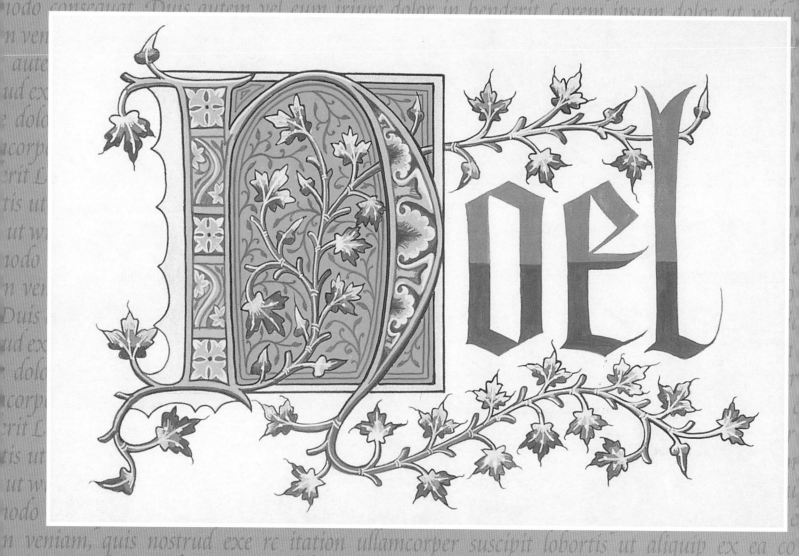

Modern Uses
of Illumination

Modern uses of illumination

This book has provided an introduction to some of the main types of illuminated letter, along with their corresponding lettering styles, border work and accompanying decorative details. However, there are countless other examples and styles that you can use as starting points for designing new pieces of work. For example, there was not the scope in this book to cover rustica lettering, the Beneventan script, the Visigothic or Lombardic styles or to explore the Byzantine and Ottonian art forms and their influences or Islamic manuscripts, which provide a wealth of wonderful designs and attractive colour schemes.

In Britain, the British Library and the Victoria & Albert Museum in London display many fine examples of illuminated manuscripts, while numerous further manuscripts can be found in museums throughout the world that you could draw on for ideas and inspiration.

There is great satisfaction to be drawn from developing new pieces from the study of historical examples. Contemporary designs based on such early originals have their own character and points of interest, and you can let your imagination wander in whichever direction you prefer.

Figures 1 and 2 show some designs for cards that are based on historical examples. Figure 3 shows a small piece that describes the meaning of a child's name, with an illuminated initial letter and border that were inspired by historical manuscripts.

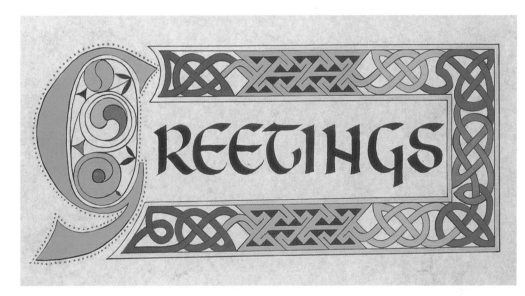

Fig. 2. A 'Greetings' card.

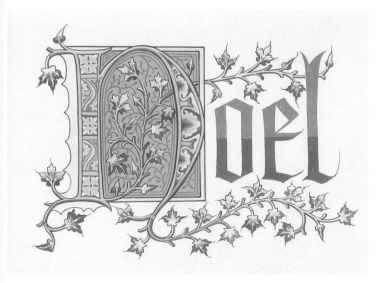

Fig. 1. A 'Noel' Christmas card.

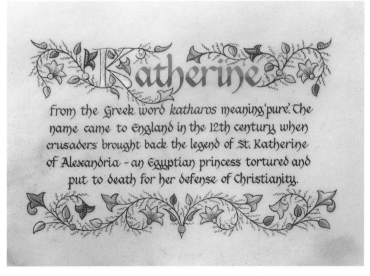

Fig. 3. Top and bottom borders frame this small text.

PROJECT *A 'Noel' Christmas card*

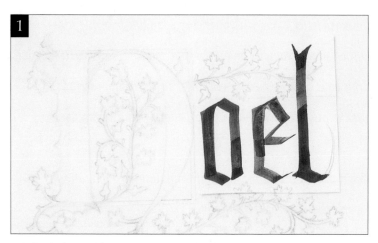

1 Begin by making a complete draft of the text and illuminated letter.

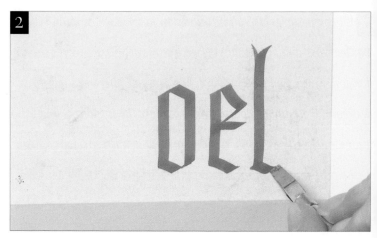

2 Cut a piece of card to the required size and write the pen-made letters into place. (A size 3 Automatic nib was used for this card.)

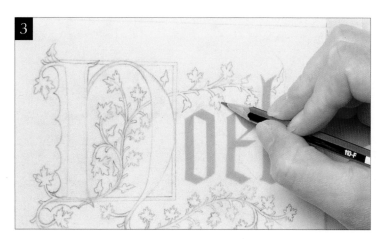

3 Trace the initial letter and decoration into place.

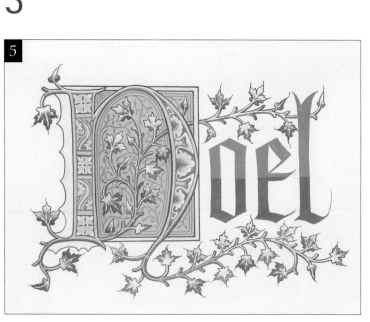

4 Work through the letter in the usual manner, with the gold areas being painted first, then the base colours and outlines, finally adding the modelling work and fine detail.

5 The written letters are given a darker overpainting to the bottom half. The design is then complete.

PROJECT *A 'Greetings' card*

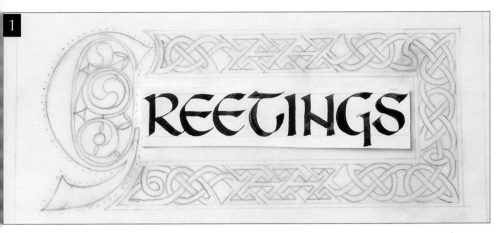

1 The draft of a Celtic 'greetings' card.

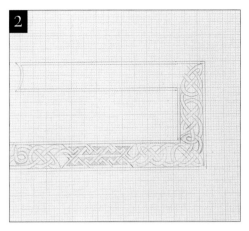

2 Work out the border design on graph paper if necessary.

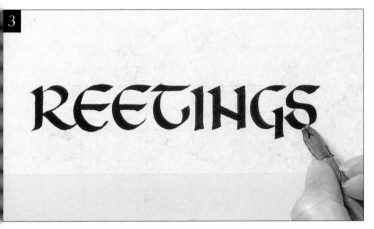

3 Write the text into place on the card.

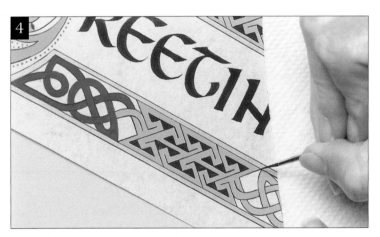

4 Paint the border in strong, vibrant colours.

5 The completed card.

PROJECT *An illuminated menu*

1 Make a draft of the text and initial letters.

3 Add line-fillers with a fine pen.

2 Write the text, then paint in the background colours of the initials.

4 Final detail is added to the initials.

Mounting, framing and caring for your work

Take care of the pieces that you create by framing or storing them well. If a piece of work contains any sort of real gold powder or leaf, it should be framed with either a mount or a thin slip of wood between the glass and the work to prevent the glass from coming into contact with the gold, which it would damage.

Figure 4 shows a framed manuscript that is based on a page from the Bedford Psalter and Hours (dated about 1420 and now in the British Library). Because the work contains a large amount of raised gilding, a thin slip of wood has been incorporated into the frame, between the work and the glass, in such a way that it cannot be seen. The main frame was hand-painted in a cream colour to match the vellum on which the work was painted and to bring out the colours of the design. This particular frame had a rebate, or rabbet, large enough to take the glass and work, as well as the additional thickness of the wooden slip, but most good picture-framers can usually find a way in which to frame any depth of painting, mount board or slip, glass and backing board, even when the frame's rebate (Figure 5) is insufficiently large. The piece illustrated in Figure 6 has a dark frame with a gold-coloured, wooden slip between the glass and vellum. This time, the gold slip has been allowed to remain visible within the main frame, thereby making the whole frame appear wider.

Fig. 4. This illuminated text, based on a page from the Bedford Psalter and Hours, is framed with a wooden slip between glass and frame to keep the glass from touching the raised gold.

Fig. 6. This piece is framed with a visible gold slip between the glass and artwork.

Fig. 5. A frame moulding showing the rebate.

Mount board comes in a large range of colours, so it should be easy to find one that will suit your particular piece of work. You will sometimes have a choice of several thicknesses, in which case choose the thickest, because this will protect the work better. Some mount boards also have a grained, or laid, texture, which can look attractive (Figure 7). Picture-framers will cut mounts with bevelled edges to size for you, which look better than the straight-cut mounts that you can make yourself (Figure 8).

Provided that they are not too large, manuscripts or individual, richly illuminated letters can often benefit from quite large margins around the work (Figure 9). Alternatively, the mount can serve as the margin if it is taken quite close to the edge of the painting (Figure 10). If the piece contains detail that extends into the border and makes the work look unbalanced when it is centred, wider margins will help to make the artwork appear more centrally positioned within the frame (figures 11–12).

Fig. 9. Allow large margins around detailed pieces.

Fig. 7. Mount board samples.

Fig. 8. Bevelled edge to mount aperture.

Fig. 10. Mount board used as a margin.

Fig. 11. Border decoration can often make a piece look unbalanced if small margins are used.

David the Bard on his bed
Cariwch medd Dafydd fy
of death lies, pale are his
nhelyn i mi, Ceisiaf cyn
features, dim are his eyes.
marw roi tôn arni hi.
Yet all around him his glance
Cod wch fy nwylaw i gyrraedd
widely roves, until it alights on
y tant, Duw a'ch bendithio fy
the harp that he loves.
ngweddw a'm plant.

Give me my harp, my companion
Neither mi glywais lais angel
so long, let it once more add its voice
fel hyn, "Dafydd, tyr'd adref a chwar
to my song. Though my old fingers
trwy'r glyn." Delyn fy mebyd,
are palsied and weak, still my fine
ffarwel i dy dant, Duw a'ch
harp for its master will speak.
bendithio, fy ngweddw a'm plant.

You should also remember that vellum will not remain flat if it becomes too warm (Figure 13), but will instead try to return to its original shape (when it was still part of a calf). It is likely that framed vellum will buckle. As long as it does not buckle too much, this is not really a problem – indeed, it can even add character to your manuscript – but try to avoid displaying framed vellum in an excessively warm site, for example, on a wall above a radiator or fire.

Never hang a piece of work in direct sunlight, which will fade non-light-fast colours very quickly and will also prematurely age the writing surface, whether it is vellum or paper (Figure 14). Instead, try to hang your work on a wall that receives no direct sunlight. Artificial light can be ideal for work that contains gilding, because light coming from different directions will highlight the gold beautifully as you move about examining the piece, and will really show it off to best advantage.

Another factor to consider is damp: mould can grow on vellum and paper if they are kept in very damp conditions. If this has happened to one of your pieces, it should be removed from its frame and treated before being reframed and hung in a dryer position. If the piece is greatly valued, employ or consult a professional picture-framer about the best cleaning process.

If the work has not been framed, look after it by keeping it laid flat – preferably not rolled up or folded – in acid-free tissue paper in a storage area that is free from damp. If you take it out to show people, explain that it is best not to touch it. People are fascinated by original artwork and will often want to touch the paint or gold – some may even try to rub it to see if it is real! Apart from any damage that they may do, however, people's fingers will always transmit a certain amount of grease and dirt to anything that they touch, even though their hands may appear to be perfectly clean. So before showing a piece to viewers, make sure that they understand that they can look, but not touch.

I hope that this book will provide an inspiration to many readers, and that it will encourage you to produce more illuminated pieces and thus keep a very beautiful art form alive.

Fig. 13. A piece of vellum will warp dramatically in the heat.

Fig. 12. Larger margins will help to centralise the text and decoration.

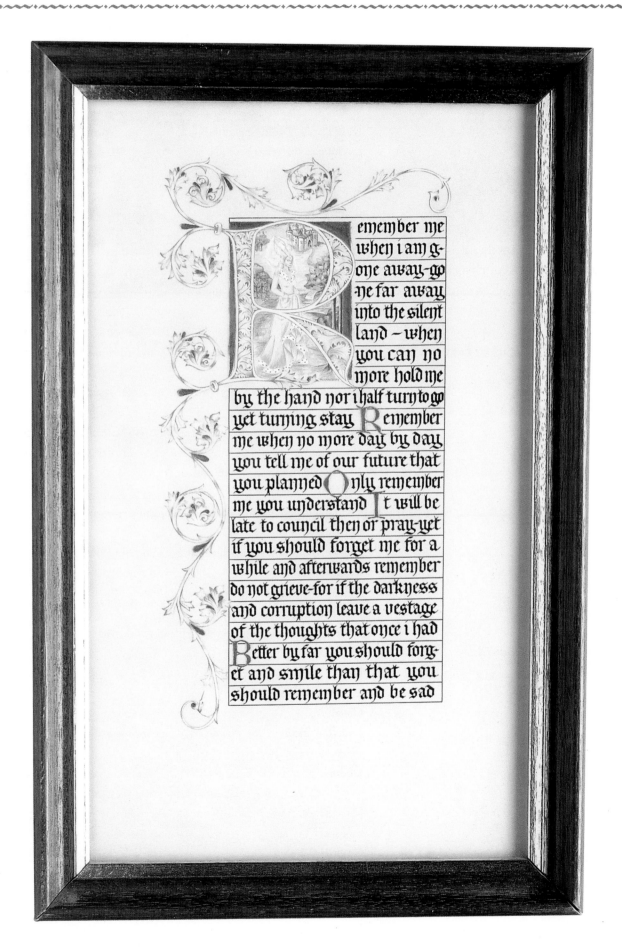

Fig. 14. Direct sunlight will fade non-light-fast colours very quickly.

Glossary

Acanthus:

a decorative foliage design based on the acanthus plant, much used during antiquity.

Anglo-Saxon:

the period from 500 to 1066 in England.

Anthropomorphics:

human forms used for decoration.

Antiphonal:

a manuscript containing the sung parts of the divine office.

Antiquity:

the classical period of Greek and Roman art, before the decline of the Roman Empire during the fifth century.

Ascender:

the part of a letter that extends above the top writing line.

Bas-de-page:

a scene at the bottom of the page.

Bestiary:

a book of beasts, real or imaginary.

Book of hours:

a book used for private devotions based on the divine office.

Breviary:

a manuscript containing texts used for the celebration of the divine office.

Burnish:

to polish or rub a surface to achieve a bright shine.

Burnisher:

a tool used to polish a surface.

Byzantine:

a style of painting that emanated from the Eastern city of Byzantium (later renamed Constantinople and then Istanbul), particularly from the ninth to the eleventh centuries.

Camaieu:

a painting in shades of a single colour.

Canticles:

short hymns.

Carpet page:

a large, decorated page of illumination covering most of the sheet.

Clarea:

a mixing medium for powdered pigment made from whisked egg white.

Counterchanged:

a design in two or more sections in which the colours and patterns are reversed in each portion.

Crazing:

a thin tracery of lines on a piece of raised gold due to the cracking of the gesso beneath.

Damp-fold drapery:

a style of painting that gives drapery the appearance of wet fabric clinging to the body.

Decorated initial:

an initial letter whose decoration does not represent any particular feature.

Descender:

the part of a letter that falls below the bottom writing line.

Diaper:

a pattern, usually repeating, spread over a surface as decoration.

Divine office:

the cycle of devotions made at eight prescribed periods during the day.

Drolleries:

amusing figures used in medieval art.

Dry brushwork:

a painting technique that uses minimal paint to give a blending effect.

Epistolary:

a service book containing the epistle readings for the mass.

Evangelary:

a manuscript containing the gospel readings for the mass.

Foliate-bar border:

a border based on a straight-edged framework decorated with flowers and foliage.

Folio:

a sheet of writing material.

Glair:

a mixing medium for powdered pigments made from whisked egg white.

Gothic:

a period, and style of illumination, between antiquity and the Renaissance, roughly dating from the late twelfth to the early sixteenth century.

Gradual:

the principal choir book used in the mass.

Grisaille:

a painting consisting solely of shades of grey.

Grotesques:

hybrid figures, usually composed of human and animal forms, and often having a comic character.

Herbal:

a book containing information about, and illustrations of, plants.

Historiated initial:

an initial letter containing a recognisable scene relating to a particular event.

Humanistic:

a style of painting that revived classical learning and originated in Florence, Italy.

Hymnal:

a manuscript containing the hymns sung in the divine office.

Inhabited initial:

an initial letter containing figures or creatures, but not in an identifiable scene.

Insular:

a period, and style of illumination, in Britain and Ireland between 550 and 900.

Key pattern:

a geometric pattern of interlocking shapes.

Knotwork:

a pattern made with a continuous weaving line, found particularly in Celtic art.

Kyriale:

a book containing the ordinary chants of the mass.

Line-filler:

a small piece of decoration used to fill space at the end of a line of text.

Littera florissa:

light, pen-worked decoration added to letters.

Liturgy:

the rites, observances and procedures of public worship.

Majuscule:

a capital or upper-case letter.

Mass:

part of the liturgy, the celebration of the Eucharist.

Minuscule:

a small or lower-case letter.

Missal:

a service book containing the texts used for the mass.

Modelling:

detail applied to a painting to achieve a sense of form.

Mortar:

a vessel in which substances are pounded or ground with a pestle.

Overpainting:

subsequent areas of paint on a background colour.

Parchment:

the skin of a sheep that has been prepared for writing or painting.

Pounce:

a powder used to clean and abrade the surface of vellum in preparation for writing or painting.

Psalter:

a book of psalms.

Romanesque:

a period, and style of illumination, in the Western world of the late eleventh and twelfth centuries, so called because it was based on Roman principles of construction.

Sacramentary:

a service book of prayers used during the mass.

Terminal:

the end point of a stroke of a letter or piece of decoration.

Trompe l'oeil:

'deceives the eye', a style of painting that attempts to give objects as naturalistic an appearance as possible.

Trope:

an early musical note.

Troper:

a book containing tropes.

Upright:

the vertical stroke of a letter.

Vellum:

the skin of a calf that has been prepared for writing and painting.

Zoomorphics:

animal forms used for decoration.

Index

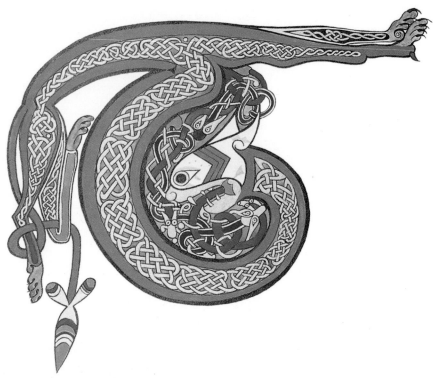

Credits and Acknowledgements

The author and publisher would like to thank the following:

Mr Window
for permission to reproduce the large family tree on page 94

Mrs Angela Lynskey
for creating the flower display shown on page 117

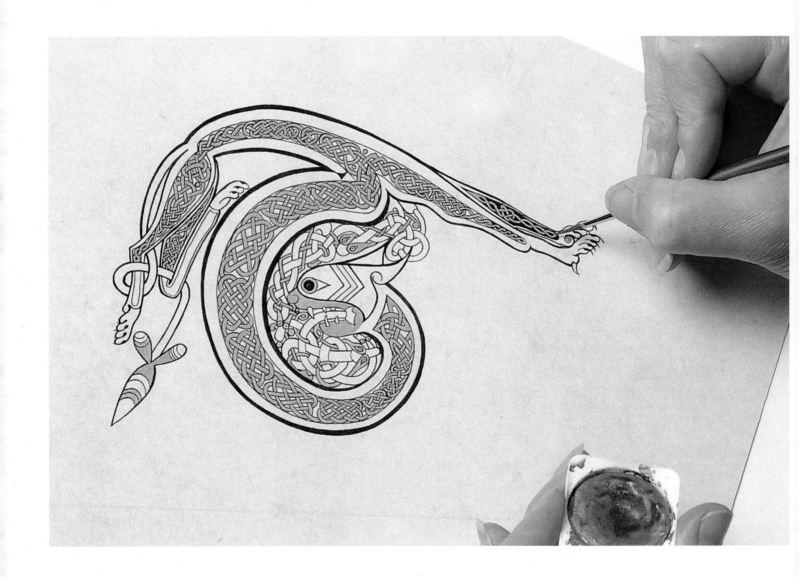